Direct Stone Sculpture

A Guide to Technique and Creativity

Milt Liebson

Schiffer Publishing Ltd

1469 Morstein Road, West Chester, Pennsylvania 19380

DEDICATION

Ability is but a seed lying dormant
in all men...Ambition, a fertilizer, a by product
of our way of life.
Encouragement, the necessary fuel to germinate
the seed and utilize the fertilizer.

To my wife, Lila.

Milt Liebson

Published by Schiffer Publishing, Ltd.
1469 Morstein Road
West Chester, Pennsylvania 19380
Please write for a free catalog.
This book may be purchased from the publisher.
Please include $2.00 postage.
Try your bookstore first.

Acknowledgments

Of necessity, a great many people must be consulted in compiling a volume of this type. While the actual subject is an accounting of my personal experiences and expertise in direct stone carving, the project could not be completed without the encouragement, cooperation, and assistance of those supportive of the undertaking.

Initially it was my students who urged me to transpose my methods of teaching and guidance into an up-to-date treatise on direct stone carving. A work of this type had not been done in over twenty years and, although I was aware of the scarcity of adequate texts in the field, I had been in the practice of recommending the available reference material to them. I thank them for their confidence in me.

The rights and reproductions departments at the various museums that I contacted have been extremely helpful in researching and supplying me with photographs of the work of the master sculptors which appear in this volume. In particular, I wish to thank the staffs at the Museum of Modern Art, New York City, the Hirshhorn Museum, Washington, D.C., The Art Institute of Chicago, The Philadelphia Museum of Art, The Cleveland Museum of Art, and the Whitney Museum of American Art.

My thanks are extended to American sculptors Ruth Zuckerman, Bernard Stone, John Libberton, Paul Silverstein, Francisco Rivera, and Soviet sculptor Yuri Orechov, who have contributed photographs of their work. Tom Mathison at Sculptor's Supplies Company, New York, is due a special note of gratitude for his cooperation in supplying photographs and graphics of tools and equipment. Finally, a note of appreciation for the assistance of my editor, Douglas Congdon-Martin, whose advice has been directed toward making this book the standard in the field for many years to come.

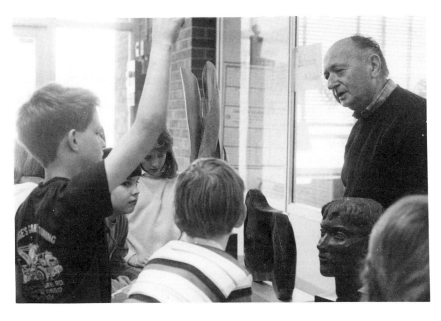

The author demonstrating sculpture techniques to students at Cranbury School, Cranbury, New Jersey.

List of Sculptures

Contents

Introduction and Approach

Art libraries have held a fascination for me and I have spent many hours examining books on technique and procedures for all the artistic media in the hope that I could discover an author who would project part of himself into his writings.

The great master, Jacques Lipchitz, in his autobiography, *My Life In Sculpture* reveals quite candidly that he never wanted to teach simply because he did not wish to disclose his secrets, his techniques, and methodology. Conversely, I have gained much from teaching. Sharing my ideas with others has expanded my vision, my thoughts, and my creative productivity.

It is my sincere belief that a teacher cannot teach unless he is willing to give part of himself to his students...his ideas, his thoughts, his emotions, and disappointments. A teacher cannot communicate simply by explaining step 1, step 2, step 3, etc. Rather, he must succeed in capturing the confidence of the student, by understanding the capabilities, the goals, and ambitions of the student. He must intertwine his thoughts with those emerging from persons seeking his expert advice.

It is a difficult task intensified by a scarcity of teachers in the field of direct stone carving. A suitable tutorial is a proper initial step which must be accompanied by a determined work effort on the part of the reader.

Practice, practice, and more practice is required of the student and I shall concentrate on describing my personal experiences with the "how to" rather than just the "do it."

The art form is a result of individual human creativity. When instructor and pupil reach a common level of emotional understanding, the transfer of knowledge can take place. The attainment of this creative parallel continues to be my goal.

The author and students in a class at the Clearbrook Community Association, N.J. Photo by Herb Lichtman.

Prologue

"Art is a command. The hands must be trained by practice, the mind by constant acquisition of knowledge, and the heart by its undefeated faith and desire to overcome all obstacles. For sculpture is a thorny road beset by barriers, defeats, and disappointments."

Malvina Hoffman

"Sometimes out of despair, when we have given up, the stone itself sends a message—should one say, bit by bit—so that we may receive it. Finally everything falls into place and emerges with a precision so remarkable it cannot be chance."

Isamu Noguchi

Chapter I

History of Stone Sculpture

Stone sculpture was the first artistic endeavor of humanity. From the earliest times, human beings created artifacts, weapons, and instruments of every day life from fragments of the rocky domain. Documentation was recorded by means of crude images scratched on the walls of caves. Painting was a luxury for prehistoric people and developed well after the first use of stone objects to create three dimensions was recorded.

Let us initiate a brief account of the history of stone as an art form with the reminder that the Ten Commandments, which Moses received, were carved in stone and that throughout the ages sculpture was the primary art form. The Egyptians, Greeks, and Romans were primarily sculptors. The great structures of Egypt and the tranquil beauty of the statues and artifacts of Greece and Rome continue provide us with an accounting of their culture and every day life.

Egyptian art was extremely idealistic, creating a harmony between God and humans. This spirit was strong enough to endure for centuries, surviving periods of upheaval and invasion.

Sculpture was the form most suited for expressing the Greek ideal. Sculptural form during this period reached a level of perfection never again attained. Greek sculptors were obsessed with the perfection of the human body and it is believed that the figures were a depiction of gods in human form.

In all parts of the Roman world, excavations indicate that sculptural styles followed Greco-Roman formalism in all correctness, often as a result of duplicating the art and culture of Greece.

Before entering the period of Renaissance Art in the West, we must remember that other parts of the world, the Far East, Middle East, Africa, South America, and Central America, contributed sculpture utilizing stone, clay, wood, as well as the precious metals and bronze.

The renaissance in art in Italy was dominated by returns to traditional forms. In sculpture, its essential tradition was a grasp of the corporal reality of the human body. In discussing Michelangelo, 16th century, it is important to note that the great master despised bronze. He considered its apparent hardness a deception since the building of clay modeled for casting was, in his view, an easy process. Only direct carving seemed to him worthy of a great artist, for he conceived it to be the artist's goal to liberate the forms and forces hidden within a block of marble.

Although somewhat dominated by painting, sculpture continued to maintain a prominent place in the art world of Western Europe during the sixteenth, seventeenth, and eighteenth centuries. Classicism was the rule and was primarily of religious motif. Since the church commissioned the majority of the sculptural and painting assignments, complete freedom of expression was lacking.

On a recent trip to Italy I had the opportunity to examine a great deal of the sculpture on display in the museums and their store rooms. I was conscious of the apparent single-mindedness of the subject material. Religious classicism was the dominant factor! In one of the museums of Florence, I came upon a limestone statue, unidentified as to artist, and apparently executed during the sixteenth century. The subject was a young Florentine

apprentice, life-size, seated, and busily carving a stone sculpture.

How wonderful! I fantasized that the artist carved the statue in his spare time because he wanted to and uninfluenced by the dictates others. It was, in my view, an early form of freedom of expression.

Classicism in sculpture persisted throughout the seventeenth, eighteenth, and nineteenth centuries, influenced to some extent by the discovery of the lost cities of Herculaneum and Pompeii. This influence however, was wearing thin. Sculpture in the nineteenth century was stale and unexciting. The classic style had endured for five hundred years. It was tired and passe. It might be said that the only contribution of the nineteenth century sculptors was that they gave the twentieth century sculptors something to revolt against.

Revolt they did! Rodin's late nineteenth century portrayal of Balzac departed from the typical classical pose and appearance. As was the case with the French impressionist painters of that period, controversy arose regarding the apparently new style. However, the best was yet to come. The great sculptors of the twentieth century rekindled an awakening of stone as a medium. Gone was the yoke of suppression and dictation by church, state, and public acceptance. Artists revelled in the newly found freedom of expression. Individual creativity and emotional awakenings were the contributions of such sculptors as Brancusi, Arp, Archipenko, Hepworth, Moore, Noguchi, de Creeft, and others.

Although Rodin was a contributor to the revolt against classicism during the latter part of the nineteenth century, he did not utilize stone as a primary medium. It is a fact that he did not carve stone. Rather, he avoided it completely, preferring bronze castings of plaster and clay models. Stone sculptures attributed to Rodin were actually of copies of his modeled plaster or clay work executed by means of an apparatus called the Pointing Machine which was in use during the eighteenth and nineteenth centuries. A great deal of the stone sculpture of that time was produced by this machine. Its use involved hundreds of measurements of the model, with metal points applied to the stone penetrating to the depths of these measurements. The artist's assistants would then carve away the stone based upon the measurements and refine the subject.

When the treatment of stone sculpture by Rodin is contrasted with that of Michelangelo, who accepted direct stone sculpture as the only medium worthy on an artist's endeavors, one wonders if the Pointing Machine was the reason for the lack of interest in stone sculpture during the nineteenth century. The final product, mechanically reproduced by others, lacked the intensity, and the emotion of the artist they represented.

During your next visit to a display of Rodin's work, or perhaps to the Rodin Museum in Philadelphia, make it a point to examine some of the stone sculpture. If you look carefully, you might see tiny pin holes covering some of the areas. These are the remains of the pointing machine process and not a result of carving by Rodin.

Finally, classicism was gone, perhaps never to return. Freedom of expression emerged and individual creativity flourished. With it, came a rebirth of the love for direct stone carving.

Gallery of Stone Sculpture

Early Twentieth Century: The Revolt Against Classicism

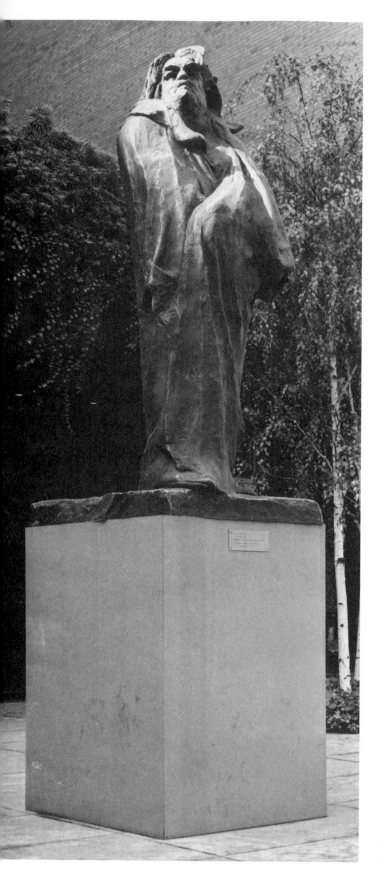

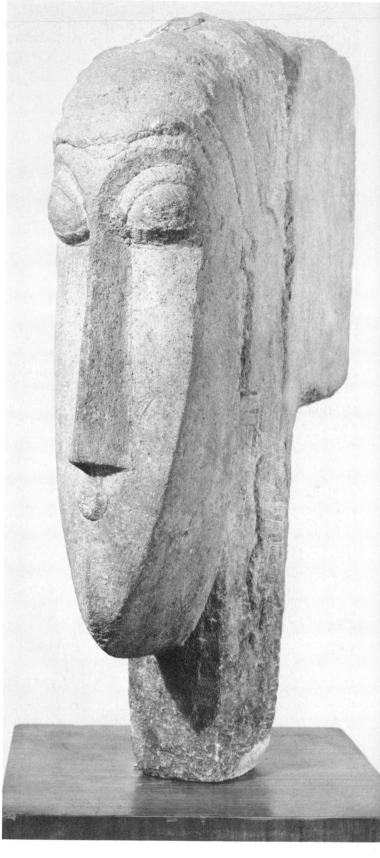

Rodin, Auguste, *Monument to Balzac*, 1897-98. Bronze
(cast 1954), 111" x 48¼" x 41". *Courtesy of the Museum of
Modern Art, New York, presented in memory of Curt Valentin by
his friends.*

Modigliani, Amedeo, *Head*, 1915. Limestone, 22¼" x 5" x
14¾". *Courtesy of the Museum of Modern Art, New York, a gift of
Abby Aldrich Rockefeller in memory of Mrs. Cornelius J. Sullivan.*

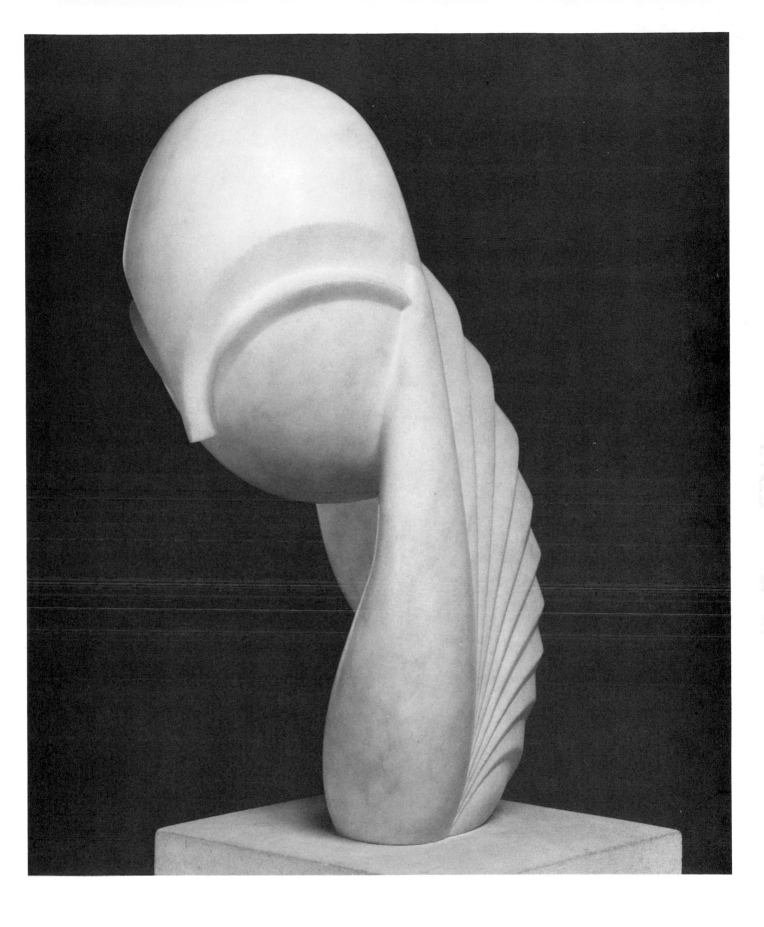

Brancusi, Constantin, *Mlle. Pogany*. Marble with limestone base, 19" high. *Courtesy of the Philadelphia Museum of Art, Louise and Walter Arensberg Collection.*

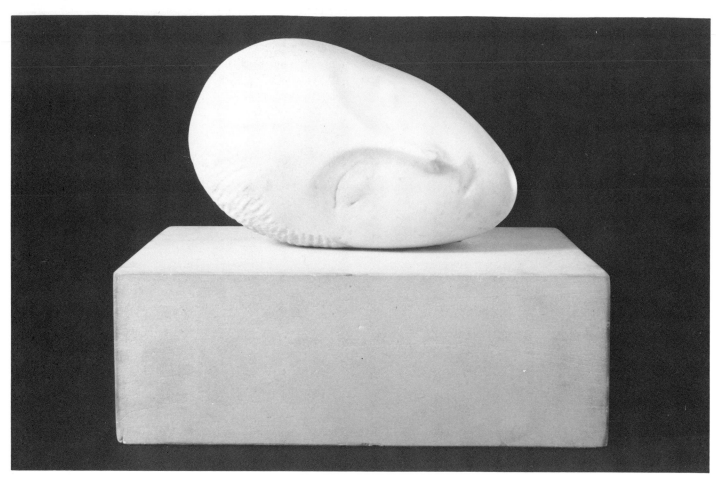

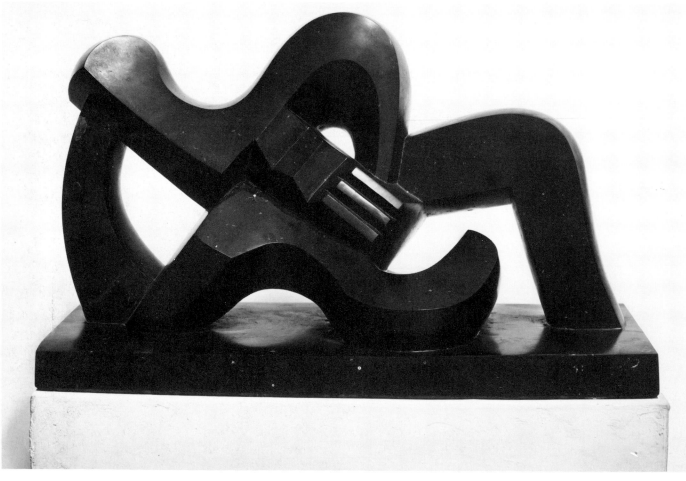

Opposite top photo:
Brancusi, Constantin, *Sleeping Muse I*, 1909-1911. Marble, 7" x 10⅝" x 8". *Courtesy of the Hirshhorn Museum and Sculpture Garden, a gift of Joseph H. Hirshhorn.*

Opposite bottom photo:
Lipchitz, Jacques, *Reclining Nude with Guitar*, 1928, Black Limestone, Front View, 275' 8" long *Courtesy Museum of Modern Art, New York, Mrs. John D. Rockefeller 3rd Collection.*

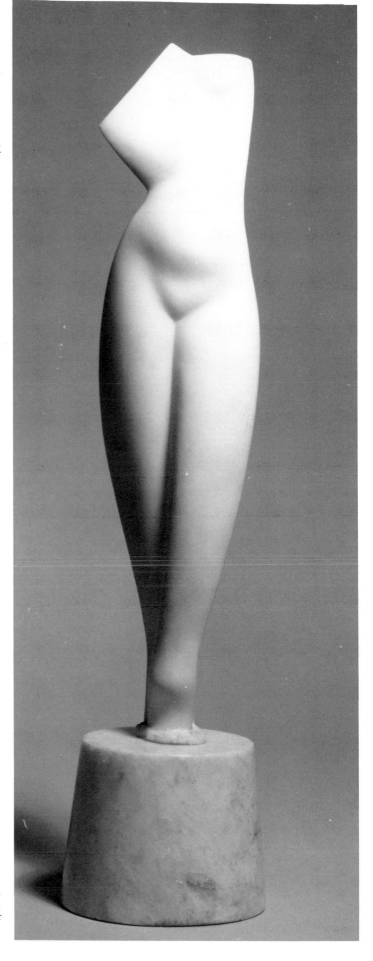

Archipenko, Alexander, *Flat Torso*, 1915. Marble on alabaster base, 18¾" x 4½" x 4½". *Courtesy of the Hirshhorn Museum and Sculpture Garden, Smithsonian Institution, a gift of Joseph H. Hirshhorn, 1966.*

15

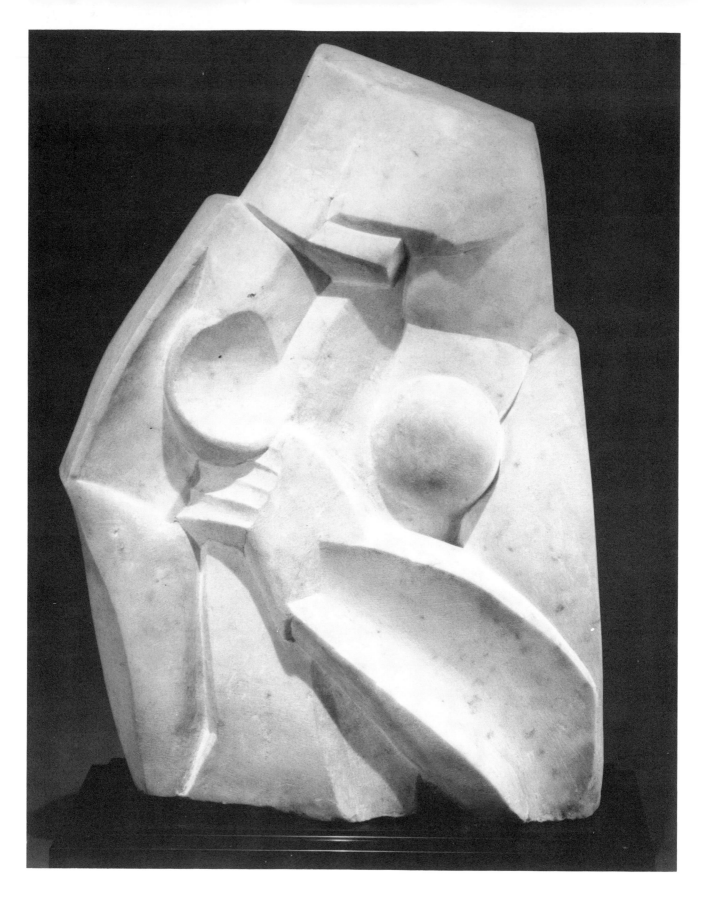

Zadkine, Ossip, *Mother and Child, (Forms and Lights)*, 1918.
Marble, 23¾" x 16½" x 7½". *Courtesy of the Hirshhorn*
Museum and Sculpture Garden, Smithsonian Institution, a gift of
Joseph H. Hirshhorn, 1966.

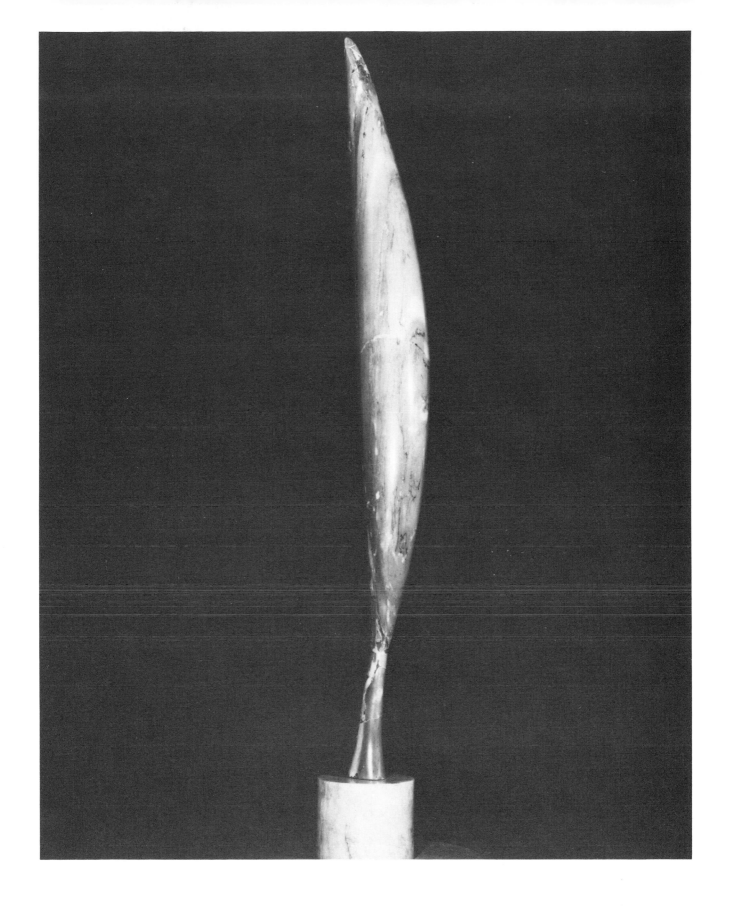

Brancusi, Constantin, *Yellow Bird*, 1925. Marble, 45″ high (without base). *Courtesy of the Philadelphia Museum of Art, Louise and Walter Arensberg Collection.*

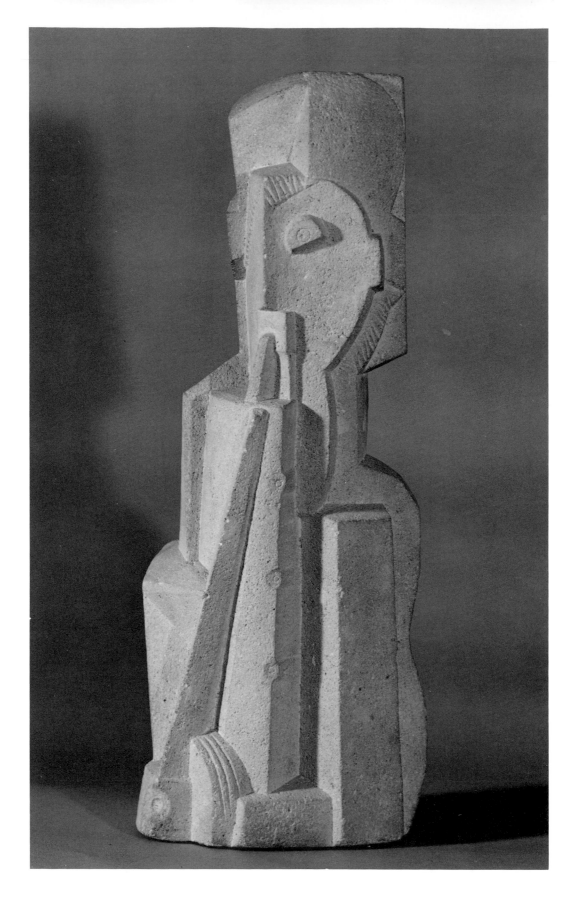

Laurens, Henri, *Man with Clarinet*, 1919. Stone, 23⅝" x
8⅞" x 6⅜". *Courtesy of the Hirshhorn Museum and Sculpture
Garden, Smithsonian Institution, a gift of Joseph H. Hirshhorn,
1966.*

Chapter II

Essentials of Stone

It is possible to begin carving stone with comparatively little technical knowledge of stone and with the simplest of tools. Experimentation and concentrated work effort is the greatest teacher of all. However, unguided experiments on the wrong stone can lead to frustration and disillusionment for the novice or inexperienced fledgling sculptor.

I have had students come to me uncertain of their ability to carve stone. Invariably it has been the case that through their own inexperience or through the advice of an instructor, they had started on a stone which was far beyond their ability at that particular point in their career. I recall a young man who after enrolling in my class in direct carving, expressed his desire to carve prepared blocks of plaster. After explaining that plaster was at best an intermediate material, he confessed to having tried stone during his college years. The instructor of the art course had him start on marble, the wrong advice for the student at that time. The student became discouraged at his lack of success, packed his tools away and turned to other media. I convinced the young man to try the stone medium once again and suggested the proper material. Success was inevitable! With guidance, the proper medium, and a good effort, an outstanding sculpture was produced.

It is not my intent to present the reader with a detailed course in geology, but a basic knowledge of the categories and properties of stone is as important as the carving techniques themselves.

Each category contains many varieties of stone. For our purposes I shall describe those stones regularly supplied by stone dealers and those suitable for carving.

Those who are interested in a detailed description of rocks and stones should refer to *A Field Guide to Rocks and Minerals*, by Frederick H. Pough. This handy volume sponsored by the National Audobon Society and Wildlife Federation is available at most bookstores.

As the formation of the earth evolved over the millennia, stone that formed fell into three general classes: igneous, sedimentary, and metamorphic. These classes were based upon formations produced as a result of heat, pressure, or a combination of both.

Igneous stone was formed as a result of intense heat produced by volcanic action and subsequent cooling of masses of earth and debris. The speed of the cooling and the location, whether beneath the surface (intrusive), or above the surface (extrusive), determined the physical properties of the stone.

Sedimentary rocks originate by the action of pressure without heat. As stone and rocks of any sort are exposed on the surface of the earth, the sun, rain, air, and frost attack them, breaking the rocks down to soil which is carried as run off by water and streams. Beds of sediments are layered and stratified. As they become thicker, the extreme pressure of their weight forms them into rigid, cemented masses. Sedimentary rocks are found lying in thick beds, often forming deposits thousands of feet thick.

Metamorphic rocks are by far the most popular stones for the sculptor. They evolve by the combination of heat and pressure upon existing

sedimentary stone formations. A sedimentary stone such as limestone when subjected to heat and pressure undergoes "metamorphic" changes as it decomposes and combines with decaying mineral deposits. As the process continues, crystalline metamorphic rocks are formed and the original mixture of minerals are destroyed.

Chart 1

CLASSES OF POPULAR STONES

IGNEOUS	SEDIMENTARY	METAMORPHIC
lava	*limestone	*soapstone
obsidian	*sandstone	*marble
felsite	dolomite	*alabaster
basalt	coal	*serpentine
diorite	shale	*onyx
gabbro	salt	*chlorite
*granite		slate
		*travertine
		schist
		*alberene
		*wonderstone

*Popular Carving Stone

The scale of relative hardness of the various stones was originated by a German mineralogist, Frederick Mohs in 1822 and has been followed ever since. While it is not an exact mathematical relationship, it does provide us with guidelines for determining the hardness of stone. It merely states that 10 on the scale is harder that 9, just as 9 is harder than 8, and so on. The relationships on the scale are approximations and it is up to the sculptor to determine the correct stone for his use. It is important to understand that the Mohs scale alone cannot determine whether or not a stone is suitable for carving. Other factors which influence the selection of a stone are color, impurities, fragility, and density, among others.

All stones can be carved to a degree, but only a handful have become popular. If we were to apply these to the Mohs scale of hardness, their relationships would be approximately as follows:

Chart 2

MOHS HARDNESS OF STONE

```
10 diamond
 9 corundum
 8 granite*
 7 quartz
 6 marble*, travertine*, onyx*
 5 apatite
 4 limestone*, sandstone*, serpentine*
 3 alabaster*, wonderstone*, alberene*, soft serpentine*
 2 soapstone*
 1 talc
```

*Popular Carving Stone

I would not recommend granite, marble, travertine, onyx, or any of the stones of equal hardness for the fledgling sculptor. The difficulty in carving these stones would be detrimental to the training of the student sculptor and would deter his interest in continuing. It is said that a sculptor does not gain recognition as a sculptor until he or she has carved marble. Nevertheless, I would suggest that the student successfully complete five or six works of stone in ascending order of hardness prior to undertaking marble. Conversely, at the other end of the scale, soapstone should be avoided. Although soapstone is quite lovely with delicate shading and graining, it is extremely soft, and will tend to fracture at the slightest pressure. Its softness will instill a feeling of complacency that will do harm in the progress of student's training. Often, the material will fracture during carving causing distress to the carver. In addition, soapstone is heavily laden with talc, a material that can cause illness and lung disease if inhaled over a period of time. The bottom line regarding soapstone is that I do not allow the material in any of my classes.

It remains, therefore, for me to recommend stones at the middle of the scale. These stones are the most popular with sculptors in training and with professional carvers as well. Alabaster, wonderstone, limestone, Virginia alberene, and the softer grades of serpentine are preferred for the novice and those with some advanced training.

SPECIFIC STONES FOR SCULPTURE

Metamorphic and sedimentary stones are the most popular for carving. The popular core of this group includes marble, alabaster, serpentine, Virginia alberene, and African wonderstone. While there are others in this group which can be carved with a great deal of success, those mentioned remain the most preferred.

Marble has long been a favorite for sculptors. Since the time of the Greeks, through the period of the Renaissance in Italy, and to the present, marble has been the classic stone for carvers. It varies from extremely hard varieties such as Belgian black to softer varieties of Vermont and Carrara (Italian) marble. Examples of marble for carving are: white Carrara statuario, Rosfi rose, red alicante, Portuguese rose, Portuguese pink, Chinese black, Chinese grey, Chinese white, black marquina, Belgian black, and Vermont white.

There are many varieties of this beautiful stone. The Marble Institute of America, Washington, D.C., lists the color ranges of 295 marbles currently available from around the world.

Alabaster is a soft stone that I strongly recommend for beginning or advanced students. It is one of the most beautiful stones, available in a variety of colors, crystalline, marbled, and in opaque or translucent form. Henry Moore, the master English sculptor, once wrote that he avoided carving alabaster simply because viewers were so engrossed by the beauty of the stone that they ignored his work in carving the material. I must agree completely, and I have had similar encounters.

The most striking of the alabasters is the domestic variety of pink, native to Colorado. I have had great success with this stone, both in my own work and with that of my students. It is a stone that I stock in my studio at all times.

Alabaster is available from all parts of the world and offers a wide range of colors which vary with the source of origin. The more popular are beige, brown, green/red, grey cloud, honey/tan, orange opaque, orange translucent, pink, raspberry, tawny beige, white & black, white & brown, white translucent, white on white, and yellow.

African wonderstone and Virginia alberene are excellent materials for beginners, advanced students, and professionals. These stones are fine grained, medium to dark grey in color, and when polished, appear grey-black to jet black in color. The alberene or soft serpentine, as it is sometimes called, is another that I stock in my studio.

Sedimentary stones offer limited varieties for carving, but include one of my favorites, which is limestone. The "oolitic" variety, a limestone composed of minute rounded concretions resembling fish roe, is the preferred type for carving. The material is available in buff or cream color and is quite porous. It is about twice as hard as alabaster and more roughly textured. It will support intricate carving, severe undercutting, and is excellent for creating textures. In addition, it can be polished to a beige tone, at the discretion of the artist.

The finest "oolitic" limestone is quarried in Indiana and is another material which I recommend at my studio. Other limestones are available from other parts of the United States and Europe. French limestone, referred to as Caen stone, was used to a great extent by Henry Moore.

Another sedimentary stone, sandstone, is composed of fine grains of sand held together by a binding material of varying degrees of hardness. This binding material might be quartz, iron oxide, calcite, clay, or certain crystalline forms of calcium carbonate. The hardness of the stone varies with the amount of quartz in combination. The more quartz, the harder the stone is to carve. Conversely, when little quartz is present, the stone will tend to crumble and fracture. Colors may be grey, red, brown, blue, or black, depending on mineral content. Sandstone is quarried primarily for the building trade in this country and those quarried in England, France, and Canada have produced good quality stones for sculpture.

My personal preference does not favor the use of sandstone for carving primarily because I consider it a health hazard. The large number of silicates found in this stone presents a problem. Inhaling of silicates can produce lung disease and a good respirator should be worn if this stone is to be carved.

Chapter III

Tools and Equipment

In order to perform properly in any capacity, it is always advisable to obtain the best equipment that you can afford. Tennis players should use the best rackets, carpenters the best hardware, and sculptors the best carving tools available. It simply makes the job easier, and, in the long run, it helps you perform more effectively and more economically. In addition, a wide range of accessories must be available to support the basic repertoire of carving tools.

One only has to examine any catalogue available from the various sculpture supply houses to appreciate the number of supportive equipment available to the sculptor. It is easy for the novice to become confused and for the advanced student to become overwhelmed when confronted by the array of equipment and supplies. Where do you begin? Which chisels should you use? What type of files should you use? Which polishing materials are the best?

There are many questions to be answered and I shall proceed throughout this book by revealing the materials and procedures that I employ in my own work. It would be advisable for the reader to follow my methods and, after gaining experience, feel free to experiment with varied equipment which might suit their physical dexterity.

The following chart offers a listing of the various types of paraphernalia available. Some are essential to success in the field of stone sculpture, but it is critical to note that not all of the items listed are required. As a matter of procedure, I shall elaborate on the selection and usage of each category of equipment during subsequent chapters on methodology.

Chart 3

TYPES OF EQUIPMENT

bases & pedestals	protective equipment
canvas items	rotary burrs
compressors	sanding & polishing supplies
electric grinders	sharpening supplies
files & rasps	stone for carving
flexible shafts	stone carving tools
mounting supplies	workbench
pneumatic tools	

Without a doubt, this is a most imposing list. However, it is not intended to intimidate or deter the student from his or her intended goal. In reality, only a small number of tools is needed to successfully complete a project. I shall discuss each tool in turn as it is used in the process of carving and recommend the purchase of a basic inventory of these tools and supplies. The basic tools however, are an absolute necessity, and the elimination of any part of the repertoire will prevent completion of a successful sculptural process.

All of the equipment and supplies which will be described in this volume are available at sculpture supply companies in all parts of the country.

Initially, the first consideration is a proper work space. The proper environment contributes greatly to the feeling of comfort and relaxation while working. If the work is to be performed at an established art institution or studio, it is certain that the facilities would be more than adequate. In

arranging for your private space in a garage, basement, or a part of a home, proper ventilation must be assured to eliminate the dust produced. Window, or roof ventilation fans should perform adequately.

Of critical importance is the provision of a workbench. The primary type would be one that would enable the sculptor to walk around the bench in order to view the work from all angles. A secondary selection would be secured against a wall. Adequate overhead lighting is needed with the addition of auxiliary illumination to highlight areas of direct work.

The illustrations below depict workbenches available from the various supply companies. Note that they are thirty-three inches tall and sturdy enough to prevent vibrations while working.

CARVERS' BENCHES (Butcher Block)

Selected edge grain hard rock maple . . . electrically bonded . . . lacquer finish. An excellent work surface for stone carvers, woodcarvers, etc.

No. WB-24 Top Size-24″ x 30″ x 3″ thick
Legs- 3″ x 3″
Height-33″
Weight-85 lbs.
Shipped knocked down flat
(Easily assembled)

No. WB-48 Top Size - 24″ x 48″ x 1-3/4″ thick
Legs-3″ x 3″ (Legs offset on one side to accommodate the mounting of a woodworking vise)
Height-33″
Weight-87 lbs.
Shipped knocked down flat
(Easily assembled)

Carver's benches, courtesy of Sculptor's Supplies Co., 222 East 6th Street, New York, N.Y. 10003

BASIC STONE CARVING TOOLS & SUPPLIES

1 Fine Point Chisel—74A
1 Medium Point Chisel—74B
1 Five Point Chisel—67O
1 Flat Chisel—76A
1 Rondel—75D
1 Italian Steel Hammer, 2 lb.—552
1 Cabinet Rasp 8″
1 Round Rasp 8″

1 Riffler Rasp 10″—167
1 Riffler Rasp 10″—164
1 Riffler Rasp 10″—161
1 Pitching tool 2″ blade—516
1 Safety Glasses 2003
2 Sandbags SB-10
1 Respirator—66

The pages that follow illustrate the wide range of carving tools and supplies that expand upon the selections that I have made. Substitutions can be made based upon availability. As you gain experience, additions can be made based upon your observations and physical dexterity.

Purchasing a complete set of tools including each size across the board, would be quite expensive and unwise. It is better to ease into increasing your repertoire of tools based upon your own personal experience.

The hammer is an important piece of equipment which deserves particular attention. It is not unusual for students to acquire the incorrect weight. One that is too light will require a stronger blow to get the job done, and one that is too heavy will create rapid fatigue. In my opinion, the one pound hammer is totally useless. I use several hammers for my work, and they range from one-and-one-half to two pounds in weight. The soft iron hammer is sometimes referred to as a "student hammer," and it is one that I do not advise. After a short time, the edges will tend to flange outward creating a problem. It is much more advisable to obtain a good tempered steel Italian tool that will last for many years.

Eye protection is an absolute necessity. When chiseled, stone will fly in all directions and you must protect the eyes at all times. In my classes, I will not allow a student to proceed without proper eye coverage. Safety glasses, style 2003, are adequate for those who do not wear corrective lenses and goggles, VCB-3, serve well for those who do. Style 327 will fog and become useless and is not recommended. Face shield PS-148 or CPV-1584 afford the best universal protection for face and eyes.

Sandbags are a necessary item for positioning stone while carving. They absorb shock and noise, and protect the stone against bruises. The bags can be filled either with sand, or the lighter and equally effective cat litter.

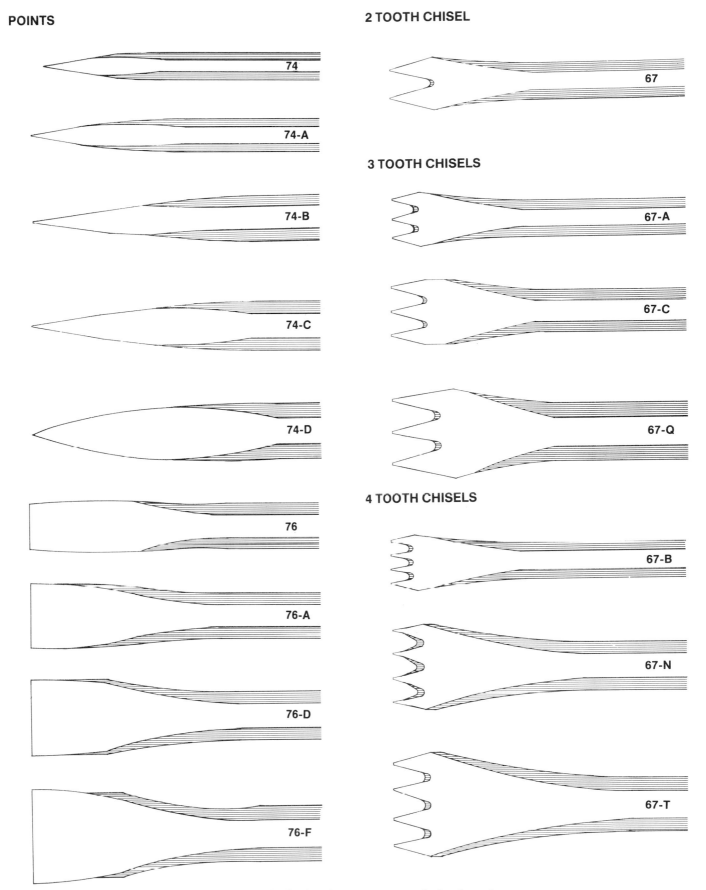

POINTS

74

74-A

74-B

74-C

74-D

76

76-A

76-D

76-F

2 TOOTH CHISEL

67

3 TOOTH CHISELS

67-A

67-C

67-Q

4 TOOTH CHISELS

67-B

67-N

67-T

Points and toothed chisels, courtesy of Sculptor's
Supplies Co., 222 East 6th Street, New York, N.Y. 10003

5 TOOTH CHISELS

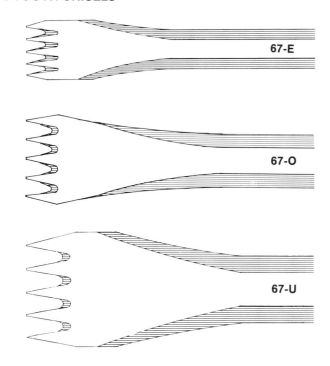

67-E

67-O

67-U

6 TOOTH CHISELS

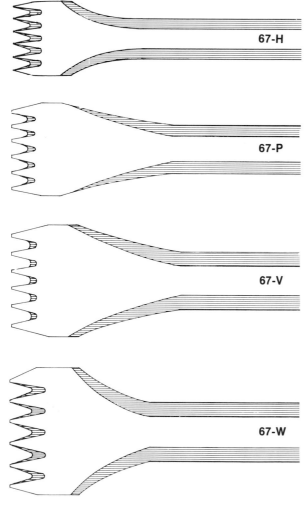

67-H

67-P

67-V

67-W

9 TOOTH CHISEL

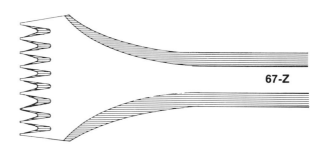

67-Z

CAPE CHISELS

75-A

75-B

RONDELS

75-C

75-D

FINISHING CHISELS

75-E

75-F

HAND CARVING TOOLS

Exceptionally fine quality professional Italian hand forged tools. . . Marble tempered.

Face shown full size

Approx. 8-1/2" long

Toothed chisels, cape or flat chisels, rondels, and finishing chisels, courtesy of Sculptor's Supplies Co., 222 East 6th Street, New York, N.Y. 10003

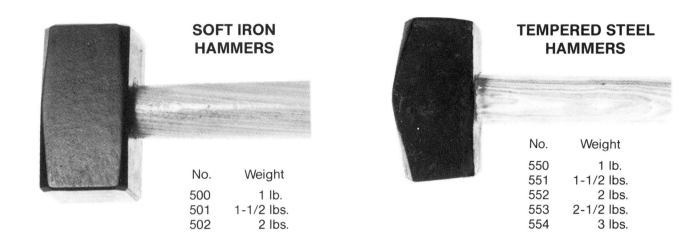

SOFT IRON HAMMERS

No.	Weight
500	1 lb.
501	1-1/2 lbs.
502	2 lbs.

TEMPERED STEEL HAMMERS

No.	Weight
550	1 lb.
551	1-1/2 lbs.
552	2 lbs.
553	2-1/2 lbs.
554	3 lbs.

Sculptors hammers, courtesy of Sculptor's Supplies Co., 222 East 6th Street, New York, N.Y. 10003

CABINET RASPS - A good basic half-round rasp . . . works well on stone and wood.

Sizes - 6" 8" 10" 12" 14"

PATTERN RASP - A fine quality rasp with hand cut teeth . . . excellent on all materials from lucite through marble.

Size - 10"

VIXEN FILES - A single row of teeth across the cutting edge . . . leaves a very smooth surface . . . can be used on most materials.

Sizes - 8" 10" 12" 14"

ROUND RASPS - A good quality medium tooth rasp.

Sizes - 6" 8" 10" 12" 14"

Rasps, courtesy of Sculptor's Supplies Co., 222 East 6th Street, New York, N.Y. 10003

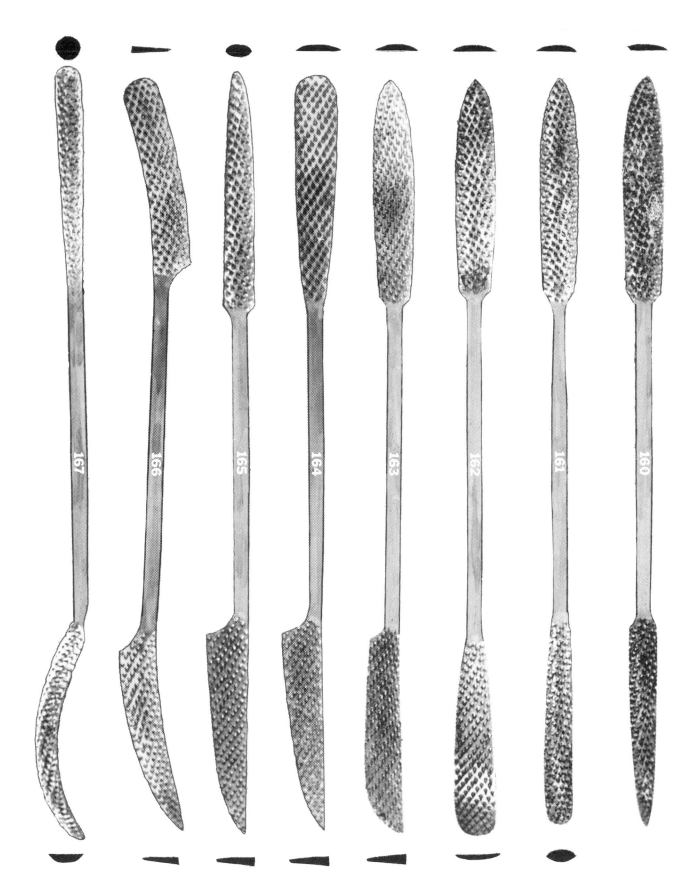

Riffler rasps available in sizes from 7" to 14", courtesy of Sculptor's Supplies Co., 222 East 6th Street, New York, N.Y. 10003

28

PLASTIC GLASSES

Excellent inexpensive eye protection . . . with side shields and brow-bar.

SAFETY GLASSES - UNICUS No. 2003

Features: Nylon frame
Case hardened clear lenses
Clear side shields
Adjustable sidearm lengths

SAFETY GLASSES - UNICUS No. 2061

Features: Nylon frame
Case hardened clear lenses
Clear ventilated side shields
Adjustable sidearm lengths
and inclination
Replacement: Clear Lenses

SAFETY GOGGLES - IMPACT No. 327

Features: Soft vinyl perforated frame
Clear lense
Replacements: Clear lens
Non-fogging lens

SAFETY GOGGLES

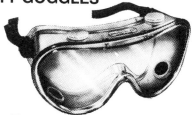

Feature: Transparent PVC ventilated frame
Vistamax No. VCB-3
Lens - Polycarbonate 1.4mm thick
Replacement: Clear Lens
Vistamax No. C4V
Double Lens - Non-fogging
Replacement: Clear double lens

FACE SHIELD - No. PS-148

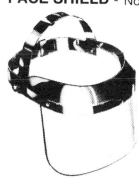

Plastic headframe
Adjustable headsize
8″ Clear swivel visor
.040 thick
Aluminum strip at bottom
of visor
3 point visor fastener
Sweatband

Replacement: 8″ Visor

FACE SHIELD - No. CPV-1584

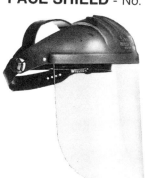

Plastic headframe
Adjustable headsize
8″ Clear adjustable visor

Self plastic reinforced
edge
5 point visor fastener
Protective brow guard

Replacement: 8″ Visor

Face protection equipment, courtesy of Sculptor's Supplies Co., 222 East 6th Street, New York, N.Y. 10003

MSA DUSTFOE - No. 66
NIOSH approved

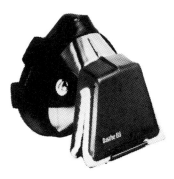

Aluminum facepiece . . . soft-rubber face cushion
. . . shapes easily to face.
Complete with filter
Replacement filters available

WILLSON DUST AND MIST - No. CP-560
NIOSH approved

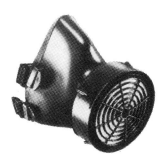

Soft-rubber face piece . . . rolled edge cushion
shapes easily to face.
Complete with 2 filters.
Replacement filters available

WILLSON PAINT, DUST AND PESTICIDE
No. CP-ATX-2 - NIOSH approved

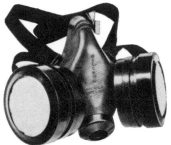

Soft-rubber facepiece . . . rolled edge cushion
shapes easily to face.
Complete with dust filters and vapor cartridges.
Replacements available.

FOCO PNEU -
VAPORS/GASES AND DUST
No. 5092

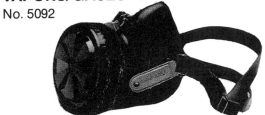

An excellent fitting mask with a quick release
headband.
Complete with -
 A/ST Cartridge - Organic vapors/gases
 and dust
Accessories -
 B/ST Cartridge - Acid vapors/gases
 and dust
 A Cartridge - Organic vapors/gases
 ST Filter - Dust

SANDBAGS (Unfilled) - a necessary item for
positioning sculpture while carving . . . also
absorbs shock and noise. Velcro closing provides
easy filling.

No. SB- 8 8″ x 10″
No. SB-10 10″ x 12″

Respiratory protection equipment, courtesy of Sculptor's
Supplies Co., 222 East 6th Street, New York, N.Y. 10003

Chapter IV

Using the Basic Tools

Now that you have acquired all of your basic tool supply, let us discuss the manner in which it is handled in the sequence of its usage.

HAMMER: I have always felt that the handle supplied with stone hammers is too long and creates an imbalance in the feel of the swing. Remove about 2 inches from the end, leaving a handle length of six inches. Now when the hammer is used, you will notice a proper and lighter feel to the swing.

The action of the hammer will vary with the tool used. Do not over-swing as if you were driving a nail into a board. It is best to keep your elbow tucked in at your side, and utilizing a flexing wrist motion, rapidly and firmly, deliver blows to the chisel. The handle is grasped securely, about an inch below the head. When using the hammer, remember that the carver should not look at the head of the chisel, but rather at the tip of the chisel where it contacts the stone. Concentrating on the head of the chisel will cause you to miss repeatedly, striking your fingers, possibly inflicting painful damage. Remember that it is the weight of the head of the hammer that does the work instead of the muscle of your arm. Allow it to produce the work for which it was intended.

SINGLE POINT CHISELS: These are the most important of the chisels used in stone carving. A conservative estimate would be that it is used about seventy-five percent of the time. It is the tool with which the artist creates the shapes and illustrates his creativity. The primary purpose of the point is to "block out" the intended form and to remove the bulk of excess stone.

I have had students in my classes who admitted that in their prior training, they had never used the point. They were quickly convinced that the dexterity of the point cannot be over-stressed, and that it is possible to achieve a completed sculpture utilizing that one tool.

Once you master the use of the point, the door will be open to accept the challenge of any subject or any stone. Progress and development in the art of stone carving cannot be achieved without proper use of this tool.

All chisels, point, claw, or flat, are held on the shaft firmly, without excessive pressure at a position of about one inch below the bottom edge of the tempered tip or striking area. Place the chisel across the base of the fingers, and as you close the fist, position the thumb against, and slightly resting on the index finger. This may feel awkward at first, but you will rapidly become accustomed to it. Locating the thumb in the position described will help avoiding painful bruises to the finger should you miss the head of the chisel when striking with the hammer. As you strike the tool with the hammer, you will find that your hand will gradually slip upward toward the other end of the shaft. Do not hesitate to shift continually downward toward the proper position. An improper placement of the hand will make it difficult to control the tool.

The point should be held at about a forty-five degree angle to the surface of the stone. This angle may vary slightly based upon the surface of the medium, but you will find that maintaining the

forty-five degree angle is proper. Too shallow an angle will cause the point to skip over the stone, whereas too sharp an angle will bruise the stone.

"Stun marks" occur when the point is held at about a ninety degree angle and struck with the hammer against the stone. This causes a crushing of the crystals below the surface of the stone up to a depth of as much as one inch. In the finished product, it appears as a whitish blemish that can only be removed by chiseling beneath the area involved. When the proper angle is observed, there is a slight crushing of crystals at the surface which can be easily removed by subsequent procedures without the need to alter the surface due to "stun marks."

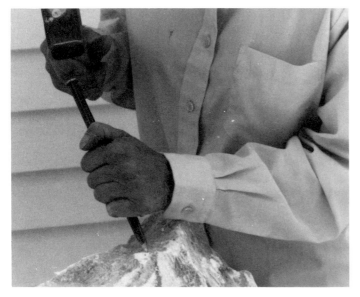

Holding the point chisel

If you are using the point for the first time, it will be quite normal for you to be tentative and apprehensive. This will pass as you gain experience, and the sensation will become comfortable and natural. Position the tip of the point against the stone and begin tapping with the hammer. Use a slight pressure of the outer edge and palm of the hand against the chisel to maintain the point of the chisel against the stone. As you tap, the point begins to travel in a straight line and stone begins to break away. Increase the pressure against the chisel so that the groove becomes deeper as the line progresses. Continue for about two or three inches. Start another groove parallel to the first groove, about an inch apart, and of about the same length. Continue with a third similar groove. Create a tic-tac-toe effect by initiating grooves similar to the first series, but perpendicular in pattern. This is called "cross hatching." By tapping with the point at

the boxes created by the tic-tac-toe, you will notice that stone chips will become easily dislodged. This is the manner in which stone is removed.

Recently, during a work session, a visitor to my studio remarked that my technique reminded him of that of Michelangelo. After expressing my gratitude for the compliment, I asked for an explanation. He explained that he had been to the studio of the great master and had observed works in progress which had been maintained as museum pieces. What he had seen was the "cross hatching" effect created by the point, similar to the process that I have described. To be compared to Michelangelo was certainly an honor. However, in reality, the technique that I was using has been, and still is the accepted procedure for "blocking out" and removal of stone.

It is critical that the grooves created by the point, though shallow at first, become deeper as the groove progresses. If this is not the case, it is evidence that the student is far too timid. This tendency must be overcome and will be corrected by practice. The gradual deepening of the grooves is required for the removal of stone and the creation of shapes, otherwise the student will discover that he or she is really removing surface without initiating a form.

TOOTHED CHISELS: Toothed chisels, or claw chisels as they are called, are available in two through nine points. The favorite of Michelangelo was the two point claw chisel and is one that I enjoy using. However, as a training tool, I recommend using a five point or perhaps a four point claw. After experience is gained, you will want to experiment with other types and concentrate on your own particular favorite.

The claw is a tool that the sculptor uses to refine and define the "blocked out" shapes created by the point. It is used as a painter uses his paint brush by carving and refining the rough form, removing surface, deepening and flattening areas, creating curves, and otherwise establishing the final form desired by the sculptor. The claw is pressed firmly against the surface, travelling in all directions, east, west, north, and south, to shape according to the sculptor's plans.

It is absolutely imperative that in using the claw, all prior markings created by the point are eliminated. Getting beneath the grooves established by the point will remove all of the crushed crystals. This will avoid the possibility of blemishes and stun marks that might mar the final product. When

completed, the sculpture should have a combed look or raked look.

The finishing chisels are claws with flattened tips. If they are available, you can use them to refine the "clawed" sculpture prior to the next stage.

Once again, each subsequent tool is used to remove chisel marks created by the prior tool.

FLAT CHISELS, CAPE CHISELS, & RONDELS: These tools are one step further along the refining process. As the name implies, there are no teeth or points to be concerned with. During use, they are held at a low angle of about 20 degrees, with the flat edge against the stone. The purpose is to remove all of the markings and ridges created by the claws and to leave the surface flat though rough. The rondel chisel is a flat tool with rounded edges to facilitate penetration of concave areas. Cape chisels are narrow flat chisels with fairly thick tips and are used for specific narrow areas that cannot be reached by conventional flat chisels.

RIFFLERS & RASPS: When the sculpture has been refined to its final shape, you will find the rifflers and rasps invaluable for improving details of curves, planes, concave, and convex areas. The cabinet and round rasps are used for broad areas and openings while the rifflers are used for fine details to obtain the delicate touch required to satisfy the sculptor's desires. My own tool supply includes as many as twenty to twenty-five rifflers of various shapes and all of them are used as the occasion arises. I have recommended three in the basic tool list and it is expected that the inventory will increase as experience with these tools is obtained.

RESPIRATORS: Dust protection is a function with which we should be concerned. During routine "pointing" or "clawing" procedures, a simple parchment mask may be worn with adequate immunity against dust. However, when using power tools or other methods which produce heavier amounts of debris, you should routinely use a respirator such as the MSA Dustfoe No. 66 as illustrated on page 30. A respirator should be worn when working with limestone, sandstone, wonderstone, serpentine, alberene, and other stones with high concentrations of silicates or talc.

WORK GLOVES: The use of gloves is optional and for that reason they are not included on the basic list of tools and supplies. Some sculptors find them a necessity while others find them a hindrance. I consider them quite helpful in preventing scrapes produced by the rubbing of the stone against unprotected hands. For that reason, I wear one glove on my left hand. Since I am right handed, that is the hand that holds the chisel and brushes against the stone. The preferred type is all-leather, or leather palmed. Cloth gloves will cause slipping of the tool in the hand.

Bull chisel, hammers, points, flat edge chisels, texture tools, rifflers, rasps, and glove.

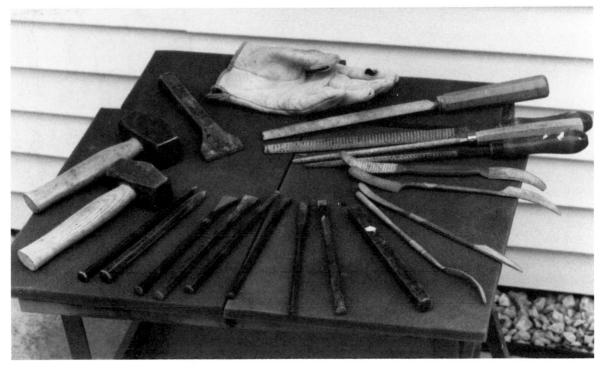

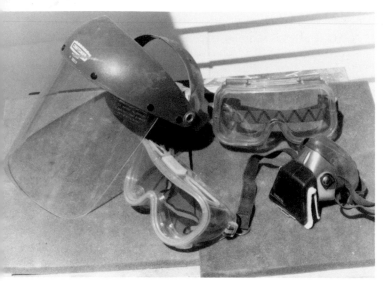

Protective devices: face mask, goggles, and respirator.

It should be clear to you that I have described the tools in the order of usage for a definite reason. Any chisel and hammer, in any sequence, will chip away at a boulder of a soft stone. However, there is a time accepted methodology of precision that will enable you to progress and improve your skills. Once you learn to use the point and the remaining tools correctly, you will be able to accept any undertaking. Applying the haphazard philosophy to the more difficult materials such as limestone and marble would produce disastrous results.

The correct sequence is:
1. Point: block out
2. Claw: carve and shape
3. Flat and rondel: refine
4. Rifflers and rasps: refine

CARE & MAINTENANCE OF TOOLS

The tradition upon the manufacturing of fine quality steel has seemed to diminish over the years. The old cliche, "They don't make them like they used to," certainly appears to be the rule. The best carving tools available are still those imported from Italy for the simple reason that Italy is still the stone carving capital of the world. The village of Pietrasanta, near Carrara, is filled with carving studios and artists. There are many shops offering sculpture supplies for sale, and the conversation in the cafes and restaurants center around the art of sculpture. It is a charming place to visit and one that you will cherish as a memory. Best of all, you can purchase the finest hand carving tools at any of the many shops of the village.

In this country, most major cities have supply shops that offer stone carving tools of Italian import as well as domestic varieties. In either case, tools are an investment and must be properly cared for.

TOOL HOLDERS - Excellent for protecting tools . . . each rolls up and ties for easy storing and carrying.

No. TH-9 - 9 pockets

No. TH-24 - 24 pockets

I have noticed tools being carried loosely in a tool box without regard for moisture penetration or protection against damage. It would be advantageous to purchase a canvas tool holder of the type illustrated which would provide safe storage and portability. I have always made it a point to clean my tools after use and at times rub them gently with a light grade of machine oil to prevent rusting.

As a general rule, new tools are forged and tempered by the manufacturers to be ready for use. However, in some instances, sharpening is required. As tools are used they should be sharpened as needed. It is wise never to allow tools to become dulled to a degree that extreme regrinding is needed. The need for sharpening is evident when the tool does not readily bite into the stone as it is tapped by the hammer. If the chisel skips over the surface when being applied at a forty-five degree angle, sharpening is necessary.

Tempering of a tool simply means hardening the metal to withstand the blows against the stone. In stone carving points and chisels, only the tips are

tempered to about one inch of the tip. The balance of the tool remains as soft metal. If the entire length of the chisel were tempered, the tool would bounce when struck against stone. It would also vibrate and create a great deal of discomfort to the hand.

When tools are manufactured, tempering is achieved by overheating the tips. Shapes are formed much in the same manner that the blacksmith of past years forged horseshoes and tools. Conversely, temper can be withdrawn from a tool by overheating during sharpening and this remains to be guarded against during the procedure.

Sharpening can be done with a hand held carbide sharpening stone. This method is slow and tedious, with a low degree of efficiency. My preference is for the use of an electrically powered bench grinder fitted with a two inch fine carbide grinding wheel. The tool must be continually dipped into water during the process to prevent overheating. Grinders are available as "wet wheels" referring to a continual flow of water over the wheel which keeps the tool cool at all times. However, this incurs an expense in equipment that is unnecessary.

When sharpening the point, you will notice that the tool has a seven sided handle that changes to four facets or planes in the tempered area. The edge of the grinding wheel which faces you as it turns is round. It is possible that this surface would create a bevel on the flat surface of the chisel, therefore, I use the flat side of the wheel for sharpening the flat surfaces of the chisels. Apply each of the four planes gently to the grinding wheel. Keep the angle of the tool intact. Cool the area continually by dipping the tip of the tool into a cup of water. Feel the tip regularly during the procedure, using your judgement to determine completion.

Allow the newly sharpened tool to "set" for several minutes before using. Freshly sharpened tips are brittle, and premature use might cause the tip to break.

After an extended period of time and after repeated sharpenings, it is possible that a large portion of the tempered tip becomes worn away. Unless you have your own facilities for tempering tools, it is far more efficient to buy a new tool at this junction.

The flat chisel and the claw or tooth chisel require sharpening less frequently than the point as they are not applied to the stone with the similar intensity. Planes and bevels must be maintained during the sharpening process. Be careful not to create new surfaces, rather concentrate on

renewing the existing ones. Cooling must be continual as it is with the points. Claw chisels must have their teeth renewed after sharpening by placing them upright in a vise and applying a small triangular file between the teeth. If this is not done, the points would tend to flatten out after several sharpenings.

All of the prior rules are applied to rondel chisels as well. Since the tip is rounded, you will have to use a rolling action, from one side to another to obtain an even action of the tool on the grinding wheel.

Practice goes a long way in perfecting your technique. With little effort. you will soon become an expert in the art of sharpening tools.

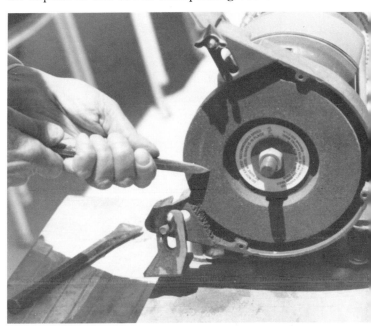

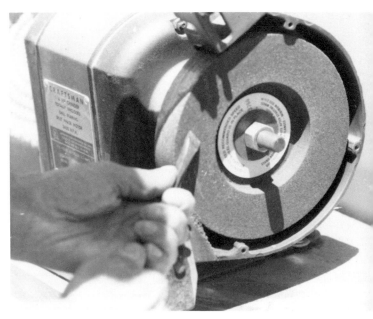

Sharpening the point and flat chisel with bench grinder.

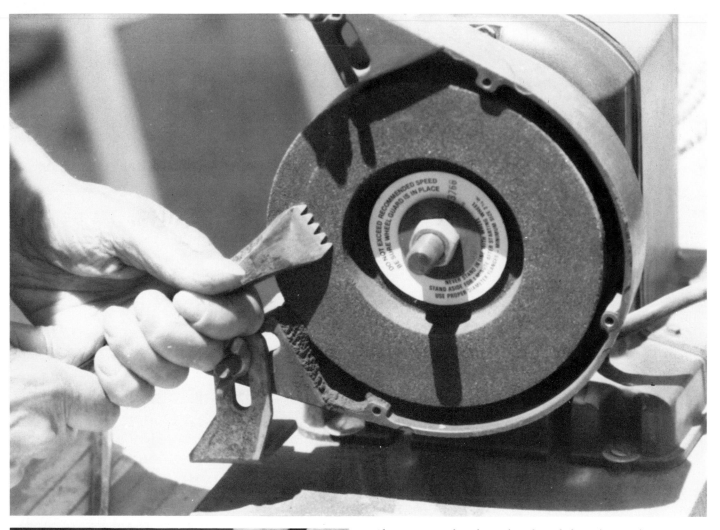

Sharpening the claw chisel with bench grinder.

Refining the points of the claw chisel with a triangular file while the chisel is held in a vise.

Chapter V

Three Dimensional Form

The master sculptors of the early part of the twentieth century were the innovators of their time! We have discussed the departure of classicism and the arrival of freedom of expression. Interest in direct stone carving was renewed and the pointing machine was discarded.

To this day we pay homage to the genius of such as Brancusi, de Creeft, Arp, Boccioni, Hepworth, Archipenko, Lipschitz, Moore, and others of the period. This is correct and without question...but what is the motivation for this admiration? Was the work produced during the earlier portions of the century superior to that of the later years? I believe that, to accept that concept would be a false assumption.

Innovation has always been rewarded by recognition. After all, who was present to challenge the success of Brancusi at the beginning of the century? A good deal of the stone sculpture being produced today is every bit as dynamic and qualified, to exist on an equal or higher plane of excellence, as that of their predecessors, yet so much of the work produced goes unrecognized. Conversely, if the carvers of the early part of the century were to compete among today's artists, it is quite possible that the high acceptance of their work would be somewhat tempered or diluted by the fierce competition.

Undoubtedly, competition is the reason for the explosion into new media and concepts of the three dimensional form during recent years. Artists are continually searching for a new technique, a new material, a new concept that would establish them as the originators of a process in order to gain fame and recognition.

In their frenzy to establish originality and financial reward, too many sculptors have been ignoring the very basics of form and design. We accept the fact that necessity is the mother of invention. However, innovation should not give birth to trash. Regardless of innovative styles, techniques, and materials, the underlying theory which produces three dimensional design should remain the same. Fortunately, we are aware that during any experimental period in art, the good will surface, while the bad will fade away.

In order to see and understand shapes and forms, we must accept the fact that positive and negative contours are the underlying principles behind their existence. Painters, and those artists whose work is two dimensional, consider form as occupying space, both negative and positive. Sculptors, those whose work is three dimensional, relate to negative and positive volume. If we look at our hand, we can perceive it as a positive form. It is a solid which exists in the negative volume around it. If we were to spread our fingers, the area between the fingers are negative areas which help us to see the fingers projected as positive shapes. If you can visualize the meaning of negative and positive form, you have accepted the basis of sculpture.

For the artist who creates a three dimensional form, negative volume is a critical issue. Consider that, for every positive shape, there must be a negative counterpart. Solid sculptures, regardless of varied size, exist in the volume which surrounds them. At times this volume penetrates the sculpture to produce positive designs at the direction of the artist. Think of negative volume as part of the sculpture itself.

There are variable approaches to the construction of any sculptural form and these change with the artist. Considerations include the material, volume, proportion, positive-negative, expression, light, etc., and the result is the combination of many components depending upon the will of the individual.

If we were to hand several artists blocks of stone of the same size and shape, certain fundamental tendencies could be observed. Each would examine the material, consider its weight, and its dimensions. Each would demonstrate a somewhat tentative initial approach, then finally begin to carve using certain tools. The artists may have definite plans, but the limitations of ability, tools, and material may restrict them to certain realities. As the carving proceeds, new paths are discovered which will ease or accelerate their approach. Finally the individual proceeds with a definite purpose. As sculptors become more aggressive and inventive, they consider the play of light caused by the insertions of negative areas, the relationships between full and empty, between round and angular, dull and sharp, small and large, and raised and recessed. These are the variables considered as individual creativity that are the basis of sculpture.

The development of sculpture and the three dimensional form in general, throughout the history of all civilizations, included five basic concepts. These are:

1. block or natural forms
2. modeled (hollowed-out) forms
3. perforated (bored-through) forms
4. equipoised (Suspended) forms
5. kinetic (moving) forms

Initially, sculptural development pertained to a block of material which displayed mass in plain, almost untouched form, such as the pyramids, natural monuments, and meteorites.

The second stage followed the block with relationships of positive and negative, round and angular, sharp and dull carved into the stone. There was a definite understanding of negative volume as a void in a contrast to positive volume. Early examples were the Egyptian sculptures and totem poles.

After mastering the relationships of positive and negative volumes, penetration into and through the material followed. This phenomenon of development from block form to perforated form prevailed with each civilization and culture as they developed...the Egyptian, Indian, and Greek as well as primitive societies.

With the discovery of new materials and superior tools, the artist was inspired to overcome the rigidity of the block. New techniques enabled him to twist and shape marble and granite to proportions of greater visual potential. It enabled him to find a dynamic solution for sculptural expression.

A comparison of the rich curvatures of the creations of Michelangelo, with the rigid forms of his gothic ancestors, illustrates the dramatic development in techniques.

Sculpture normally rests on a supportive base, and occupies a relationship to its surroundings, such as the ground, horizontal, vertical, and oblique directions. In theory, equipoised sculpture is independent of such relationships and pertains to material and volume. Other variables are contained within the sculpture itself since the form is in a hovering or floating position at all times. Consider as an example a form supported in mid air by means of invisible wire, or the illusion created by supportive glass pedestals. A more exact example is a balloon floating in air supported by air pressure. This freedom from the elements that support the form is the basis of the equipoised sculpture which is the fourth stage of development. Without question, it is a far departure in development from that of the renaissance period.

The final stage of development is that of kinetic energy, or movement. This is most effectively appreciated in movements of the mobile as a form of sculpture. In mobiles, material is utilized as a carrier of movement. Depending upon the speed of the motion, the original solid block of material transforms itself into ever-changing relationships within its environment. Alexander Calder used the concept of the mobile with great success.

Sculpture cannot be defined on the basis of technological and cultural development. The complete comprehension of a work of sculpture requires an emotional grasp of the subject and a knowledge of the elements of construction as well. However, in creative work, it is far more important to possess the capacity and courage to inject elements of personal expression than to retain a theoretical knowledge of the elements and characteristics which constitute the final form. It remains the right of the sculptor to select or reject elements of environmental and technological change.

Gallery of Stone Sculpture

The Last Fifty Years: Contemporary Themes

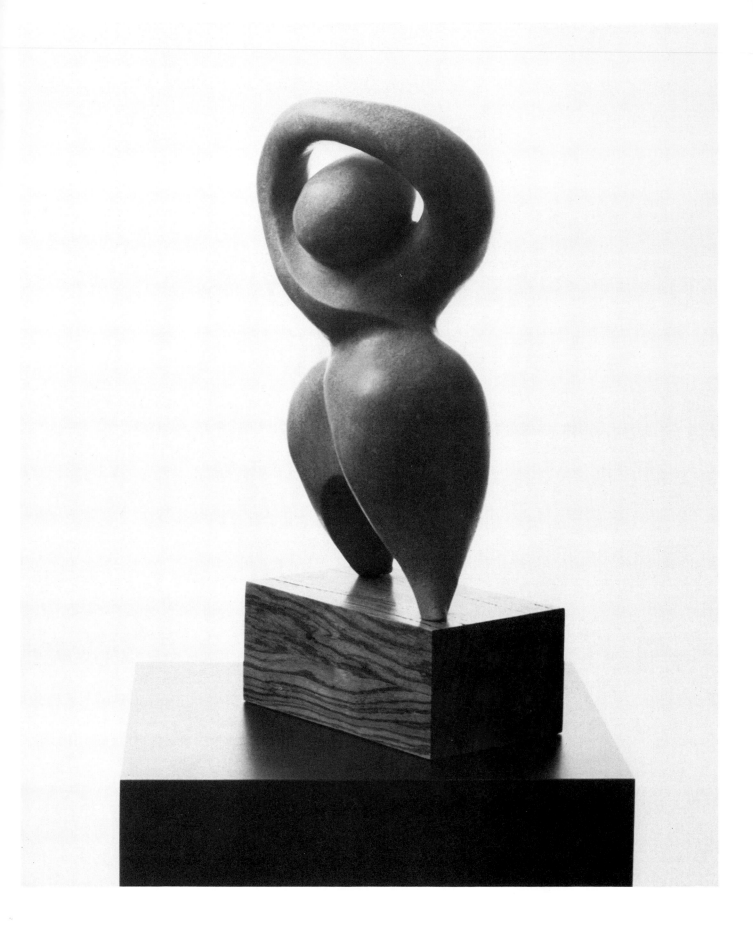

Stone, Bernard, *Homage to Martha*, 1988. Limestone, 19" h
x 9" w x 5" d. *Courtesy of the artist.*

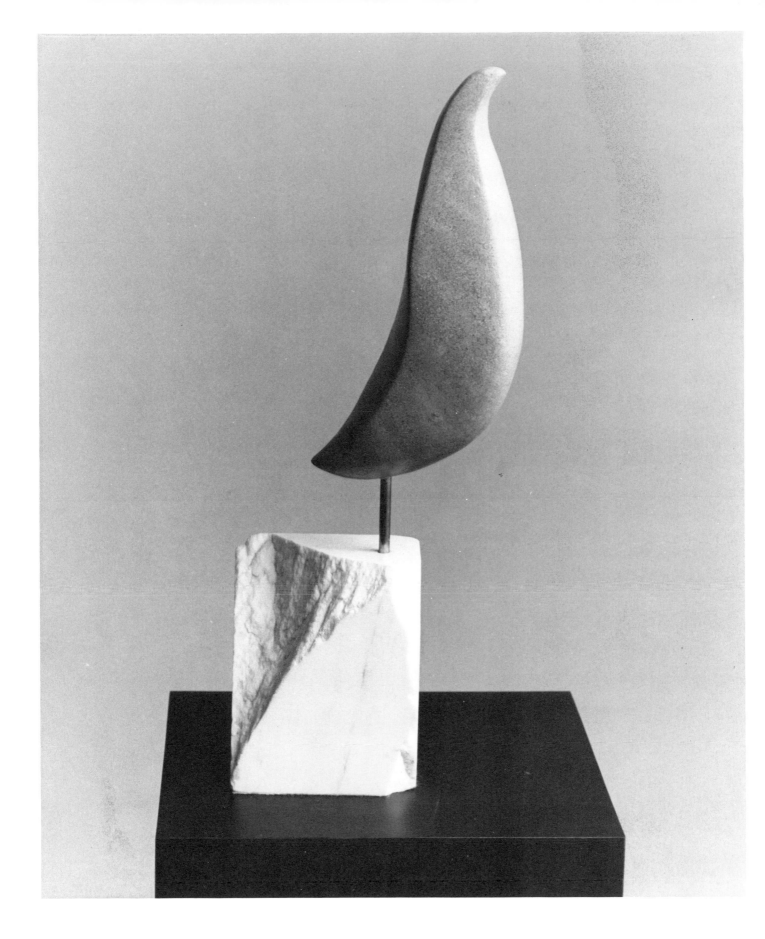

Stone, Bernard, *Arctic Sentinel*, 1989. Limestone, brass,
and marble, 24" h x 7" w x 7" w. *Courtesy of the artist.*

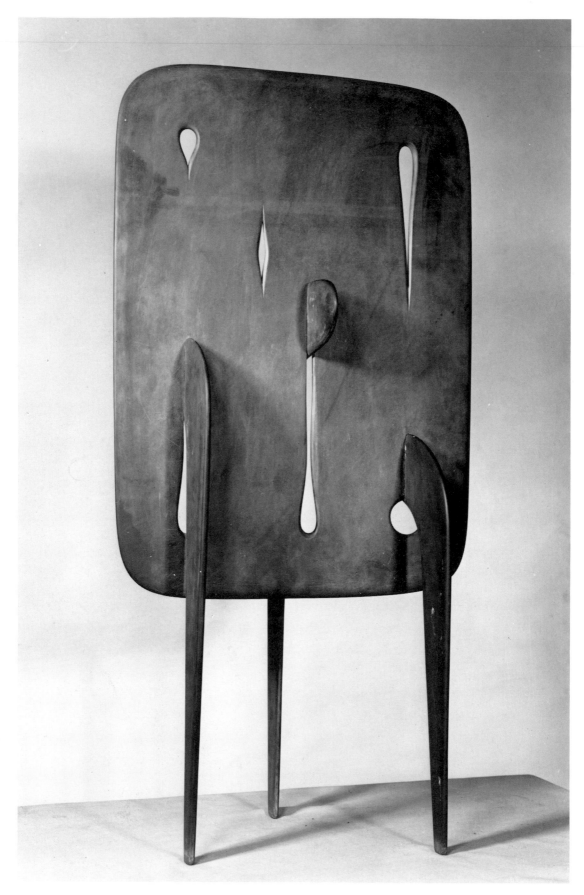

Noguchi, Isamu, American, 1904-1988, *Sculpture in Slate*,
1945-46. Slate, 97.5 cm x 47.9 cm, diam: 27.94 cm.
*Courtesy of the Art Institute of Chicago, copyright 1990. All Rights
Reserved.* Gift of Isamu Noguchi.

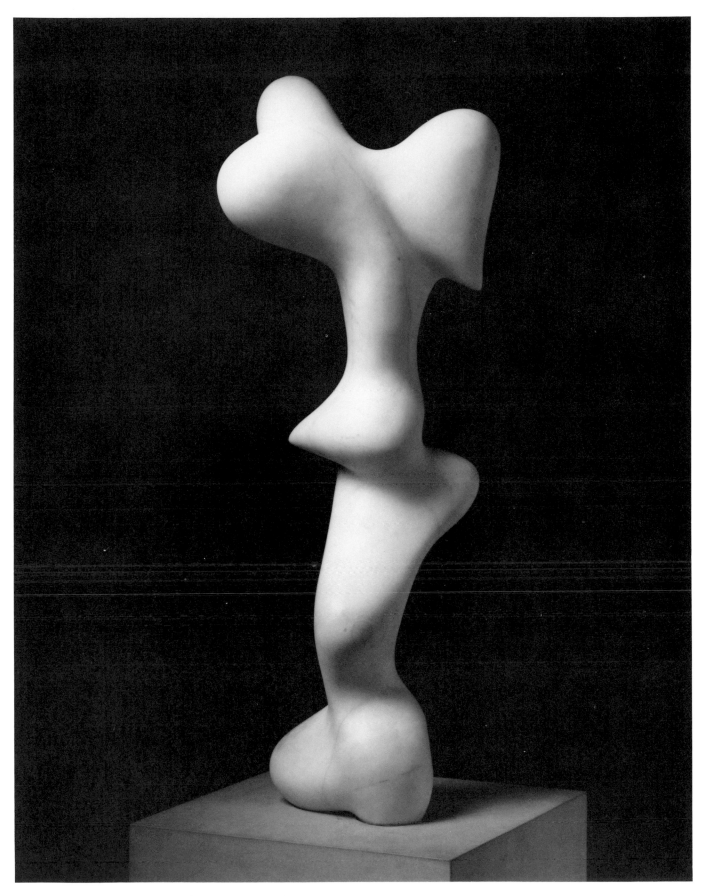

Arp, Jean, French, 1887-1966, *Growth*, 1938-1960. White
marble, ht: 109.2 cm. *Courtesy of the Art Institute of Chicago,
copyright 1990.* Grant J. Pick Purchase Fund, 1965. 357.1B.
Photograph by Robert Hashimoto.

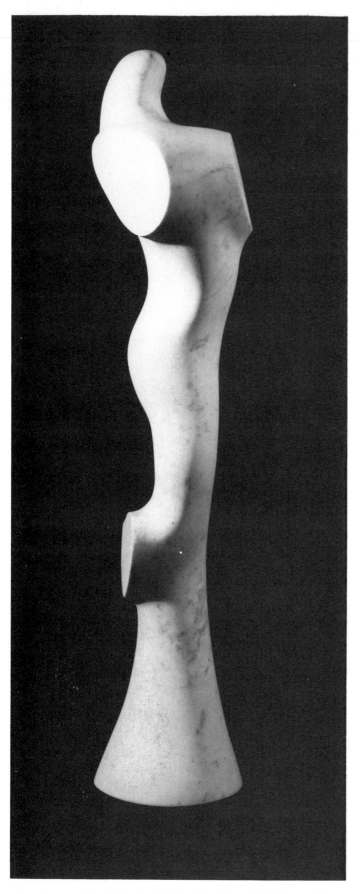

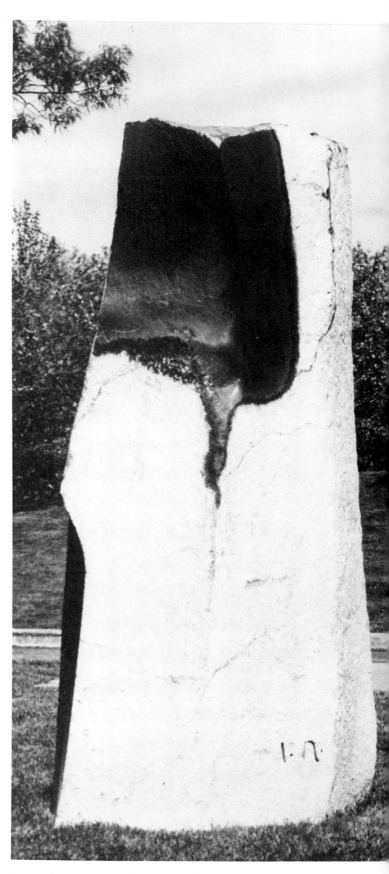

Arp, Jean, *Floral Nude*, 1957. Marble, 47¼" h, 10½" at base. *Courtesy of the Museum of Modern Art, New York, Mrs. Simon Guggenheim Fund.* Photograph by Geoffrey Clements.

Noguchi, Isamu, *Rock Carvings: Passage of the Seasons*, 1981. Basalt with mineral accretions, 113" high. *Courtesy of the Cleveland Museum of Art, Gift of the Mildred Andrews Fund, 81.46a-e.*

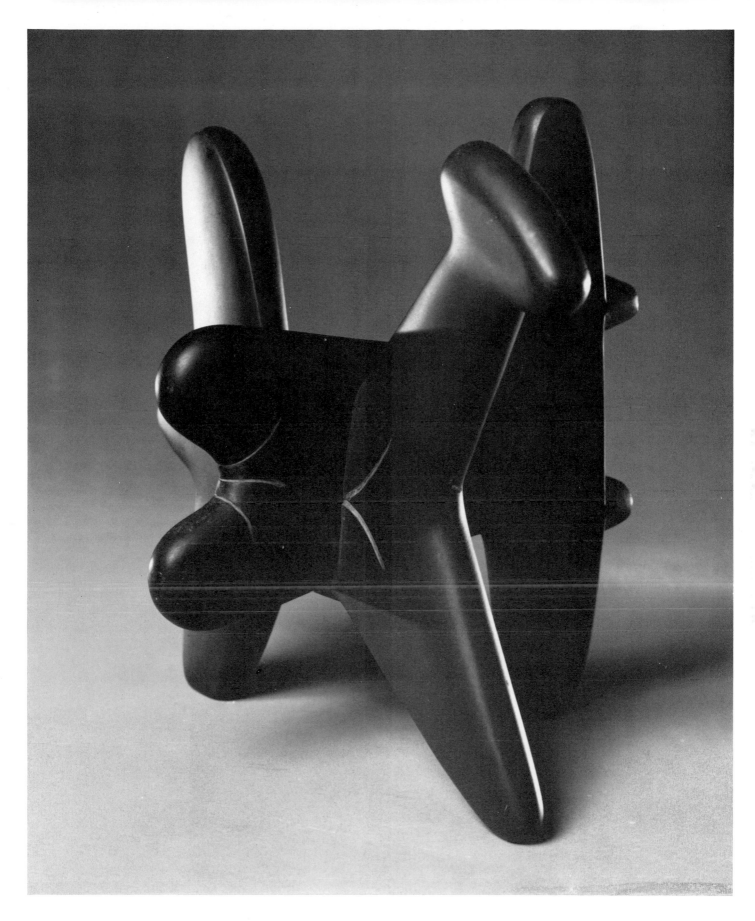

Noguchi, Isamu, *Composition*, 1943. Slate, 8⅞″ x 9⅜″ x 8″.
Courtesy of the Hirshhorn Museum and Sculpture Garden,
Smithsonian Institution, Gift of Joseph H. Hirshhorn.

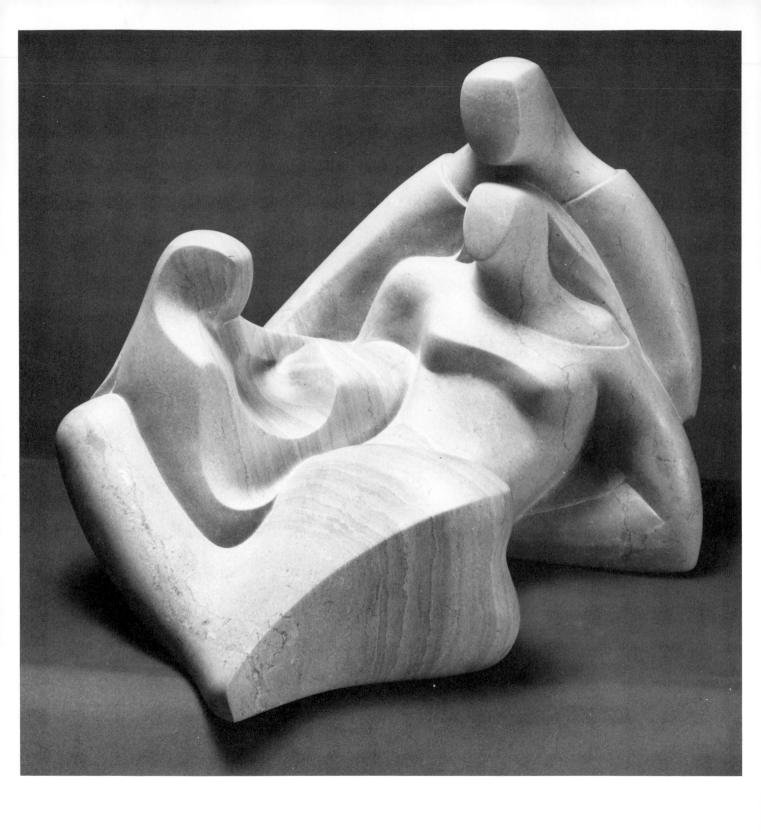

Zuckerman, Ruth V., Triada. Trani marble, 15½" h x 20" w x
16" d. *Courtesy of the artist.* Photo by Reis Birdwhistell.

46

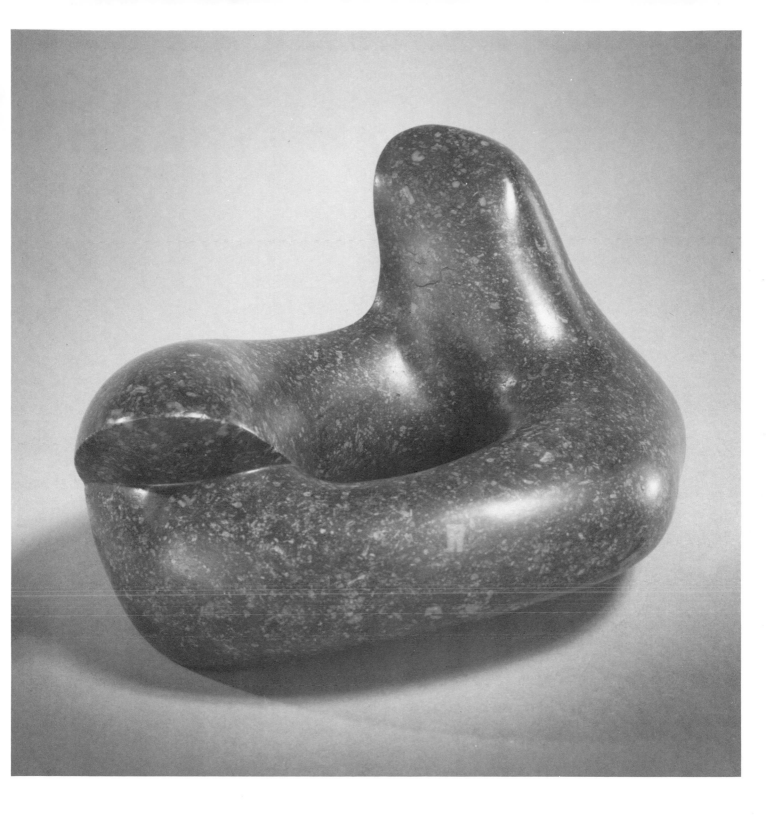

Arp, Jean, *Snakebread*, 1942. Granite, 5⅜" x 10¼" x 7¼.
Courtesy of the Hirshhorn Museum and Sculpture Garden,
Smithsonian Institution, Gift of Joseph H. Hirshhorn.

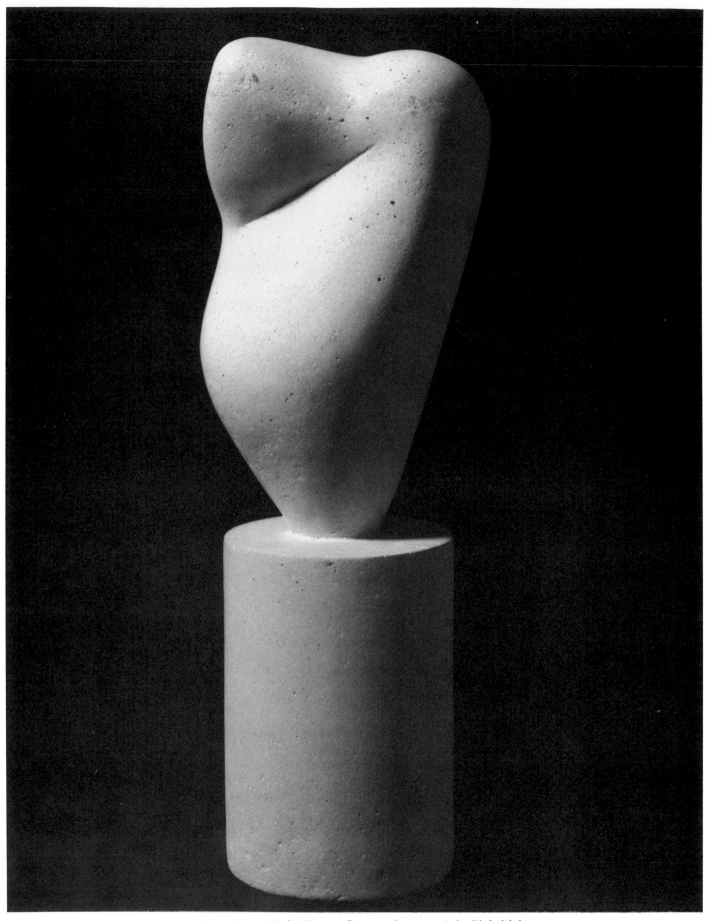

Arp, Jean, *Owl's Dream*. Stone. *Courtesy of the Philadelphia Museum of Art, A. E. Gallatin Collection.*

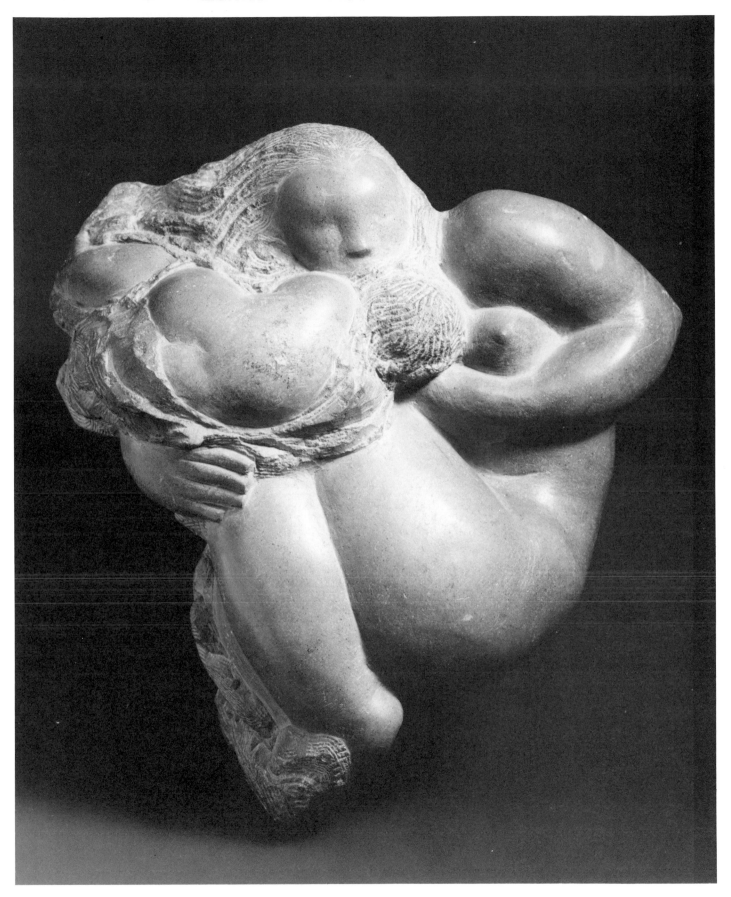

de Creeft, Jose, *The Cloud*, 1939. Green stone, 13½" x 12½" x 8½". *Courtesy of the Collection of Whitney Museum of American Art, New York, Purchase 57.24.* Photo by Jerry L. Thompson.

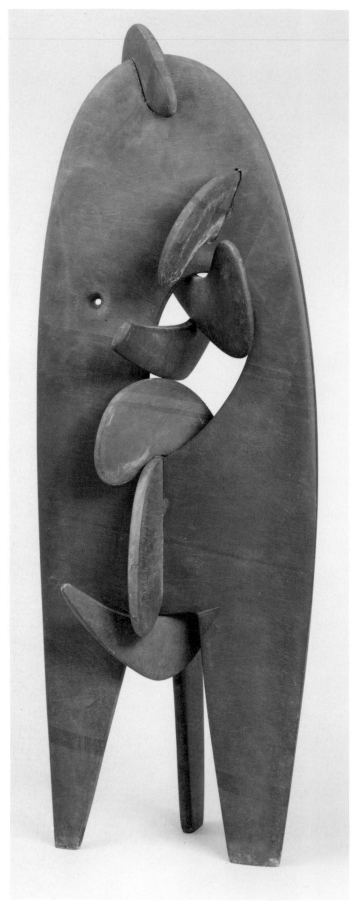

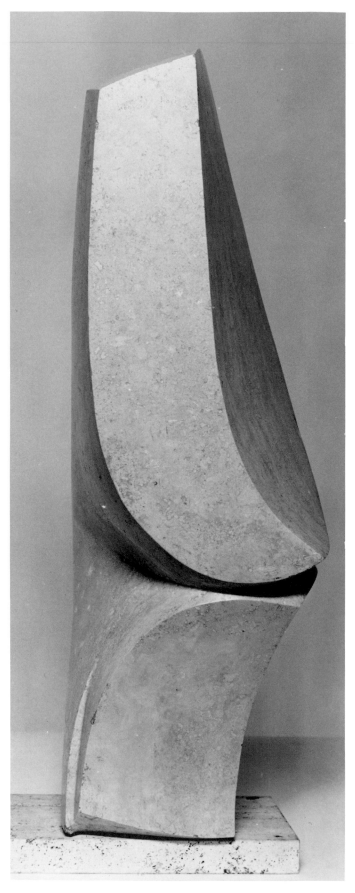

Noguchi, Isamu, *Humpty Dumpty*, 1946. Ribbon slate, 58¾" high, 1946. *Courtesy of the collection of the Whitney Museum of American Art, New York, Purchase 47.7.*

Nagare, Masayuki, *Wind Form*, 1965. Polished Italian travertine, 31⅜" x 10¼". *Courtesy of the Hirshhorn Museum and Sculpture Garden, Smithsonian Institution, Gift of Joseph H. Hirshhorn, 1966.*

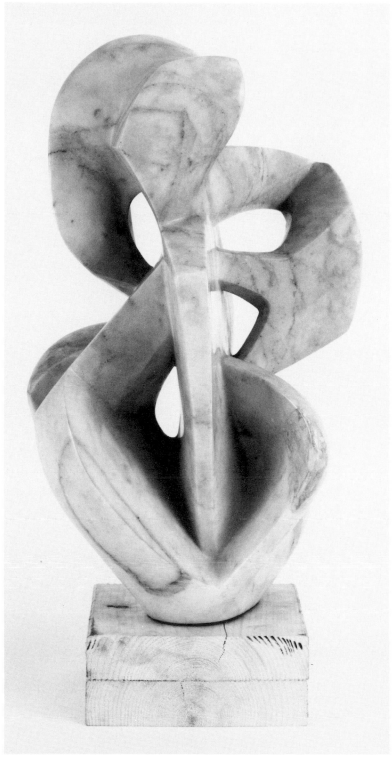

Schnabel, Day, *Transformations*, 1956. Marble, 19¾" x 12"
x 10½". *Courtesy of the collection of the Whitney Museum of
American Art, New York, Purchase 57.24.* Photo by Geoffrey
Clements.

Rosati, James, *Hamadryad*, 1957-1958. Marble, 35¼" x
8¾" x 7". *Courtesy of the Hirshhorn Museum and Sculpture
Garden, Smithsonian Institution, Gift of Joseph H. Hirshhorn,
1966.*

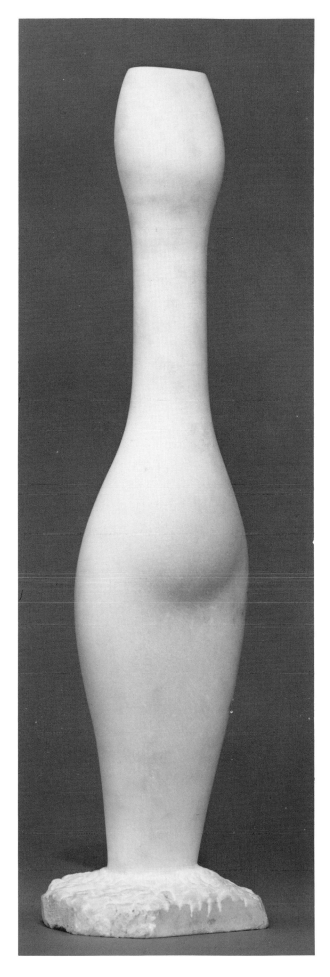

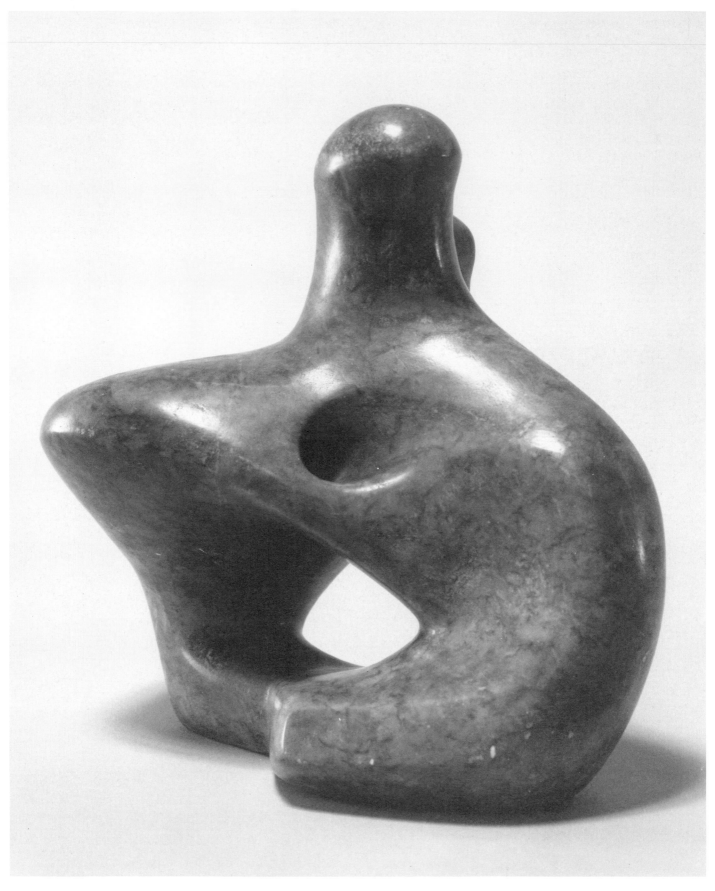

Moore, Henry, *Carving,* 1935. Cumberland alabaster, 11½" x 11⅝" x 6¾". *Courtesy of the Hirshhorn Museum and Sculpture Garden, Smithsonian Institution, Gift of Joseph H. Hirshhorn, 1966.*

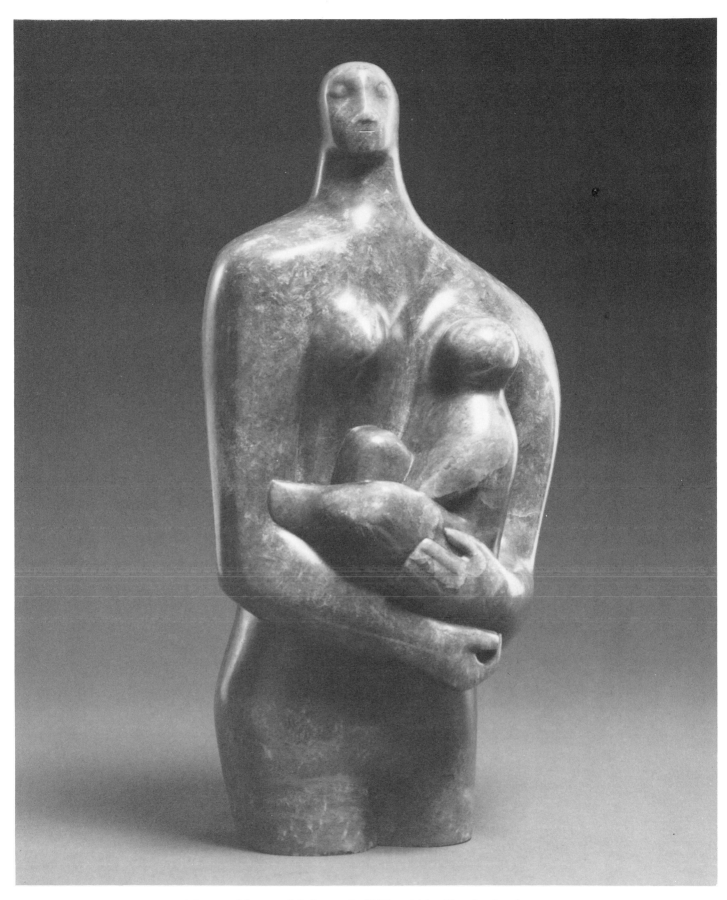

Moore, Henry, *Mother and Child*, 1931. Cumberland alabaster, 17½" x 9" x 6⅞". *Courtesy of the Hirshhorn Museum and Sculpture Garden, Smithsonian Institution, Gift of Joseph H. Hirshhorn, 1966.*

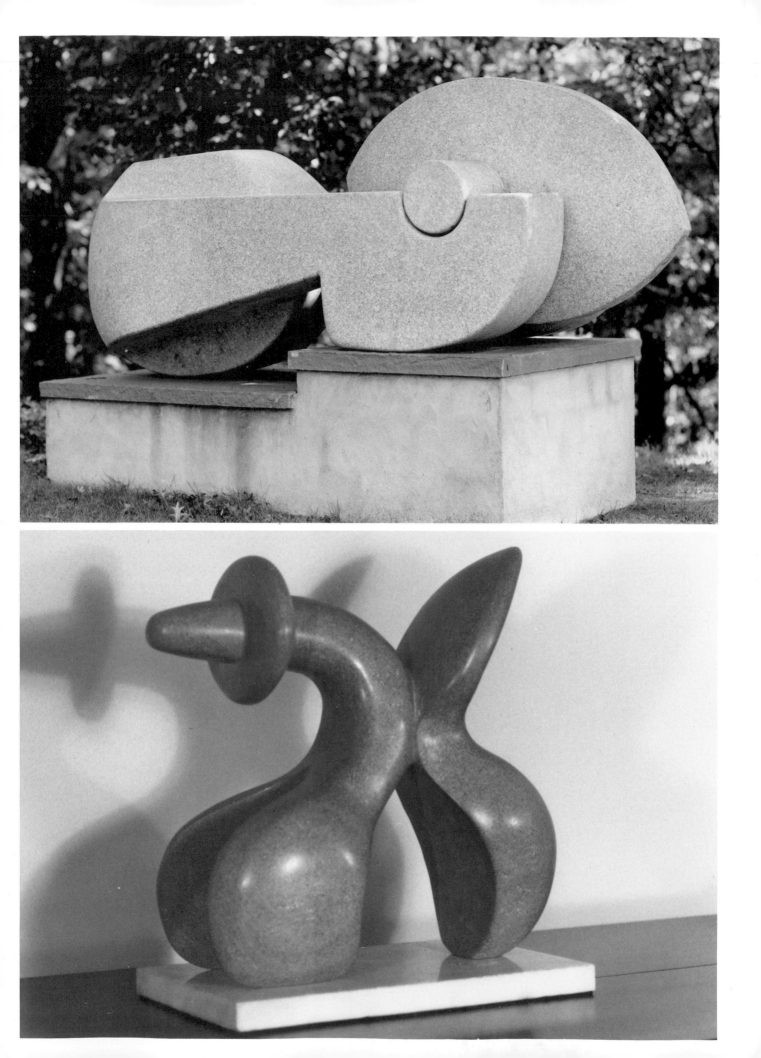

Opposite page top:
Cascella, Andrea, *I Dreamed My Genesis*, 1964. Granite, 46"
x 1098" x 36". *Courtesy of the Hirshhorn Museum and Sculpture Garden, Smithsonian Institution, Gift of Joseph H. Hirshhorn, 1966.*

Opposite page bottom:
Silverstein, Paul, *The Mexican Experience*, 1985 limestone
14" x 13" x 8", Courtesy of the artist. Photo by the author.

Camargo, Sergio de, *Column*,

1967-1968. Marble, 55¾" x 11" x 9". *Courtesy of the Hirshhorn Museum and Sculpture Garden, Smithsonian Institution, Gift of Joseph H. Hirshhorn, 1966.*

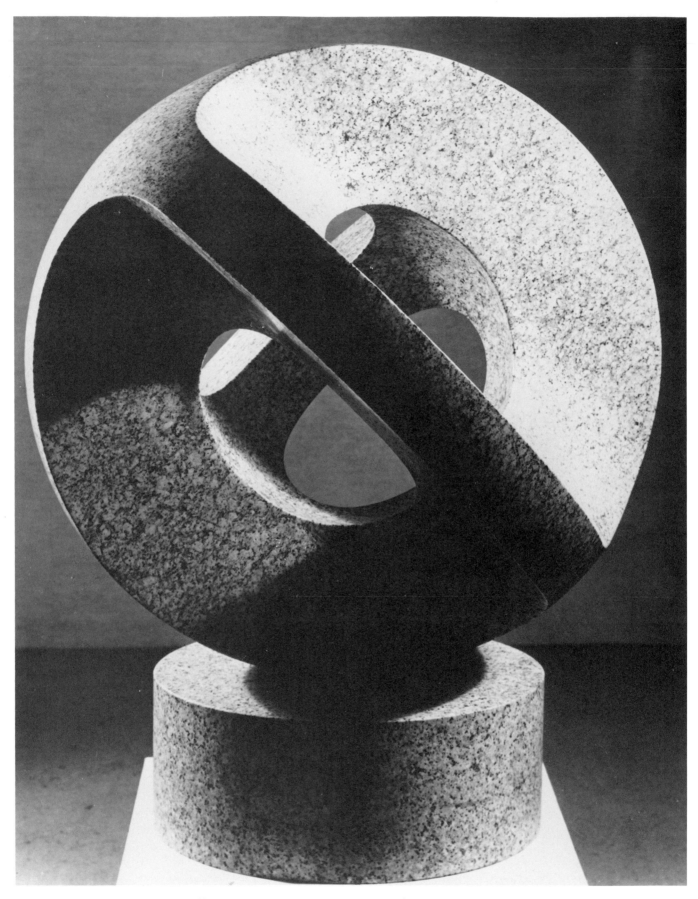

Bill, Max, *Construction*, 1937, executed 1962. Granite, 39″ x 31¼″ x 31¼″. *Courtesy of the Hirshhorn Museum and Sculpture Garden, Smithsonian Institution, Gift of Joseph H. Hirshhorn, 1966.*

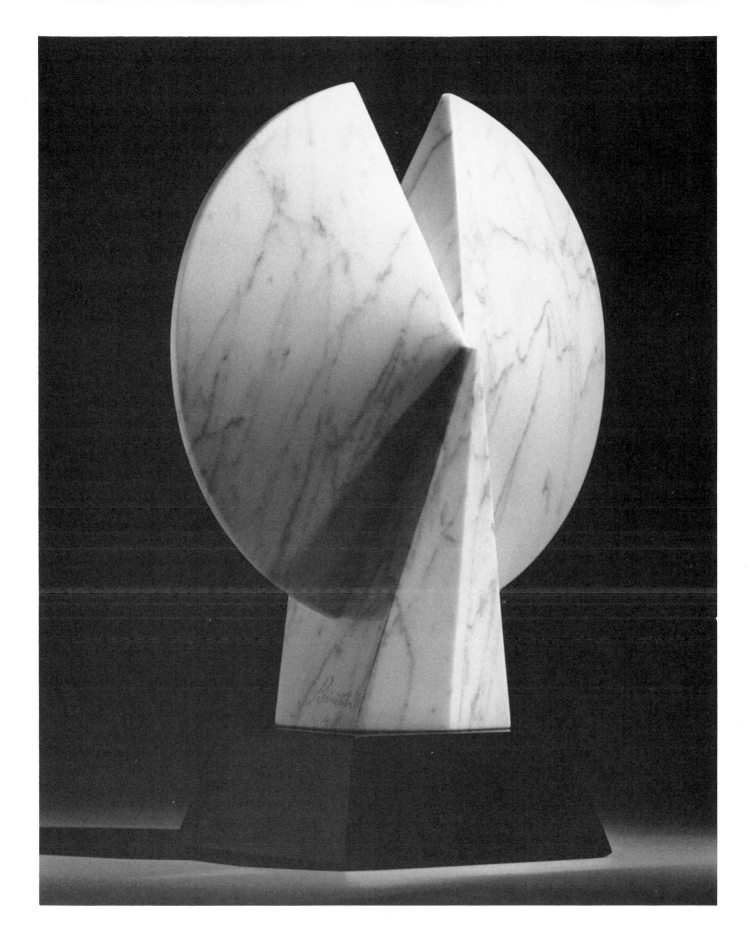

Libberton, John, *Peace*, 1988. Carrara marble, 16" x 11" x 6". *Courtesy of the artist.* Photo by the artist.

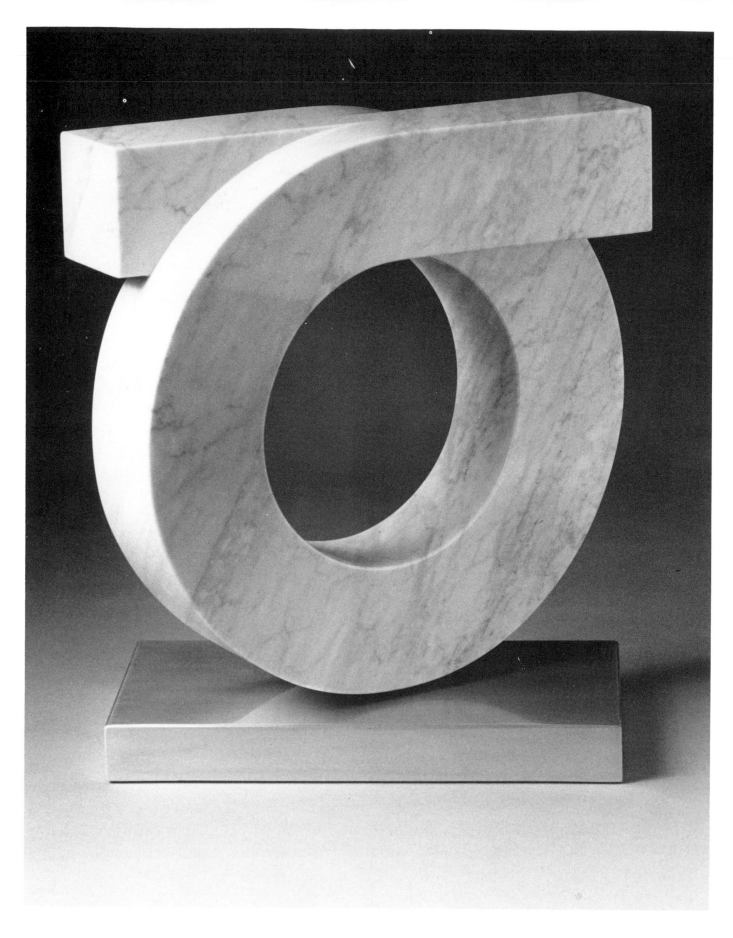

Libberton, John, *Liberated Circle*, 1989. Carrara marble,
15" x 14" x 7". *Courtesy of the artist.* Photo by the artist.

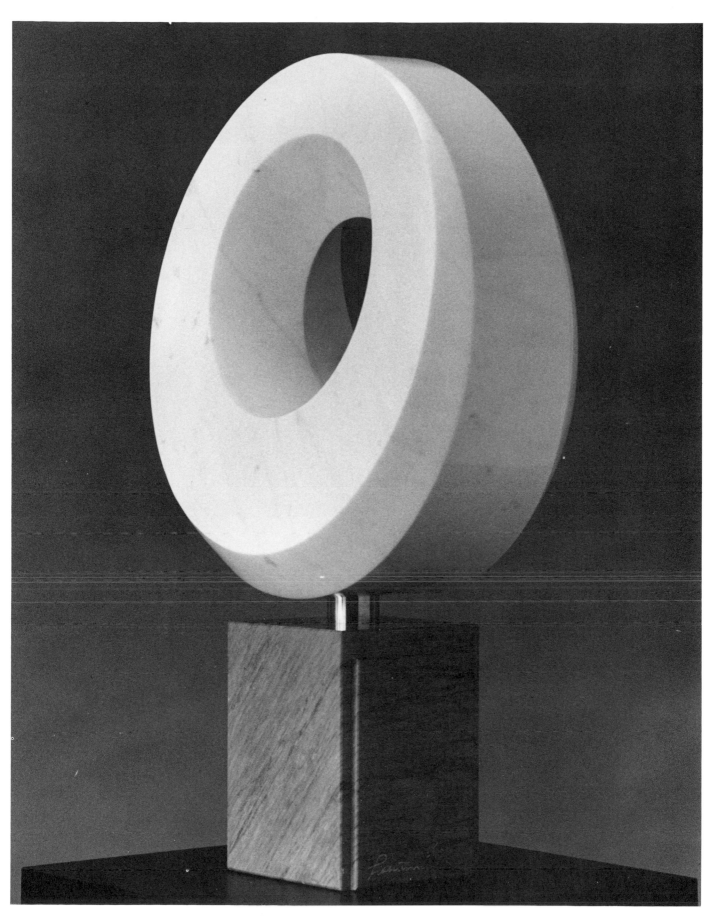

Libberton, John, *Apogee*, 1988. Bianco pura marble/
bardiglio base, 31″ x 21″ x 10″. *Courtesy of Highlands Gallery,
Carmel, California and the artist.* Photo by the artist.

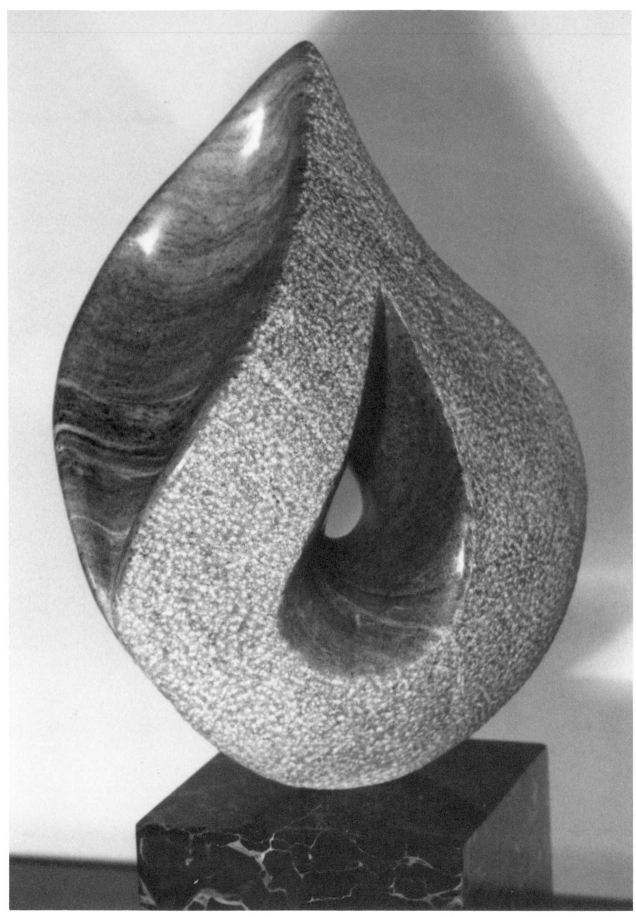

Silverstein, Paul, *Flame*, 1982. Vermont gray marble, 17"
x 11" x 6". Courtesy of the artist. Photo by the author.

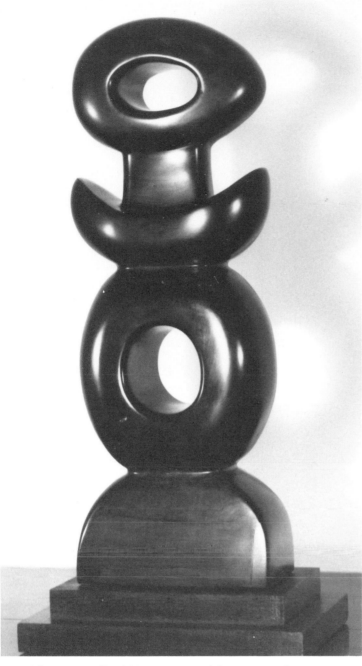

Silverstein, Paul *Totem,* 1987. African wonderstone, 18"
x 7" x 4". Courtesy of the artist. Photo by the author.

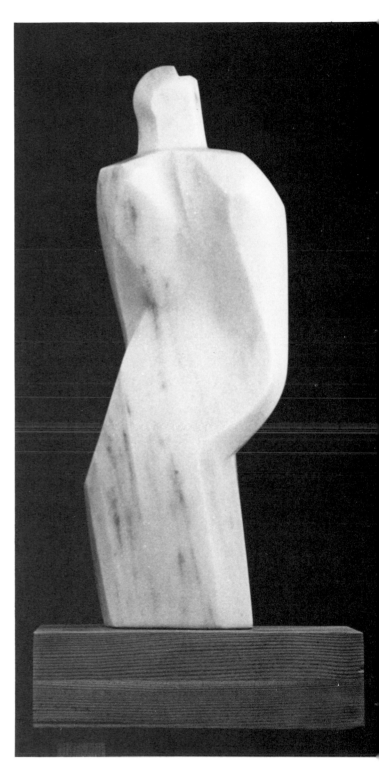

Rivera, Francisco, *The Wanderer,* 1982. Vermont marble,
height 18". *Courtesy of the artist.*

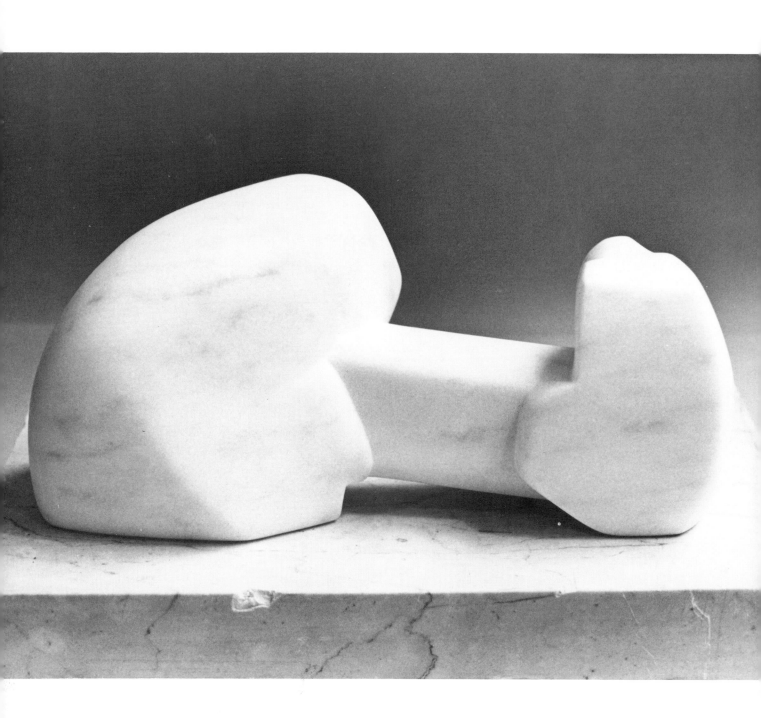

Rivera, Francisco, *Bone Piece*, 1979. Vermont marble, length 11½". *Courtesy of the artist.*

Chapter VI
Direct Stone Carving

A question often asked by students and gallery clients is "Where do you get your ideas?" often followed by the statement, "I'm not very creative and I wish I were." Creativity, a gift awarded to us by our creator, is a virtue inherent in all human beings. Many of us use it. In others it lies dormant ready to be awakened.

We can kindle innovation by becoming involved in the arts and being aware of the physical aspects of our world. Great literature, music, the visual and performing arts, all contribute to their patrons the ability to utilize intellect and expand horizons of imagination.

The world around us is filled with the forms and shapes of nature, the greatest sculptor of all. As you travel, observe the shapes of mountains, landscapes, gnarled tree trunks, rock formations formed through erosion by rivers and oceans, and the contours of the constructions of creative people. Visit the libraries to examine the many volumes of photographs of the work by contemporary and past great sculptors.

Innovation and creativity do not have to be acquired. They can be ignited!

The term "direct stone carving," has appeared throughout this text without an attempt to clarify its meaning. It is significant at this time, that we understand the term and its antithesis, "indirect stone carving." Both terms involve the carving of stone. However, the approach varies. Indirect carving refers to the formation of a small model of clay, wax, or other temporary material which is the guide for reproducing the form on a larger scale with stone as the medium. Direct carving involves working directly into the stone. The artist may use

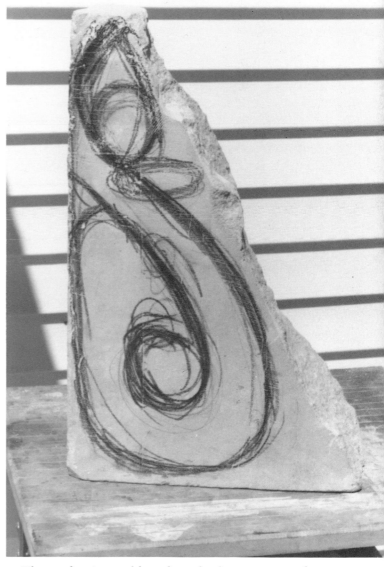

The author's workbench and a limestone with crayon planning sketch.

sketches or may draw upon the stone with chalk or crayon. Nevertheless, the sculptor has visualized the form and proceeds to remove unwanted stone to free the shapes within.

For the carver working at stone for the first time, it is best to use the direct approach rather than to work from a model. The beginner must understand that he or she is entering a learning process and that experimentation with stone as a medium is of prime importance. Not only will mistakes be made, they *must* be made. It is important to appreciate the feel of the tools on the stone, to become accustomed to the various tools, their functions, and to understand the carving characteristics of the stone being worked on.

The novice is usually plagued by timidity, and the ever present "fear of failure." These must be overcome, and can be overcome by only one procedure...experiment, and practice, practice, and more practice.

SELECTING A STONE

It is time to get to work, and that means a "hands on" procedure where you will provide the creativity, and I will help you attain the technical skill that is required. Creativity is the impulse sent by the brain to the hands; technical skill, the transfer of creativity from the hands to the medium. Creativity is an inherent quality that you possess. Technical skill is what I can teach you.

The selection of a stone is not difficult. For beginners, I would advise the use of alabaster, or Virginia alberene. Sculptors who have completed several works of softer stones should attempt a harder stone such as limestone, and advanced carvers should consider limestone and marble.

Those carving for the first time should consider a stone that weighs between forty and sixty pounds. A boulder that weighs less would tend to wobble and move when chiseled and become difficult to manage. Larger pieces of stone are preferred, although for a first experiment, it is best to obtain the recommended size. Assuming that the beginner does not have a design plan in mind, look for a stone that has a random rectangular dimension.

It is best to avoid ovals or blocks with straight sides. The stone should convey a message from its shape, or perhaps stimulate the thought of an idea of what you wish to do with it. If this is not the case, do not be concerned. Approach your task with an open mind. Ideas will formulate as you begin to work.

Test the stone by tapping it with a hammer. If cracks or faults are present, the stone will issue a dull sound. This material should be avoided. If a bright "ring" is heard, the stone is probably solid and suitable for carving.

The potential final color of the finished sculpture can be determined by pouring some water over the raw stone. This is similar to the phenomenon of discovering brightly colored pebbles in the surf at the ocean. When the pebbles are removed from the water and dry, the colors fade. Replacing them in the water renews the shading and tints.

Carvers with prior experience may well consider blocks of stone with straight machine cut dimensions. Limestone and African wonderstone are among stones supplied in this manner. Although it is difficult to perceive "messages" from these shapes, they are of greater value for those approaching their task with preconceived plans. Drawings may easily be projected upon the stone as preparation for carving.

I rarely approach a project with a stone of less than one hundred pounds. The average weight is about one hundred and fifty pounds. My preference is a random shape, and I favor the adventure of determining the subject matter as I carve. It is my method of "igniting" creativity. The exception, however, occurs when I accept a commissioned assignment. At that time, the material must conform to the sketches and subject matter that has been submitted to the client.

THE PROCESS OF STONE SCULPTURE

I do not believe in having students follow a step by step carving of my design. This would be doing the trainee a disservice. Creativity is an emotion of the individual intellect, and those who attempt to copy the work of others perform as robots without sensitivity or perception. It would be far better for the neophyte to develop his or her own design and enjoy the feeling of pride that accompanies it.

As you continue to accept instruction and guidance, there will be a gradual recognition of a discernible form emerging from the stone. This phenomenon will be accompanied by a sense of confidence and exhilaration that will offer encouragement and satisfaction. No one can teach that...you have to experience it!

The technique of carving stone is a slow meticulous procedure which cannot, and should not be rushed. The steps and materials involved are indicated on the chart below. Each will be discussed

as this chapter progresses.

1. Roughing (blocking) out: single or double pointed chisel
2. Refining: claw, rondel, straight edge chisel, rifflers, and rasps
3. Polishing and finishing: carborundum stone, carbide abrasive papers, polishing block, buffing wheels, and wax
4. Mounting on a base

ROUGHING (BLOCKING) OUT

Direct carving into stone can be generically referred to as an "art of subtraction." When an artist creates sculpture by modeling with clay or plaster the process is an "adding on" or building up of forms to reach the desired conclusion. Direct sculpture involves the relationship of negative and positive forms produced by the process of subtraction.

If we were to remove stone from one area of our subject to a depth of three inches, it would produce positive forms on each side of the excavation. It is the relationship of these positive and negative forms that determine the shape of our finished product.

The newcomer to stone carving, having acquired the basic tools and a soft stone such as alabaster, wonderstone, or alberene, is faced with the dilemma of the initial intrusion into the stone.

I strongly urge the first-time carver to approach the project without any preconceived plans for a finished product. This is a time for getting the feel for the material and tools and to experiment with the creation of negative and positive forms in order to appreciate their relationships to each other.

The initial tool that you will use is the point. You will use it to carve the basic shape of your sculpture, and it is quite possible to carve a stone sculpture using only the point.

Examine the dimensions of your stone as it rests securely on your sandbags and work bench. If it is random shaped, turn it in all directions to become familiar with its surfaces. Determine the high and low points that already exist. These are the ends of the rectangular form, and the negative and positive areas that you have inherited. Look for a sign of a "message" from the stone, a signal that helps you recognize a familiar form in the random shape. Do not be concerned if it does not exist...it will appear as you work!

Since this is your first carving, it is best that you do not attempt a portrait, a torso, or extremely realistic interpretations. Experience with stone and dimensions is required prior to such an undertaking. Think in terms of a flowing relationship of negatives and positives, highs and lows, which will lead to a non-representational abstract form. Elaborate on the basic figure eight design. Concentrate upon movement of the forms, flowing gracefully from one to another without being deterred by straight or flat planes.

Those who have selected a rectangular stone with flat edges can use a pitching tool to remove edges. This tool is part of the basic list described in Chapter III.

Pitching requires a ninety degree angle in the stone, and will not work on rounded areas. As illustrated, the flat edge of the chisel is placed about one inch or less behind the edge, with the concave side of the chisel facing outward. One or two sharp blows with the hammer will remove large chunks of stone.

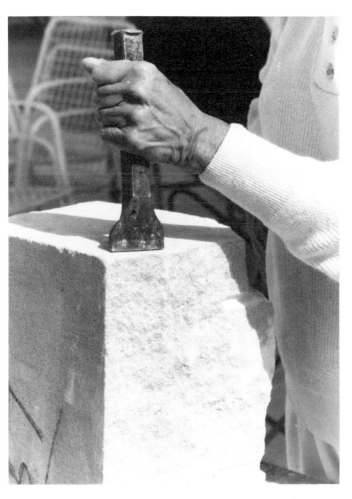

On squared edges the pitching tool can remove large pieces of stone with a minimum of work. Place the tool about ½" from the edge and parallel to it. Strike firmly with the hammer.

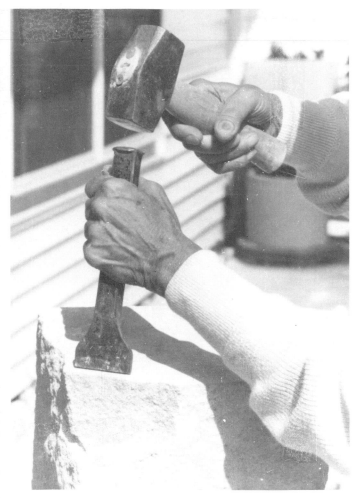

The large piece is removed, and the tool is set to remove more.

Place the block on a sturdy table, using sandbags to support it and absorb some of the impact of the sculpting.

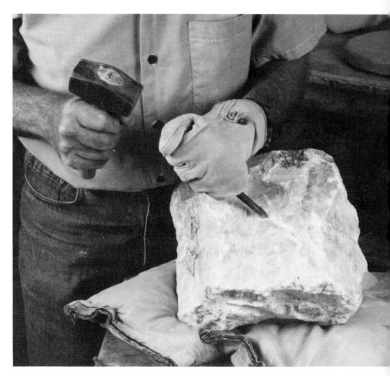

Removing material is done with the point, using the technique of crosshatching.

Use the medium point chisel for the initial stage of removal of stone. Select an area toward one end of your stone and by means of the "cross hatching" techniques, start the process of creating a negative area. Remember that the grooves, shallow at first, must deepen as they progress. The negative area should extend at least half of the length of the stone. Avoid creating small pockets of these negatives. Turn to the other side of the stone and once again, remove stone to form another negative area. Notice that these excavated areas are surrounded by positive projections. It is the interplay of these positive and negative areas that will reward you with a design that may be abstract or present you with an idea for a somewhat representational figure.

Avoid working in just one area. Move continually around the stone, observing it from all angles. Project yourself into the work. Enthusiasm will be your greatest asset.

Carving calls for an aggressive approach in which YOU must control the material! The stone will resist for a short time and it becomes a battle of wills. If you are overly timid, the stone will win. Remember that we are dealing with an art of subtraction. Nothing subtracted means nothing projected, nothing ventured, nothing gained.

If by being overly tentative, the carver fails to make intrusions into the stone in the form of negative areas, and simply skims surface, the stone will quickly be reduced in size without anything

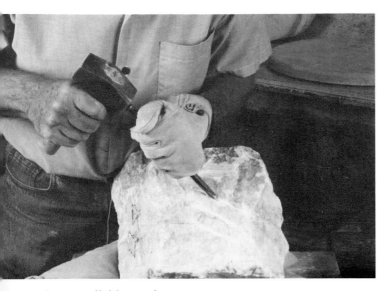

Cut parallel lines about 1" apart.

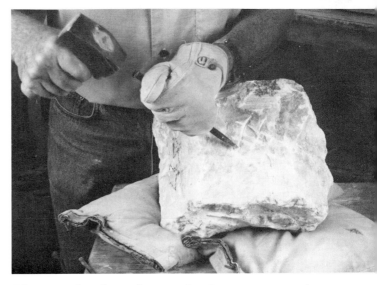

The crosshatching has made these squares chip out easily.

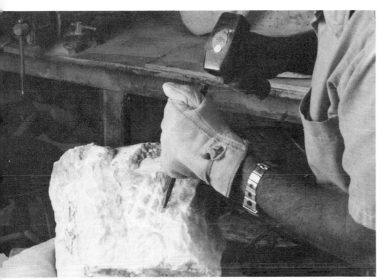

Then cut parallel lines perpendicular to the first set. This creates a checkerboard pattern.

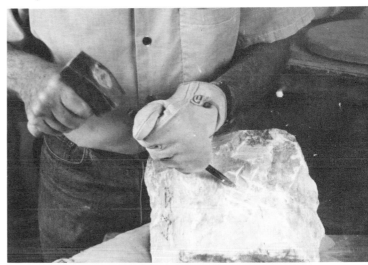

Not the angle of the chisel in this removal process. It is neither too steep or too shallow, working at approximately 45 degrees.

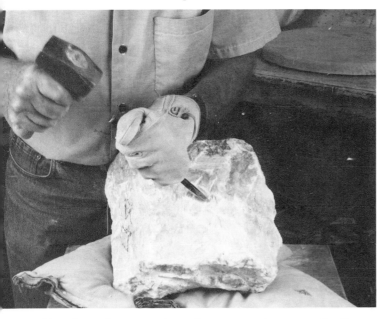

Use the point to cut into the squares between the lines.

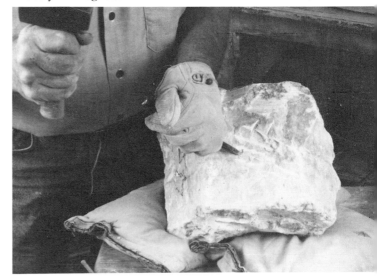

A steeper angle will cause stun marks that, though often invisible at this point in the sculpting, will mar the work when we reach the finishing steps.

changing. I have seen this phenomenon often. Students, in an attempt to defend their action, usually explain that they are attempting to "clean up" the stone and make it more uniform. This is utter nonsense! Commit to the carving procedure immediately. Show the stone that you are the boss! Success will follow!

As you continue to carve, negative areas will flow into other negative areas. Positive areas will join other positive areas and the sculpture will develop a rhythm of motion. Your goal should be to establish three dimensional forms throughout the entire mass of stone. Do not be deterred by imperfections, cracks, textures, and discolorations on the surface.

It is not necessary to assign a base portion for the mass simply because it might have a flat area. The decision for that area will be made when a final determination of the design has been reached.

Be careful to chisel away from corners, edges, and forms that you wish to maintain. Pointing into such areas will result in chips breaking away, leaving a void in desirable formations.

In order to protect against undesired chipping of stone, cut a groove with your point along the length of the area to be maintained. Deepen it gradually until it forms a safety channel between the form to be protected, and the stone to be removed. It is now safe to "cross hatch" and chisel toward the area protected by the safety channel. Stone will chip away only as far as the groove that you have cut. You may now continue to remove material, deepening the safety channel as you proceed.

As you continue to carve all parts of the stone, the joining of the negative and positive forms will generate an idea in your mind. You will recognize the shape as a pleasant abstract design or perhaps remember a more representational theme. Once your goal is established and a definite direction has been assured, do not be swayed by the opinions of others.

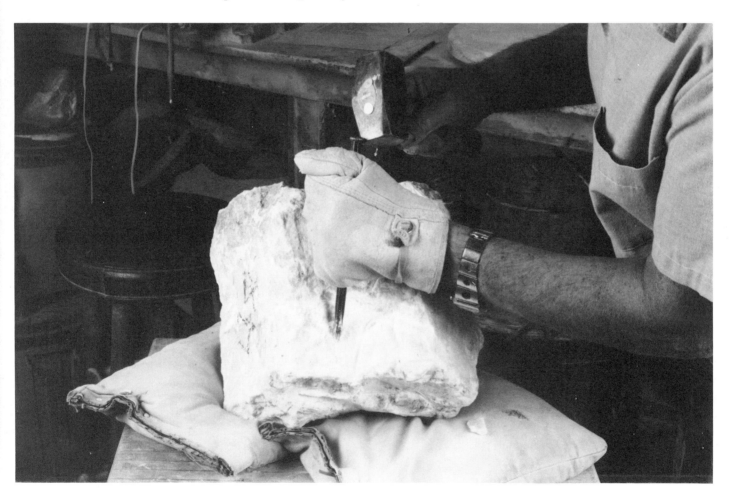

Positive forms are created by removing material to form negative spaces. On this stone we wish to create two positive forms with a valley in between. The first step is to make a safety cut on both sides of the valley.

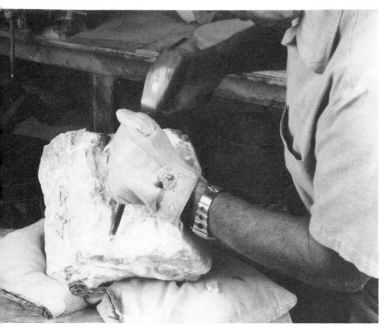

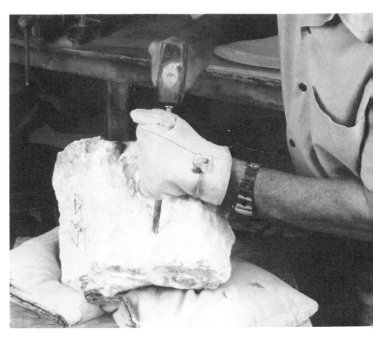

These safety cuts help protect the positive forms you wish to retain from being accidently damaged while subtracting the negative space.

When the safety cuts are made, the material between them is removed with the crosshatching method. First cut lines in one direction...

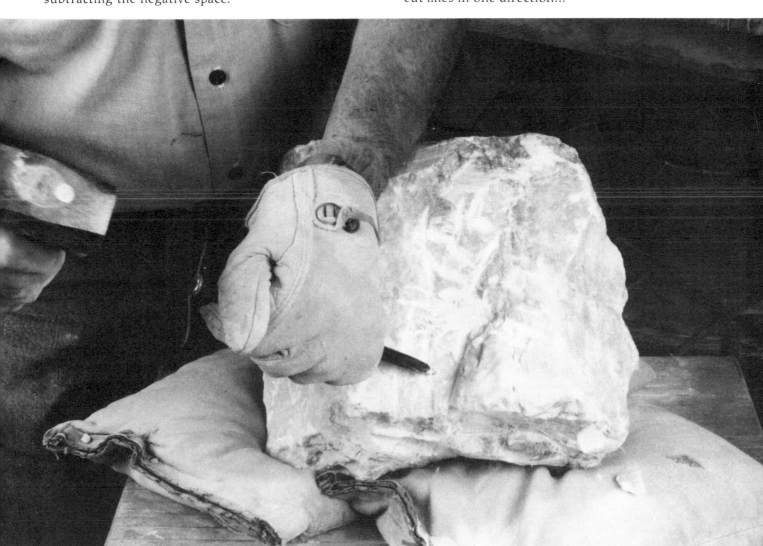

And then in the other.

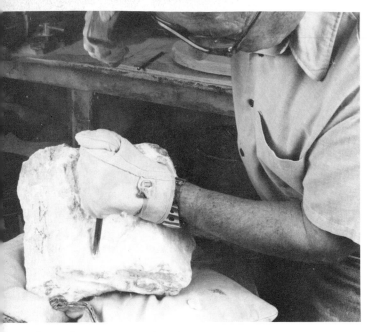 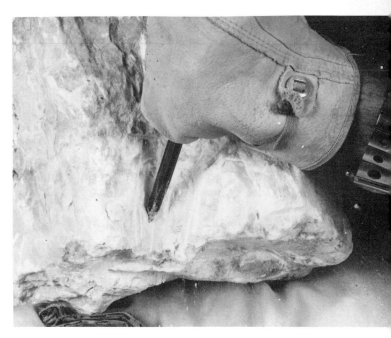

When the pattern is finished, remove the squares with the point.

As you go deeper, remember to deepen the safety cuts. Many sculptors have known the agony of forgetting this important step.

You will see the beginnings of the definition of the valley (negative volume) and hills (positive volume).

This is the roughed out negative area defining the positive areas on either side.

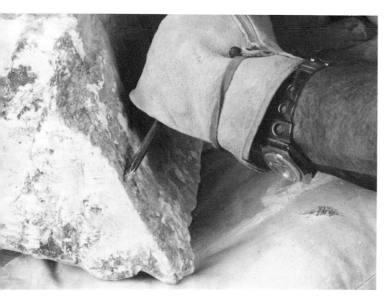

Special care must be used when working near the edges or corners of the piece. If you want to keep the edge intact, do not chisel toward it. This will cause it to chip or break away.

Chiseling away from the edge protects it and allows it to be retained.

Use the crosshatching technique to remove the stone you desire.

In my capacity as an instructor, I have been asked by students to comment on the progress of a form that is in the process of being carved. It has always been my policy to discuss technical details and to avoid changing the direction of the innovative thoughts of the artist. Those who allow others to second guess their creativities tend to develop a sickness designated as "La Manno Muerte," translated as "The Dead Hand." Symptoms of this illness are, a gradual decrease in the adventurous spirit which is so very vital for direct stone sculpture, and an inability to innovate unless told what to do. The hand and arm withdraw toward the shoulder socket, and cannot be extended unless placed on the stone by an instructor.

At any juncture during the pointing procedure, the sculpture could be "finished" as far as the roughing out is concerned. The basic shape that you have envisioned has been produced. It has balance, flowing intertwining negative and positive forms, and expresses an abstract or representational interpretation of your subconscious. It is in a rough stage, with lots of cuts, hills, valleys, and imperfections on the surface.

Once the edge is defined come back and file it.

You may recall that I have said, "Creativity is an individual emotion of the intellect." The design is yours, perhaps unseen or misunderstood by others. If you believe in the direction you are following, "go for it!" I have always believed that innovation spawns spontaneous decisions...do not second guess yourself.

REFINING

The decision to assign an area of the "blocked out" form as a lower portion on which the sculpture will rest can be made at this time or at any time during the carving process. There have been times when I have reversed my direction during carving, choosing entirely different positions as top and bottom. I prefer to delay this decision until the projected design is established in my mind.

A stone can be made to stand on a flattened point if necessary to enhance the design. I refer to this procedure as "scribing the point." You will need the assistance of another person in order to follow the following procedure and photographs:

1. On a flat firm surface, stand the stone on its point to be flattened.
2. Determine the center of gravity by releasing and adjusting the position of the stone until it stands in balanced equilibrium when released. (Be careful not to let it fall.)
3. Have your associate hold the stone securely in the position of equilibrium while you "scribe" the stone.
4. Depending on the size of the area to be flattened, place a piece of lumber, 1 or 2 inches thick against the stone. Draw a pencil line on the stone, using the lumber as a template. Continue around the stone, so that the pencil line is drawn on all sides.
5. Lie the stone on sandbags, joining the lines if necessary, and carve away the "scribed" portion with a claw.

On a flat firm surface, stand the stone on the point to be flattened. Determine the center of gravity by releasing and adjusting the position of the stone until it balances.

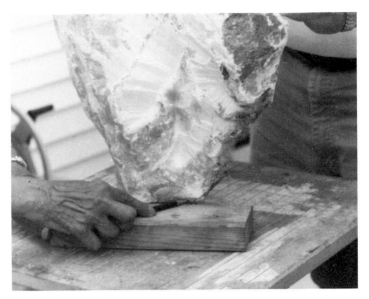

Have an associate hold the stone securely in the position of equilibrium while you place a piece of lumber, 1 or 2 inches thick against the stone. Draw a pencil line on the stone, using the lumber as a template. Continue around the stone, so that the pencil line is drawn on all sides.

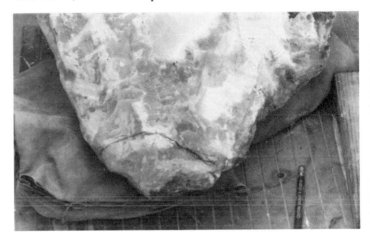

The "scribed" point.

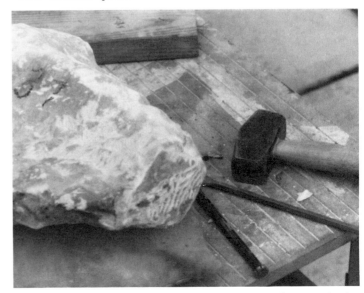

Lie the stone on sandbags and carve away the "scribed" portion with a claw.

73

6. Flatten the area with a cabinet rasp. The stone should now be able to stand alone on the area which has been established.

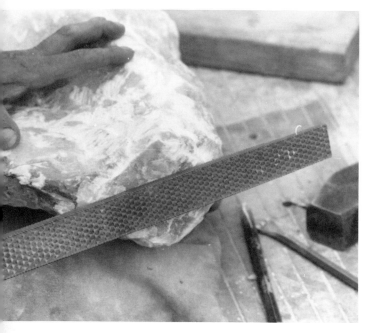

Flatten the area with a cabinet rasp.

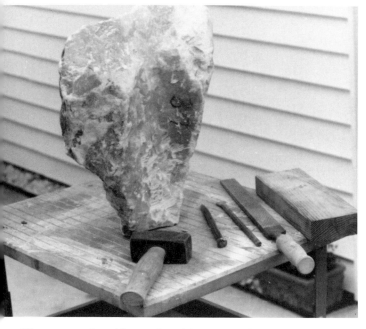

The stone should now be able to stand alone on the area which has been established.

The refining procedure will encompass use of the following tools: claw (toothed chisel), straight edge and cape chisels, rondels, rasps, and rifflers. Examine your tools in order to become familiar with their physical characteristics.

It is extremely vital for you to appreciate that stone carving is similar to peeling off the layers of an onion or artichoke. Visualize your project as a sculpture, within a sculpture, within a sculpture! The coarse outer layers are removed with the point chisel, second layer, with the tooth chisel, third layer with the flat and rondel chisels, and the fourth layer with rasps and rifflers.

Changing from point to claw, to flat chisel, to rasps and rifflers, and the removal of layers with each subsequent tool, encompasses a technique which is the very essence of technical skill. As you pass from tool to tool in the sequence, each mark from the preceding tool must be carved away! Point marks are removed by the claw. Claw marks are removed by the flat and rondel. The rasps and rifflers remove the marks left by the flat and rondel. In this manner, "stun marks" and other surface blemishes are removed.

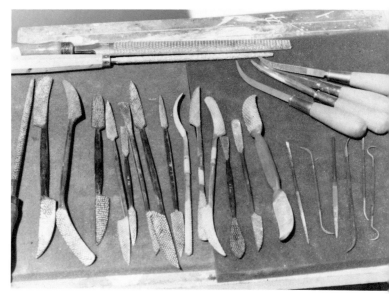

The author's work area with assorted riffler rasps and files, cabinet rasp, and round rasp.

The manner in which the claw is held is similar to that of the point. Maintain the same forty-five degree angle to make certain that you reach beneath the point marks. If the tool skips over the surface without removing stone, the angle is too shallow.

Think of using the claw as a painter uses his paint brush. As you refine, you will appreciate that the claw pulls the forms together. Proceed around the form in a cross-contour manner, traveling east, west, north, and south. Use the tool to deepen negative areas where needed, to round off and accentuate as your intuition directs you. Follow the contours of flowing lines in long continuous sweeps. Flatten planes where needed, and create the homogeneous movement you are seeking.

The work in progress has now reached a stage of

initial refinement. Hills and valleys are visible, however, they are of a much finer nature than those created by the point. Furthermore, the form has taken an aesthetic appearance, one which is approaching final form. Examine the work from all angles, and from all sides. If you are convinced that what you are seeking is within reach, continue the refining process. The flat edge, and rondel chisels are used to remove all of the markings, hills, and valleys, left by the claw. The use of these tools constitutes the continual "peeling of the onion or artichoke."

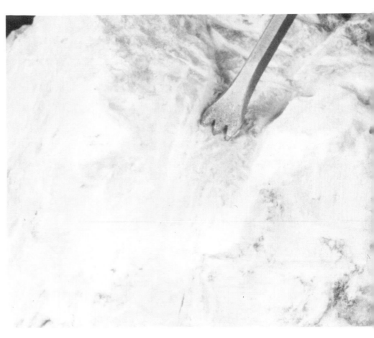

Remove all the marks left by the point, being sure to get below the point marks.

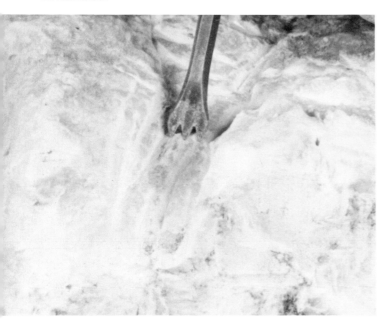

The claw is used to break down the hills and valleys created by the point.

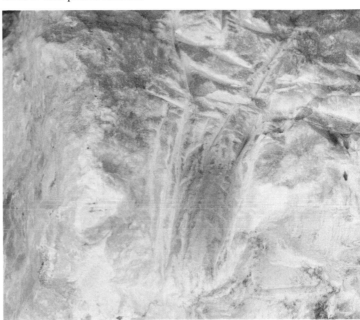

Like pealing an onion, the claw removes the next layer giving a raked texture to the surface.

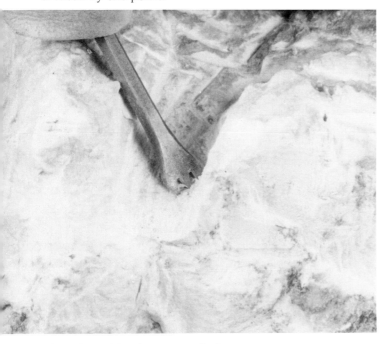

This should be done in each direction.

Apply the flat chisel to broad areas. The rondel and cape chisels are used in smaller and rounder areas where the flat surface tool cannot reach. Use the chisels gently and carefully. Light tapping with the hammer is the order of the day. Heavy blows will drive the tools into the surface and will alter your planned final appearance. The intent is to remove the markings of the prior tool (claw), and not to create new dimensions.

Do not rush your work. Proceed carefully and methodically. Give evidence that your effort is

indeed a labor of love. If it has not already happened, you should be experiencing a personal attachment and affection to your work. In reality, it is a part of you, an expression of your thoughts and emotions.

Properly applied, the final surface will appear fairly level and smooth, with slim, vertical, or horizontal markings as the remains of the chisels.

We are ready for the final peeling of layers. We have reached the sculpture beneath the sculpture, beneath the sculpture. The tools of choice are the rasps (cabinet or round) and assorted rifflers. These are the tools that not only produce the final smoothing prior to polishing and finishing, but bestow your individual sensitivity upon your work.

As a violinist caresses the strings of his instrument, or a pianist the notes of the keyboard, so does the sculptor instill the perception of his thoughts upon the work nearing completion. Sensitivity lies in the fingers of the artist's hands. The fingers holding the rasps or rifflers are the connecting link between your creativity and your work.

It leaves a fairly smooth surface.

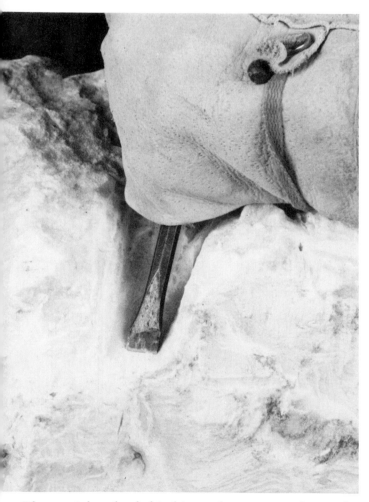

The straight edged chisel is used to remove the marks left by the claw.

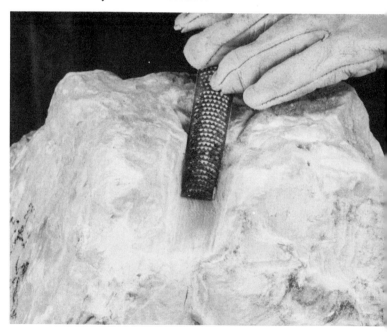

This is followed with the rasp.

Rasps and rifflers are a particular favorite of mine. I have recommended several for you to try and expect that with experience, you will increase your inventory of these tools. My tool crib probably has about twenty-five to thirty assorted rasps, rifflers, and files. In the course of my work it is likely that all will be used.

Aside from conventional sculpture supply outlets, good sources for this type of tool are

antique shops, flea markets, yard sales, second hand shops, or any outlet that might be disposing of used merchandise. I am constantly browsing through flea markets in the hope that I might find some exotic rasp or riffler which will be somewhat different from those that I already have. There is no preferred shape or abrasive surface. If it works, use it! In any case, it is fun to try.

The choice of which rasp or riffler to use for a particular area is one of personal preference. It will vary from one to another based upon individual dexterity. The final choice will depend on which feel most comfortable to you.

The cabinet and round rasps are used for broad areas, openings, and wherever they physically fit the need. These tools are applied in long sweeps, lengthwise, from one end of the form to another. It is important to avoid short choppy strokes. These will tend to produce depressions and valleys interrupting the continuity of lines and curves.

The primary purpose of the cabinet and round rasps is to remove all markings of the prior tool, the flat and rondel chisels. However, as you discover innovations in your design, these tools can be used to remove a good deal of surface in order to increase curvature and flowing dimensions. The round rasp is quite valuable in enlarging or tapering openings from one side to another.

At times, I have observed cabinet rasps or similar tools being used for bulk removal of stone. It has

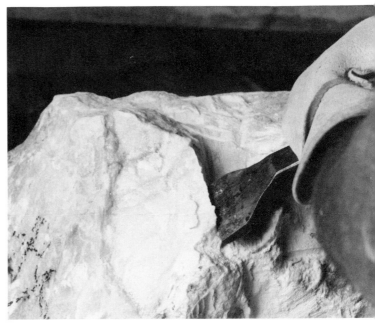

and hit with a hammer to remove a good sized chunk.

been a source of amazement to watch the poorly trained person saw away with rasps for long periods of time in an attempt to produce results that would take just a few minutes with the proper tools. Questioning the person has always revealed that they were never actually trained properly. Rasping looks easy, and it is. However, over a period of time it can become very tiring.

The cabinet rasp has two sides, one being flat, the other, convex. The flat surface has uses for the smoothing of flat planes. I prefer the convex for most of my procedures. A straight forward movement should be avoided. This will allow just the apex of the convex surface to touch the stone, and will produce unwanted depressions. The correct method should be to move the rasp forward, away from you, with a rolling action of the wrists. In this manner, as you roll the tool, the entire convex surface will reach the stone. The round rasp is handled in the same manner. Experience with the tools will show you what they can and cannot do.

The cabinet and round rasps have large protruding teeth and are capable of removing a good deal of surface. In doing so, they induce markings of their own upon the surface. Do not allow this to deter you from your goal of gaining an overall homogeneous surface.

The riffler rasps are instruments that everyone seems to enjoy. They are comparatively small, and fit comfortably in the hand. They allow you to accomplish the fine detail work within small hidden areas. They can produce graceful and flowing movements, which are vital.

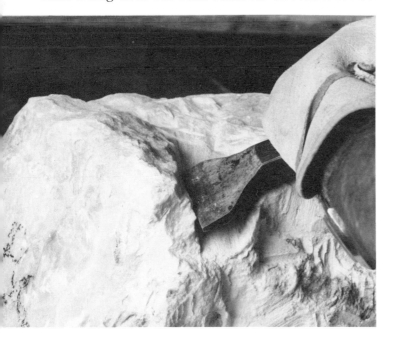

In this example the positive area on one side was getting in the way. This allowed us to demonstrate the use of the pitching tool to remove a large piece of stone with little effort. The tool is placed against the stone...

The rifflers are applied over the entire surface if needed, and in so doing will remove the heavier markings left by the cabinet and round rasps.

What is being accomplished is sculpture, within a sculpture, within a sculpture. This phrase must be constantly be repeated until it becomes a part of your thinking.

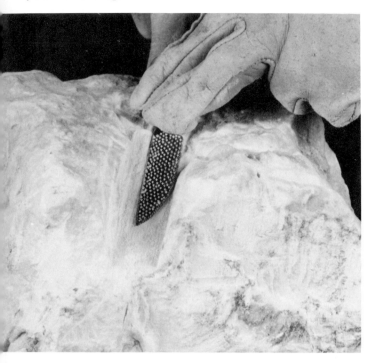

The riffler refines the stone more.

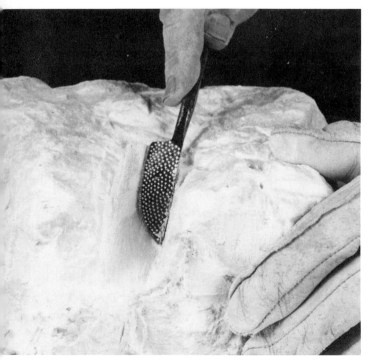

The rounded edge of the riffler allows for rounded shapes to be smoothed.

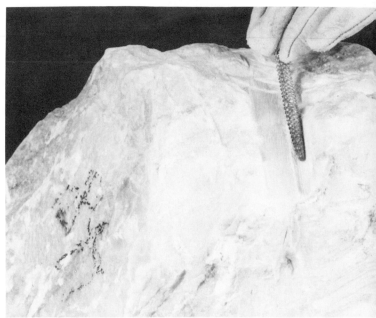

The round rasp is also used on curves.

Examine the entire work from every angle. Be precise with regard to each detail of the surface. The questions that you should be asking of yourself are:

1. Is the surface intact throughout all of the areas?
2. Have chips and nicks been smoothed and incorporated into the flow of the work?
3. Has the area designated as the base portion been leveled to allow the sculpture to stand on its own without rocking?
4. Does the surface have a continuous matte finish?
5. Do you relate to the work? Do you have a feeling of affection for it? Are you proud of your sculpture?
6. Do you feel that you have accomplished the goal you set for yourself?

A negative response to any of the above should return you to the workbench to make the proper adjustments. Do not accept mediocrity. Doing so will delay your progress as a sculptor.

CARVING LIMESTONE AND MARBLE

There is no special magical technique in the carving of harder stones. I've often heard it said, "You can't carve marble by hand, you must have power tools." This statement is without foundation, and completely false. What is needed to carve limestone, marble, or any of the harder stones is experience in the basic techniques that I have taught and the perseverance to stay with the methodology.

You will recall from the Moh's Scale of Hardness,

that limestone is approximately twice as hard as alabaster, wonderstone, or alberene. Marble is about three times as hard as the three softer stones. Furthermore, limestone is a sedimentary stone, and marble is metamorphic in nature.

The oolitic variety of Indiana limestone is composed of tiny bead-like formations and is excellent for carving. Textures, negative areas, and extrusions, are easily accommodated. The material presents a stronger resistance to carving tools than the softer stones within the alabaster grouping, but this will not present a problem.

Logical reasoning would indicate that harder stones require a heavier chisel to produce results. Many carvers proceed with this conclusion. However, "logical" is not the case. You will find it easier, and more productive to use fine or medium tools. The heavier and broader the tool is, the more resistance to the tool exerted by the stone.

The feel of the stone will be different as you use the point to rough out the block. Avoid attempting to break large areas as you may have done with the alabaster category. Slow, steady, and sure, is the preferred pattern. Cross hatching should be limited to smaller squares. Do not be impatient.

Limestone is supplied in straight cut blocks, and the use of the pitching tool, discussed previously, to break off larger chunks from the edges is often desirable. Edges can be eliminated by the use of a right angle grinder fitted with a diamond cut-off wheel. This method will be described later in this volume within the chapter, "Advanced Techniques."

The goal of every sculptor is to carve marble. It is the epitome of classical excellence and the supreme challenge, the medium of the ancient masters of Greece, Rome, of Michelangelo and Bernini, and the twentieth century genius of Brancusi and Noguchi.

The carving of marble constitutes a state of mind. It demands a regimen of loving care, patience, and concentration. It is not for the novice. It is for the sculptor who has mastered the rudiments of basic carving techniques, who can adapt to the demands of a resistant material, and who can appreciate the tranquil beauty of the final product.

Within the family of marble, the density and fragility will vary. It would be best to begin by using the somewhat softer variety of Vermont white or Carrara. Conversely, those to avoid would be Belgian black, Portuguese pink, and Georgia or Tennessee varieties.

At a workshop which I attended several years ago, I had the pleasure of watching another sculptor carving a figure of Carrara marble. It was fascinating to watch his extreme concentration, devotion to the material, and inexhaustible patience. Slow and steady...chip...chip...chip, nothing could deter him from his goal. The work continued for hours without any sign of fatigue or irritability. I could sense the great masters of the past nodding with approval.

The technique and sequence for the hand carving of harder stones remain the same as with the softer materials. The change is in the mental approach of the carver to the medium.

FINISHING AND POLISHING

The finishing and polishing of the completed sculpture is critical to the success of the work. I have seen mediocrity turn to acceptance by an outstanding polishing technique, and excellence downgraded to approval by a poor method.

An aura of secrecy prevails among professional sculptors in this area of the procedure. Each guard their personal preferences and secrets with a fervor, and rarely divulge their technique to others. At the same time, they are constantly prying among other sculptors in attempt to learn something new. In their writings, they freely describe the conventional polishing techniques, but never reveal the intricacies which provide them with the perfection they obtain.

This may seem amusing, but it indicates the serious nature of the finishing and polishing of the final product.

My earlier years as a sculptor were spent seeking the degree of perfection which was attainable, yet had eluded me. I observed, read, listened, and pried, accepting some innovations, rejecting others, until I was confident that the mission had been achieved. Finally the polish of my completed stone works had equaled or surpassed those whom I had admired, and I intend to pass the procedure to my readers.

The supplies that you will need to polish stones with a degree of hardness, which includes alabaster through marble, include the following:

1. running water
2. fine silicon carbide cylinders, round and flat
3. wet & dry carbide paper, grits 240-320-400-600
4. oxalic acid (used for marble only)
5. abrasive polishing powder block
6. 4" or 6" muslin buffing wheels with mandrels
7. electric drill, minimum 1800 RPM
8. Butcher's Bowling Alley Wax

Locate a comfortable working space adjacent to a sink or wash basin where running water is available, and where you can easily dispose of liquid waste.

At this point, your refined sculpture is susceptible to bruises and nicks. For protection, the stone can be placed on a base of two inch foam rubber, or on a soft vinyl Rubber-Maid drain board.

I prefer to use a soft vinyl Rubber-Maid tub with dimensions of about 2' x 2', or 2' x 3' with sides of about three inches high. The water that will be needed can be contained in the tub and prevent "sloshing" about the work area.

Place the sculpture in the tub, add about one inch of water and we are ready to proceed.

Silicon Carbide Cylinders

The use of silicon carbide cylinders as a first step in polishing, rather than the last step in refining, is my choice and is based upon psychological logic. As a first step, rather than a finale, attention is called to the importance that I place upon the procedure.

Some sculptors use carborundum bricks, or rubbing ricks, as they are called, as precursor to polishing. They are available as blocks of about 4" x 2" x 1", but I find them inadequate. The sculptures I create are primarily curved, and rubbing them with a flat brick creates undesired planes.

Instead of bricks, I have successfully used cylinders of silicon carbide which are about six inches long, either round, with a diameter of one inch, or triangular, each side being one inch wide. I originally obtained a supply in Italy. To the best of my knowledge, they are unavailable in this country. There are alternatives!

The Norton Manufacturing Company can supply similar cylinders which they refer to as "Six Inch Polishing Stones." These are recommended for general mold and die polishing and are available in one half inch round and triangular shapes. Your regular sculpture supply dealer can easily obtain a variety for you from the manufacturer. Refer to the "suppliers" section of this volume for addresses.

Assorted silicon carbide cylinders and alternate grinding wheel parts.

A second alternative, should the "polishing stones" not be available, is to adapt a fine grit silicon carbide bench grinding wheel, about one and one half inches wide. Place the wheel diagonally against a brick wall or a large rock and give it a good "whack" with your two pound hammer. The wheel will break and produce two or three pie shaped wedges with the curved outer edge adequately suitable for rubbing.

A third alternative would be to use silicon carbide grinding points of the type illustrated below. Though these are intended as accessories for power equipment, in this instance, hand application is to be used. They are available at sculpture supply outlets.

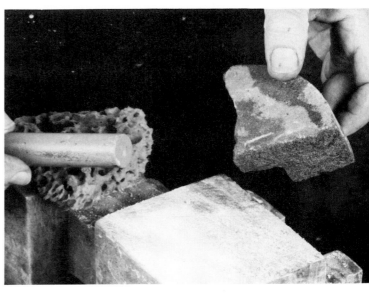

For demonstration of the finishing and polishing process, we will use a piece of Mexican alabaster. It is shown here with the tools needed to finish a piece, a sponge, broken silicon carbide grinding wheel or silicon carbide cylinder.

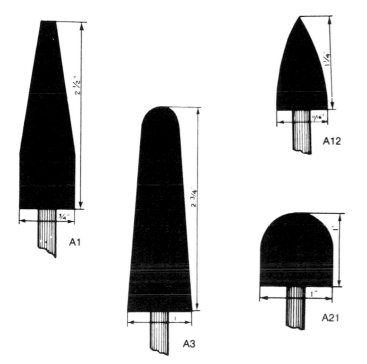

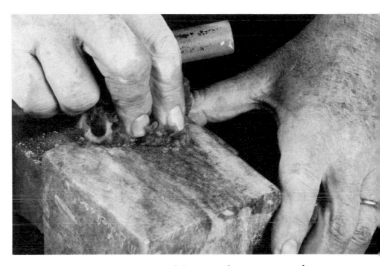

The first step is to thoroughly wet the stone with water.

The surface of your refined sculpture appears to be smooth and without imperfections. However, if you run your fingers over the surface lightly, you may feel slight undulations, minute hills and valleys, which will detract from the final polishing.

Saturate your carbide rubbing material by immersing it in the water of the tub. Wet your stone thoroughly, and proceed to massage the stone in all areas, slowly, and carefully. With a wet sponge, continually rinse away the debris created by the carbide.

Change the water of the tub as the concentration of stone shavings increases. The purpose of the water is to rinse away the stone particles thereby preventing them from clogging the pores of your abrasive material.

On a flat surface like this the silicon carbide cylinder is rubbed back and forth with medium pressure.

If the cylinder is unavailable the broken silicon carbide wheel will work.

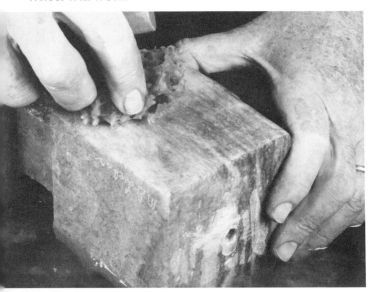

Sponge the piece regularly to remove debris and keep the work area wet.

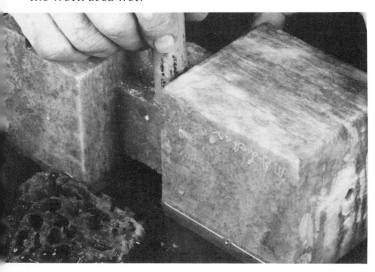

Get into all areas of the piece.

This process does not take long. It may not be physically possible to reach deep concave areas, but concern yourself with that which can be accomplished. When you are satisfied that you have improved the condition of the surface, you can move on to the next step, the wet and dry abrasive paper.

Wet and Dry Carbide Paper

The carbide abrasive paper, commonly called "Wet and Dry", can be purchased at any hardware department, builders' outlet, or sculpture supply store. It is available as 9 x 11 sheets and abrasive strengths from eighty through eight hundred, with the lower number having a heavier grit.

There is a product available called "Screen-Bak," which resembles insect screen that is used for the windows in your home. It is carbide impregnated and is available in the various grits similar to the wet and dry paper. I have not found Screen-Bak to be of any advantage for polishing. It is more expensive and is quite irritating to the fingers.

Let's stick with the "wet and dry" carbide paper!

For all stones from alabaster to marble, you will need the following grits listed in order of use: 220 or 240, 320, 400, and 600. Those who are using marble may wish to start with 180, although in almost all cases, 220 or 240 will suffice.

After the piece has been thoroughly rubbed with the silicon carbide, use 240 grit wet-and-dry sandpaper to continue the polishing process. Remember to keep the piece wet. It is important to use your fingers to maintain the sensitivity needed.

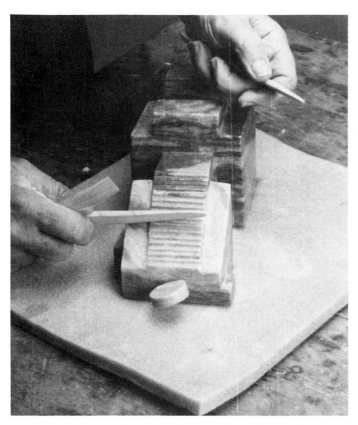

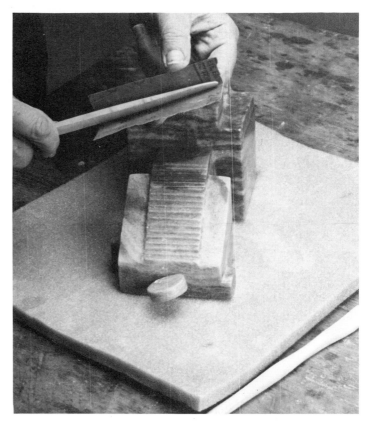

An exception to this is when sanding detailed areas, when it is important to keep a crisp edge. For these areas I find it useful to wrap sandpaper around a wooden tool used for modelling clay. These come in several shapes, and allow you to get in hard to reach places.

and sand where necessary.

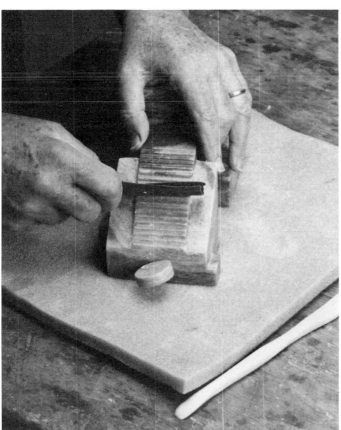

Simply wrap a small piece of sandpaper around the tool...

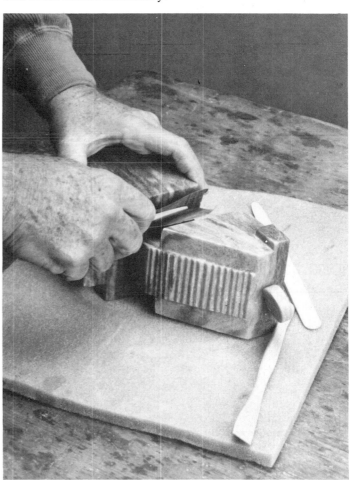

Remember to use all grades of sandpaper in these areas as you did on the rest of the piece.

All of the papers are vital to the success of the finished product. As a fine cabinet maker prepares his polished wood surfaces by sanding with coarse-medium-fine-extra fine, so must you with carbide papers for stone. Unless the stone is properly prepared, a polish and shine cannot be produced.

Added vigilance must be maintained while using the 240 paper. Your sculpture has been refined and smoothed to a matte finish, and is covered with tiny scratches and imperfections created by the former processes. It is the 240 paper that will remove all of these blemishes. The remaining grades of paper which follow the first carbide paper rubbing are the refinements and are not intended to remove surface markings.

Once again, place your sculpture in the work tub and add water as before. Cut a piece of 240 paper from the sheet; a 2" x 3" portion of the paper will suffice. Wet the stone and the paper. Dry materials must never be used as the sandy debris will quickly clog the grit of the paper and render it useless. Rub with pressure over small areas at a time, methodically and meticulously, paying particular attention to scratch marks. The pasty debris which is produced by the paper must be washed away continuously with a sponge. Do not allow this debris to accumulate, for it will not only clog the grit of the paper, but will prevent you from carefully observing as you work. Change to fresh paper frequently. Sanding with worn carbide paper is a waste of time and effort.

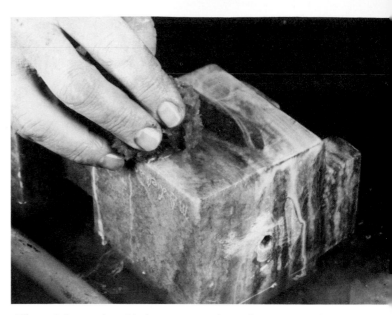

This debris should be removed with water often. Otherwise it will clog the grit of the sandpaper and make it ineffective.

Be careful that you do not reduce the level of corners or edges. The 240 paper can quickly minimize the delicate shapes that you labored to produce. Apply the abrasive toward the point or edge from all directions, never across them. In this manner, the area can be polished without reducing the configurations you have created.

Recessed areas and those difficult to reach with the fingers must not be ignored or given minumum treatment. Inner edges, curves and corners can be reached by wrapping a piece of wet and dry paper around a boxwood clay modeling tool or a wooden dowel. The space in question will dictate the shape of the assisting tool. It is best to avoid the use of riffler files or spatulas of metal for this purpose for the sharp edges of the metal will tend to bite through the paper and mar the stone.

Continue abrading all areas of the work. Do not hesitate to repeat areas where it might be required. Two complete rubbings are recommended.

The sculpture now feels uniformly smooth to the touch. All scratch marks appear to have been eliminated, and we are ready for testing.

While the stone is wet, everything looks and feels great. Scratches are indistinguishable! Enthusiasm prevails! Let us determine whether we are ready for the next paper grade.

Remove the stone from the tub and rinse it well with clear water. Remove excess water with toweling and allow it to dry completely. As it dries, small imperfections that you have invariably missed with your rubbing will appear. Go back and repeat the operation for those areas requiring attention.

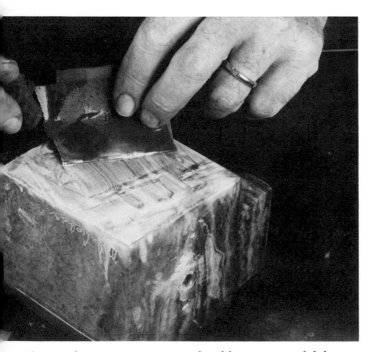

The sandpaper raises a considerable amount of debris.

Rinse and dry once more, and observe. This must be done until every scratch and nick is removed from the surface before you can proceed to the 320 paper.

As a means of encouragement, I assure you that in all my years of experience in the polishing of stone, I have never successfully removed all blemishes with my first attempt with the 240 paper. Repeating the 240 operation is something that I expect to have to do.

Once you render a perfect surface using the 240 paper, you can proceed to the next in line, the 320 wet and dry paper.

We are no longer concerned with the removal of imperfections. The purpose now is the further refining of the material in order that it may accept a polish. Recommence the sanding operation using the tub, water, and precision. Change paper frequently and wash away debris. Be exacting in your coverage of the entire work as you execute two complete rubbings.

A question is often asked, "How do you know when you have done enough sanding?" My answer has always been, "Enough is not enough." The more effort, the better the finish!

It should be appreciated that those working with the harder stones such as limestone, marble, and others in these respective categories, will need more time for each step than those working with the softer stones of alabaster, wonderstone, and the like.

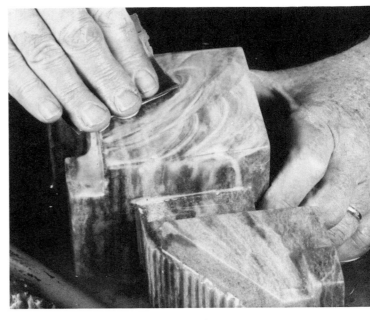

A circular motion insures complete coverage.

Inspection of the dried stone is no longer required. All blemishes have been removed by the 240 paper. Continue the process with the 320, 400, and then the 600 paper. As you continue with finer abrasives, change paper with increased frequency. Sharp edges can now be carefully smoothed using the 600 grade paper.

Finally, we are done. All of the pasty stone particles must be removed from the sculpture by placing it under running water. I prefer to move the work to my yard and shower it thoroughly with a garden hose.

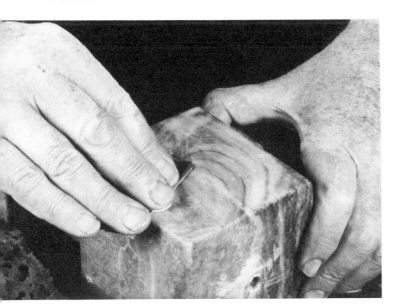

When the 240 grit sanding is complete the piece will have a very smooth feeling but will not be completely polished.

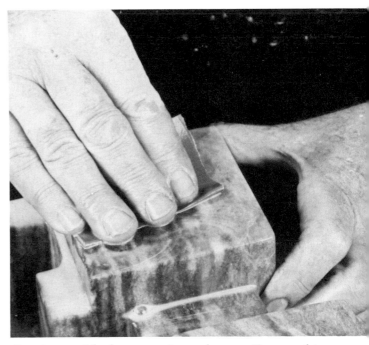

Continue with the 400 grit sandpaper. Do not skip any steps.

Dry the sculpture thoroughly and inspect it critically. If you are satisfied that you have achieved perfection, let us perform one final test. Rub the palm of your hand against the skin of your face to remove some of the natural oils. Knead your palm against the dry sculpture. A dull glow will appear indicating that the refining process has been successful to this point. The absence of the glow indicates that more refining is needed. Retrace your steps, and with a sincere effort, renew rubbing with the 400 and 600 paper. When you have achieved the glow which follows the palm kneading technique, you are ready for the next step.

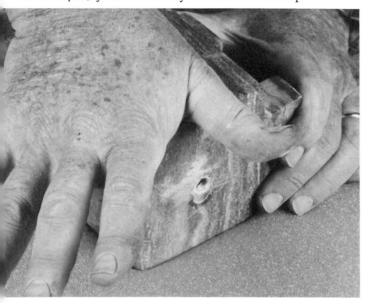

After the sanding it is wise to place the piece on a piece of foam for protection. Kneading the piece with the palm of your hand...

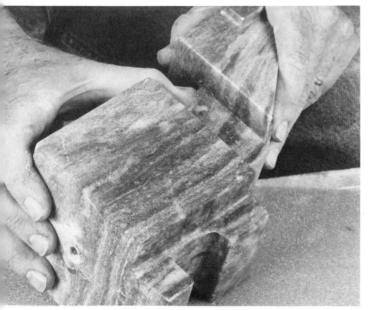

will produce a slight glow if the piece has been properly prepared.

The polishing of marble requires an additional refinement at this point. It is not intended for softer stones, but for marble only! This is to be done once the routine with the carbide paper is completed and before continuing with the polishing block.

Prepare a saturated solution of Oxalic Acid. This mild acid comes in powder form, and can be obtained at your local hardware store in small quantities. The solubility of this chemical is one part hot water to 1 part of the acid. A little extra hot water will aid the rapid solution and not affect the efficacy. Using a piece of hard felt, rubber gloves, and eye protection, rub the solution briskly over the entire form of the sculpture. Avoid simply wetting...rub it! Rinse thoroughly. If acid solution is allowed to remain, it will eventually discolor the stone.

For many years, and to this day, sculptors and the few tutorials which are available, have depended on a procedure which includes the hand rubbing of the refined sculpture with an abrasive powder. I have found this method to be vastly inferior to the system which I employ. Nevertheless, I should like to describe it to you.

The process uses Tin Oxide, a chemical supplied as a fine powder and capable of excellent abrasive results. Over the years, the price of tin multiplied, requiring manufacturers to combine the tin oxide with aluminum oxide to produce a compound referred to as "putty powder." Utilizing either of these, the sculptor would mix the powder with water to a consistency of sour cream, and rub the sculpture with a wet piece of hard felt.

The method was time consuming and boring for the creative artist. Several hours of intense, tiring effort were required. The results were satisfactory for the experienced professional, mediocre for the fledgling. Let us turn to the method whereby everyone, professional and beginner, can be a high achiever.

The materials required are:

Electric drill, minimum 1800 RPM ¼ or ⅜ chuck
2 four inch or six inch muslin buffs, with mandrels
Abrasive polishing block
Butcher's Bowling Alley Wax

The electric drill is an integral part of equipment classified as small power tools. Its usage in direct stone carving is unlimited in areas of basic and advanced techniques. It is critical that your drill have the capability of producing a minimum of

1800 RPM. Otherwise, vital functions of basic and advanced techniques will be unsatisfactory. My own drill has a capability of 2500 RPM.

Muslin buffs are available in various shapes and sizes. The chart which follows indicates those available at sculpture supply dealers.

For my work, I prefer a six inch muslin buff, tapered mandrel, 7/8" thick. Two are needed, one for abrasion, the other for waxing. The tapered, goblet, and barrel shapes have limited effectiveness and can be ignored at this time. Smaller buffs are used for smaller openings and tightly confined areas.

MUSLIN BUFFS

Diameter	Thickness	Hole	Remarks
1-1/8"	3/4"	pin	75 ply
1-1/2"	1/4"	pin	16 ply
2"	3/4"	pin	60 ply
3"	3/4"	pin	60 ply
4"	3/4"	pin	60 ply
6"	7/8"	pin	65 ply
6"	7/8"	1/2"	65 ply
7"	1/4"	pin	full stitched
8"	1/4"	1/2"	full stitched

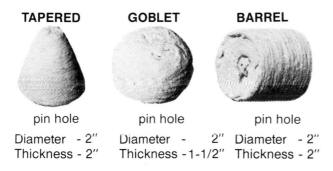

TAPERED	GOBLET	BARREL
pin hole	pin hole	pin hole
Diameter - 2"	Diameter - 2"	Diameter - 2"
Thickness - 2"	Thickness - 1-1/2"	Thickness - 2"

TAPERED MANDREL - 1/4" Shank
No. D-108 - For buffs with pin holes

ADAPTER - 1/4" Shank - For buffs with 1/2" holes

The polishing block or polishing compound, a compressed product of Italian origin, is available at most supply dealers. The 2" x 2" x 4" material is produced in various grits for alabaster, marble, and granite.

The final ingredient in the process is the Butcher's Bowling Alley Wax. This product has been on the market for a great many years and still is the finest carnauba wax product that you can use. It can be purchased at any houseware department or supermarket.

Twist your buff on the mandrel, attach it to the chuck of the drill and you are ready to go.

Apply the polishing compound to the buff as it rotates so that it absorbs the powder. Allow the buff to brush against the stone at top speed, with slow continual movement over the form. A shine will appear almost immediately. Replenish the polishing compound on the buff and continue the process until the entire sculpture is polished and you are satisfied with the results. Continued abrasion will increase the intensity of the polish. For a work of about twenty-four inches tall, you should be able to complete the task in about thirty minutes.

A word of caution is of importance. You must be careful that the metal parts of the drill or mandrel does not come in contact with the work. The result would be that the stone would very likely become nicked. If this were to happen, retrace your steps and repair the area with the use of the carbide paper, or a small riffler. Repeat the entire process for the damaged area until perfection is achieved. As you gain experience, your expertise will increase.

There are many professional polishers who maintain that once this stage of polishing is accomplished, waxing is not necessary. Nevertheless, I maintain that the use of wax is intended to seal the stone against handling, stains, and to offer protection against damage.

The Butcher's Wax is applied very lightly with the tips of the fingers. Do not remove lumps of wax from the container. Run the tips of the fingers over the wax so that they appear to be wet. Massage the wax evenly over the entire form and allow it to dry thoroughly. This will usually take ten to fifteen minutes.

Place a fresh buff on the drill. A separate buff is recommended for abrading and waxing.

When the wax is completely dry, buff to a high polish. A second coat of wax is required for best results. Your completed sculpture should be protected with soft toweling, pending the final step which will entail mounting on a suitable base.

Prior to the mounting procedure, it is advisable to establish your personal relationship with the completed work by engraving your signature or initials into the stone. This is similar to a painter signing his canvas to establish his identity as the artist.

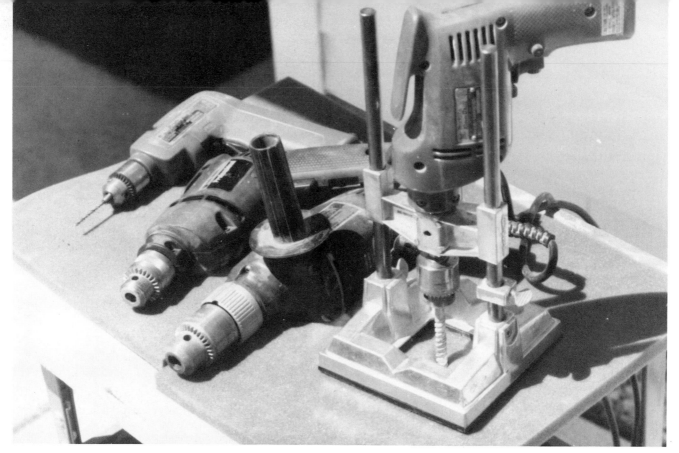

Author's assortment of electric drills and Port-Align.

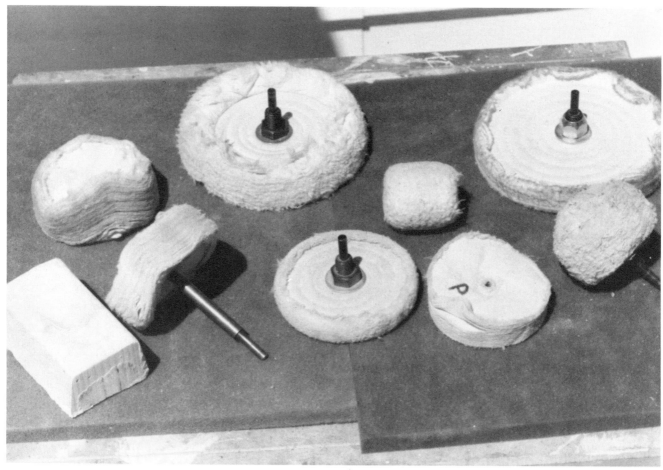

Mandrels, assorted buffers, and polishing compound
block.

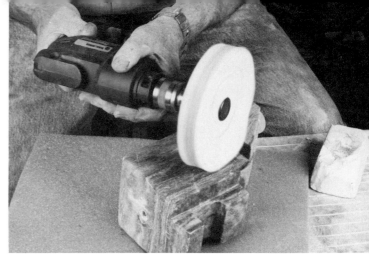

Apply the compound to the piece, moving the wheel to cover the whole surface.

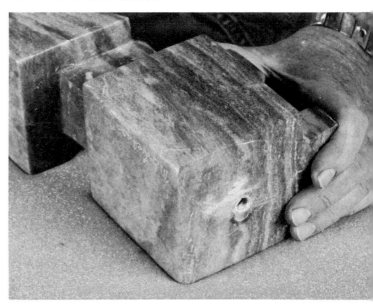

The polishing compound creates a nice glow to the surface.

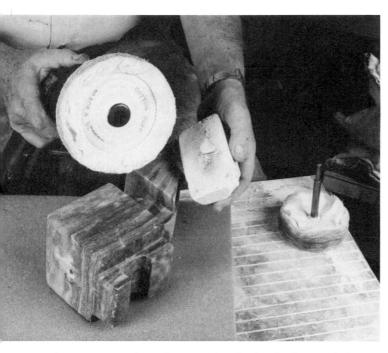

The stone needs to be completely dry before polishing. With hard stones this can happen fairly quickly. With more porous stones it can take several hours. I use a large wheel and polishing compound block. The polishing compound is available in two grades, one for alabaster or marble and another for granite.

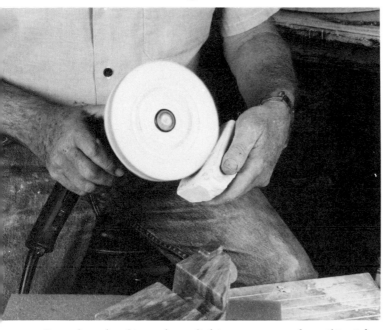

Run the wheel into the polishing compound until it picks up some of the abrasive.

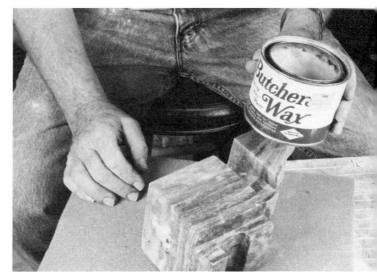

The final step in the finishing process is to apply wax to the piece. This provides protection and an added lustre. I prefer Butcher's Wax, having found it to be the best for this purpose.

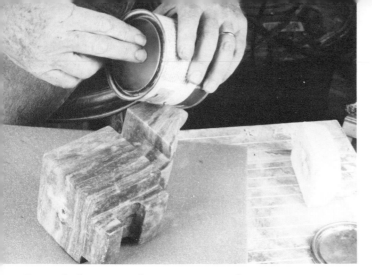

Get a light coat of wax on your fingers. Again, it is important to touch your work, so avoid the use of a rag or cloth.

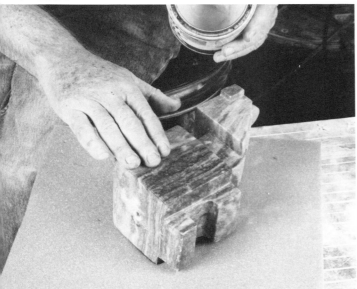

Rub the wax on the piece with your fingers and let it dry.

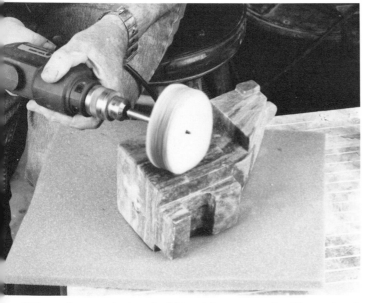

When the wax is dry, buff it with a cotton buffing wheel to a high gloss.

The most effective tool for this process is an electric engraver fitted with a carbide or diamond point. Excellent results can be obtained with a Sears model 4297 engraver or a Dremel model 290.

It is best to practice with this tool on a piece of scrap stone and when you are confident of your skill, locate a lower, unobtrusive place on the completed work and engrave the logo, signature, or initials which you will use as a means of identifying yourself as the artist. Wax the area of the engraving once again and you are ready for the mounting.

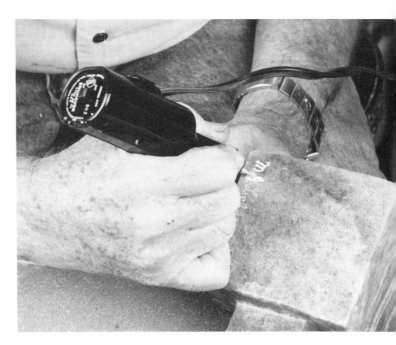

After practicing on a test piece of stone, use an engraver to sign the piece. When you are finished rewax the signature area and buff.

MOUNTING THE SCULPTURE

Placing the completed work on a suitable base for presentation is as vital as a proper frame is for a painting. Most of the sculpture supply companies offer a mounting service and they will recommend color and size, as well as do the actual mounting.

It appears to me, that as an artist it would behoove you to complete your own work rather than to rely upon someone else. The process is not difficult. It is a part of the adventurous spirit with which you originally approached the art of direct carving.

The selection of the color and material for a base is reliant upon artistic interpretation. It is as important as creating the work itself.

The materials employed for bases encompass a wide degree of variation. There is no standard formula. Wood, stone, Formica, Lucite, resins, brushed aluminum, brushed brass, stainless steel, to name a few, are employed. Whatever enhances the appearance of your work, without calling undue attention to the base itself, should receive priority. At times, sculptors will carve the base portion as part of the original stone itself.

If it works...use it!

In general, the light colored stones, such as pink Colorado alabaster looks fine on black Formica or on a stone such as black marble, or black serpentine. A grey-black sculpture of wonderstone or black serpentine is enhanced by brushed aluminum, stainless steel, or colorless Lucite. Within the wood family, walnut is an excellent choice.

A trip to your local museum, gallery, or library, to examine the works of the masters will aid you in making your decision. Rely upon the advice of your instructor.

The decision of size is once again one of individual judgment.

It has been said that the height should not be more than twenty percent of the vertical dimension of the work. The final decision is one of aesthetic appearance. Personally, I do not appreciate bases that are over-powering and my bases are seldom are taller than three inches.

Length and width will vary with the final shape of the form of the completed piece. If the upper portion of the sculpture conforms to the dimensions of the lower portion, a rule of thumb is to allow an overlapping of about one inch on all sides of the work. In the event that the upper portion extends outward over the lower, the decision might well be to have the base extended on all sides. Balance is the key. Proficiency will be acquired with experience.

To aid my students in making what seems to be a difficult decision, I have always advised them to remove some books from their shelves at home and stack them to build a base of suitable proportions. Place the sculpture on the temporary base, and observe it from all angles. Length, height, and width, can be adjusted by adding or subtracting books.

When you are satisfied with the appearance, the measurements are noted and you may proceed. If hesitancy persists, seek the advice of professionals in the field.

Ready-made and custom-made bases of varied materials are available at most sculpture supply retailers. Those with mail order facilities for national distribution are listed in the list of suppliers section.

I have been most fortunate to be able to utilize the services of an excellent carpenter who operates a studio not far from my own. Custom-made bases of the various woods, plastic laminates, and metals are manufactured with utmost precision and to my exact specifications. My students have also benefited from this association. Investigate your particular area. It is entirely possible that you can secure similar facilities.

When stone bases are required, I usually cut them from travertine, black marble, white marble, and limestone which I stock at my studio. In addition, I utilize the services of the supply companies listed at the end of this volume.

Sculpture can be installed as a permanent mount with the proper epoxy cement or as a temporary mount, capable of being removed to facilitate transportation. My work is always permanently mounted, and if transportation is required, the entire piece, base and all, is crated for shipment.

Temporary mounts, since they are movable, tend to mar the base as they are installed or removed, and I avoid them for that reason. Nevertheless, I shall describe both installations.

The materials required are:

1. Base and self adhering felt
2. Tracing paper
3. Port-Align drill stand
4. Electric Drill
5. Carbide masonry bits
6. Wood drill bits
7. Threaded steel rod
8. Turning pins
9. Devcon Plastic Steel Epoxy
10. Miscellaneous bolts and washers if needed

Of the items in the above materials list, two require special mention. The two are the Port-Align, and the Devcon Plastic Steel Epoxy. The others are regularly available supplies which will be noted during the procedure.

The most precise procedure in the mounting process is the ability to produce ninety degree drilling of holes in the sculpture and base. If either is a degree or two less than perfect, the proper mounting will be an impossible feat. Therefore, the visual observation of this drilling operation must not be attempted.

Few of us have the luxury of the availability of a drill press in our work shop or studio. Table top

varieties of the drill press do not have enough clearance to accommodate the size of stone sculpture that is produced. Wood working shops which use the large floor models would frown on the use of drilling stone with their equipment for fear that the stone dust would damage their equipment.

For many years, I have successfully used a simple piece of equipment called a "Port-Align" which I purchased at Sears, Roebuck & Company for about twenty dollars. I lovingly refer to it as my portable drill press. It allows for precise ninety degree drilling at determined depths and can be used for all stones that can be handled and moved without auxiliary lifting equipment.

An electric drill, with a minimum of 1800 RPM, is attached to the Port-Align as indicated in the instruction booklet, and you are ready to proceed. I have found it advantageous to have two or three electric drills available, one permanently attached to the Port-Align, others for various procedures that are required. Refer to the photograph.

There are many epoxy cements available and I can assuredly state that I have tried most of them. The one cement that has proven strong enough to withstand the stress of the weight of stone has been the Devcon Plastic Steel Epoxy. It is the only product that I will use, and I recommend it to my students and to you, the reader. Devcon Products are nationally distributed and are available at most hardware departments. Do not accept substitutes as "just as good." I have yet to discover its equal.

Steel rod is available in varied gauges and with smooth or threaded finish. If the rod is to be completely hidden by the mounting, I will use ordinary threaded steel rod. Should the rod be visible, due to a raised mounting or required for support, the choice would be stainless steel, or brass. The threaded rod is preferred because the configuration of the threading offers more surface for epoxy adherence than the smooth type. Furthermore, the threaded type can be used for removable mounts whereas the smooth rod cannot.

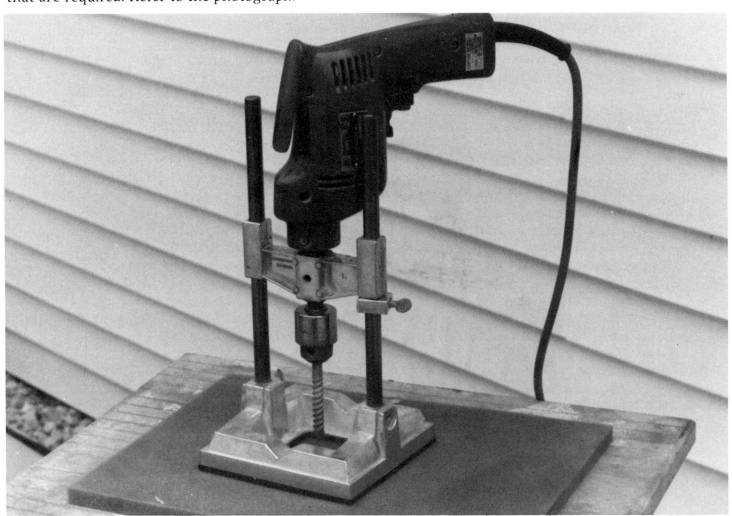

The Port-Align.

Under normal circumstances, I will use a ⅜" rod. Experience has shown it to be a gauge of universal application. The physical dimensions of the stone to be mounted will occasion the use of ⅛", ¼" or ½" rod. A narrow footing might demand the use of a fine rod. Where support and strength is required, a heavier rod must be used.

The mounting procedure is as follows:

1. Cut a piece of self-adhering felt to fit bottom of base and apply accordingly.
2. Place the sculpture on a flat surface and check to see that the bottom is perfectly flat, does not rock, and no gaps appear between the surfaces. Correct the fault if required.

Use a flat cabinet rasp drawn in long strokes across the bottom area. Test for accuracy with the edge of a steel level. Observe for gaps. Correct till perfect.

3. To accommodate a ⅜" rod, use a carbide masonry bit of the same size for drilling the stone. Drilling with a ⅜ bit in stone will produce a hole slightly larger thereby allowing room for the epoxy. The depth of the drilling will vary with the size of the sculpture. Under normal circumstances, 2½" to 3" will suffice. Experience will dictate your choice. Set the depth adjustment on the Port-Align.

If the base of the sculpture is fairly uniform in dimensions, one hole will be sufficient.

In the event the sculpture is elongated at the base, two holes will be needed, one for stability, and one of lesser depth as an anchor.

Turn the sculpture bottom side up on a cushion of foam rubber. Have an assistant steady the stone and place the Port-Align in position so that a hole can be drilled close to the middle of the stone. Hold the base portion of the Port-Align firmly against the stone in order that a perfect ninety degree angle is maintained. Complete the drilling. If a second hole is required as an anchor, a depth of about one inch is sufficient. Remove all stone debris and dust.

4. Cut a piece of tracing paper to the exact size of the pedestal or base and fasten it to the top surface on all four sides with a small strip of masking tape.
5. Place the sculpture on the paper covered base. Taking care that the paper does not tear, adjust its position until it achieves maximum viewing appeal.
6. With a pencil, trace the circumference outline on to the paper. Place a small strip of tape on a vertical side of the base to coincide with the viewing front of the sculpture.

7. Lie the sculpture safely on a foam cushion. Carefully remove the tracing paper by pulling the tape slowly from the sides of the base. Position the traced image on to the bottom of the sculpture, adjusting carefully so that the traced lines coincide with the stone.
8. Note the drilled hole (or holes) and puncture the paper with the point of the pencil at the center of the hole.
9. Reapply the paper to the base and tape in the identical position as before. The puncture marks indicate the position for holes to be drilled which will coincide with those of the stone.
10. Drill hole (or holes) in base. If base is constructed of wood or plastic laminate covered wood, appropriate drill bits must be used. Use a gauge slightly larger than the hole. For a ⅜ gauge, use a 7/16" drill bit. For a stone base, continue to use the carbide masonry bit.
11. Measure and cut the steel rod so that it is slightly shorter than the combined hole in the stone and the matching one in the base. Attach the sculpture to the base and rod to test for accuracy. It should be perfect.
12. Mix the epoxy as directed on the package. Apply to both ends of the steel rod. Place the stone in position of the base. Remove any oozing with mineral spirits. Allow a full sixteen hours for complete curing. The mounting is complete.

In the event that a temporary mounting is preferable, the procedure varies to allow for separation of the sculpture and base.

It has been the practice of some to cement the steel rod to the base and to allow the sculpture to rest on the base, with the rod loose within the stone. This might be acceptable if the completed work is rather heavy, and not easily moved. I would estimate that a weight of seventy-five pounds or more might prove satisfactory. If the stone is light and movable, it would tend to shift during handling and inflict scratches upon the base. In my opinion, it is not good policy.

If a removable mounting is desired, it is best to provide a base which is hollow in construction, or solid with an opening at the bottom of about one inch in width, to accommodate a bolt. The rod is cemented within the sculpture, and allowed to penetrate through the base to the hollow portion or to the one inch opening, and then secured with a washer and bolt. Movement of the work will be held to a minimum. This latter procedure is acceptable, though I still prefer permanent mounting.

Turning pins are available at some of the sculpture supply companies or hardware departments. They consist of a two part telescoping apparatus. One part is cemented to the stone, the other to the base. When joined, a swivel action is produced.

If movement and turning of the work is desirable, I have found it an advantage to obtain a lazy Susan, available at supply outlets. These are available in diameters of up to twelve inches, and no more than 1/4" in thickness, and provide stable turning ability when placed under the base.

There are situations when the base of the sculpture to be mounted is smaller than the Port-Align base. In this situation, the apparatus is not able to rest securely on the stone thereby preventing exact ninety degree drilling.

To correct this situation, use 1/4" plywood to construct a four inch square panel with a one inch opening directly in the center. This "jig" is placed upon the smaller surface to be drilled, the Port-Align upon the jig, and the operation can proceed. Obtain assistance to hold the sculpture upright while you are securing the drill and jig.

Sometimes the bottom of the sculpture is less than one inch, or perhaps is a broad point. It will be necessary to drill the stone using visual skills to produce the desired ninety degree openings. If the result is less than perfect, adjustments can be made. With the drill bit inserted into the hole that was prepared, twist right or left as required to adjust the angle. Test your results carefully. When it is correct, assemble the work and base as before, making sure that the epoxy fills the void in the stone completely. Prop up the completed project with weighted objects to assume the correct vertical position, and allow to cure for sixteen hours. The epoxy will be strong enough to maintain the pressure of support.

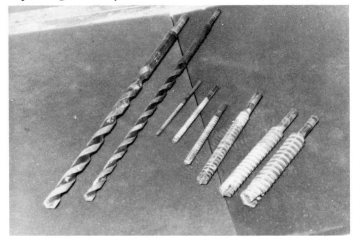

Various diameters of masonry drill bits.

After choosing a base, cut a piece of felt to fit and apply.

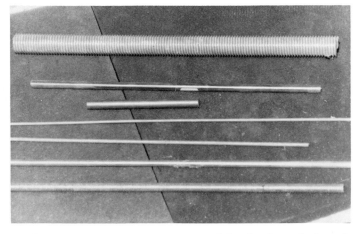

Rods come in various sizes and both threaded and unthreaded. Generally I prefer the threaded rods because they have a greater surface area to which the epoxy can adhere. The thickness of the rod is determined by the bulk of the sculpture to be mounted.

Situate the sculpture on the base in a way that is most appropriate and flattering to it.

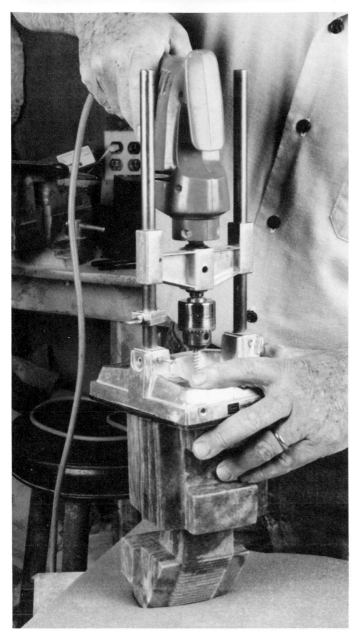

Using the Port-Align and a masonry bit, drill a hole in the base of the sculpture for the connecting rod.

Place the base on a piece of tracing paper and trace its shape.

Cut the tracing pape to fit the base...

and tape it to the top of the base.

Place an extra piece of tape on the base to denote the front.

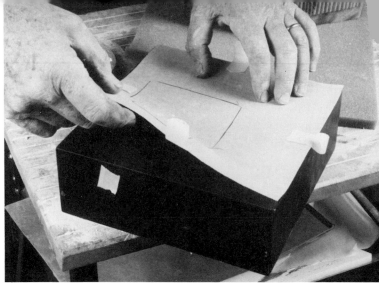

Remove the tracing paper from the base...

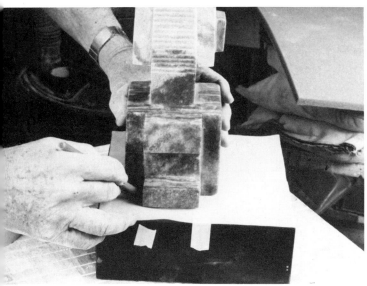

Situate the sculpture on the base in the position you have chosen...

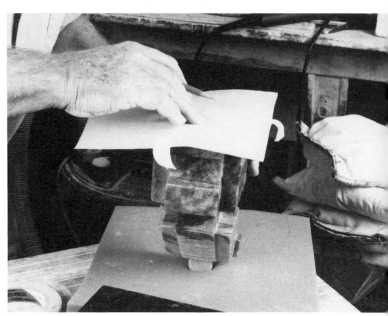

and align it with the bottom of the sculpture.

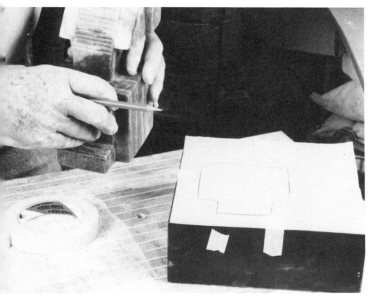

and trace around its base.

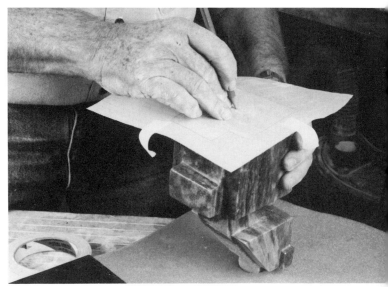

Locate the hole you have drilled, and pierce the paper with a pencil.

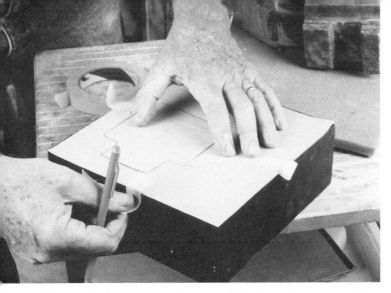

Reattach the paper to the top of the base, being sure that the front edge faces front.

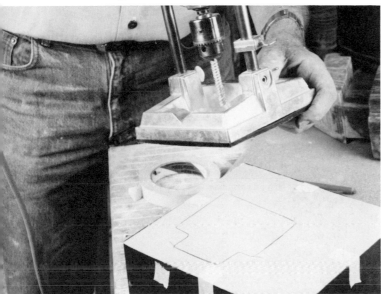

Using the Port-Align line up the drill bit with the hole in the paper.

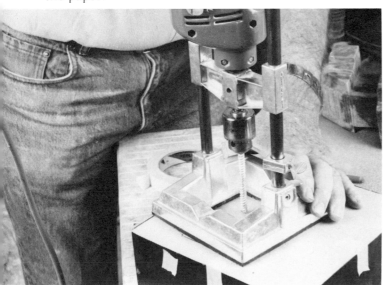

Drill a hole in the base.

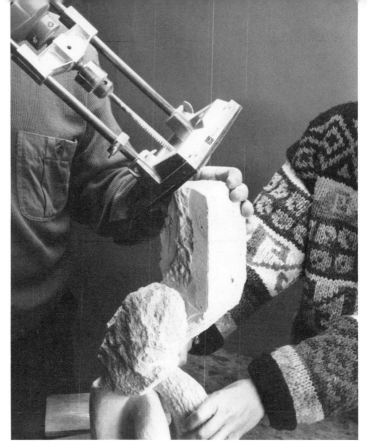

A problem arises when the bottom of the sculpture is to small to accommodate the Port-Align.

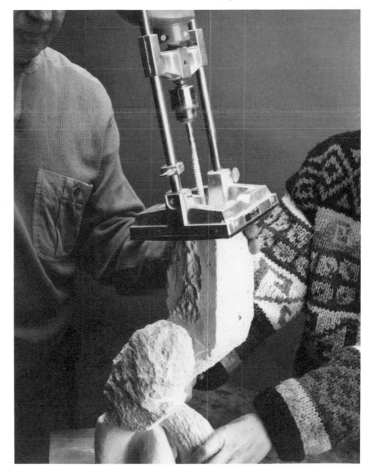

This gives an unstable position from which to drill.

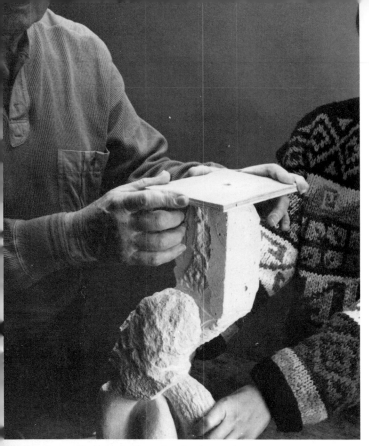

A piece of plywood with a hole in the center will rectify the situation. It needs to be large enough for the base of the Port-Align. Situate it so the hole is over the point where you wish to drill.

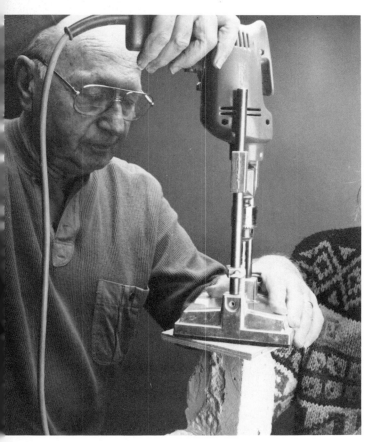

Line up the drill and do the job.

Use a file handle or pencil to gauge the depth of the hole in the base.

Measure the depth.

Follow the same steps to measure the depth of the hole in the sculpture.

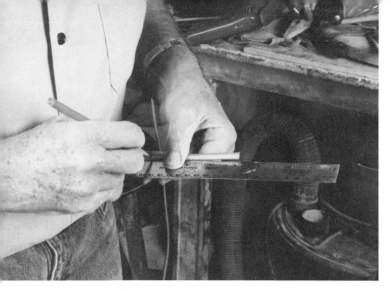

Add the two depths together and mark a piece of threaded steel rod to a length just a slight bit short than the sum.

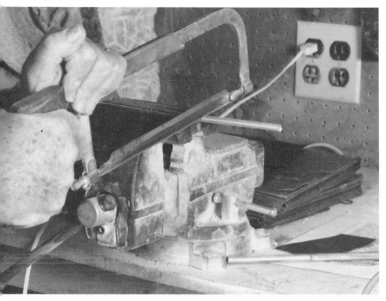

Cut the rod with it held in a bench vise.

Do a test fitting...

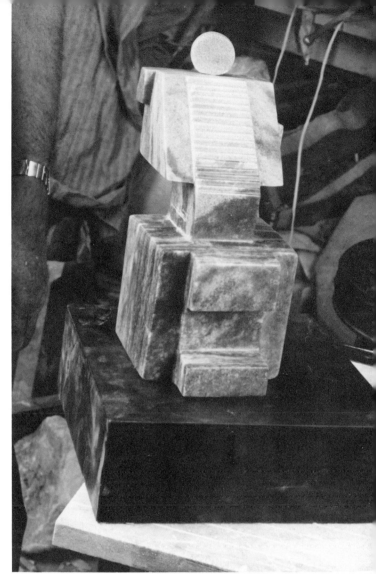

to make sure everything goes together properly.

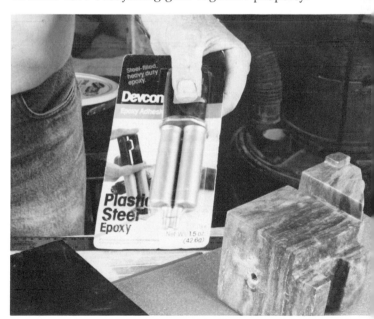

I have found Devcon Plastic Steel Epoxy to be so superior for mounting stone sculpture that I recommend it to you.

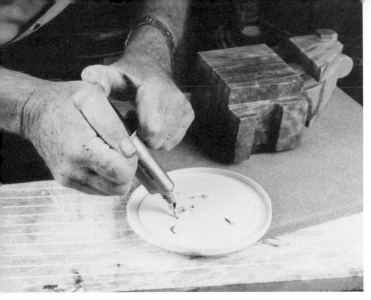

Dispense the amount needed on a lid or other discardable surface.

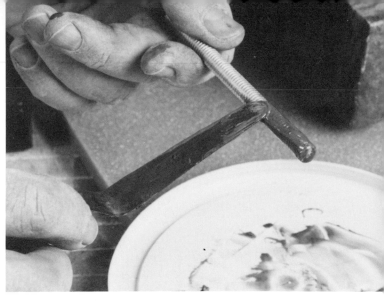

Apply the epoxy to the end of the threaded rod...

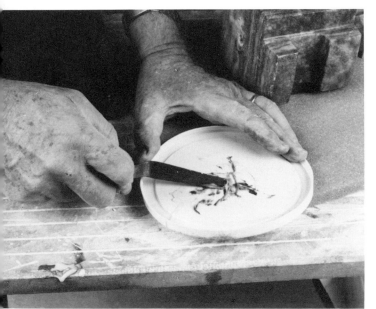

Mix the two parts of the epoxy with a spatula.

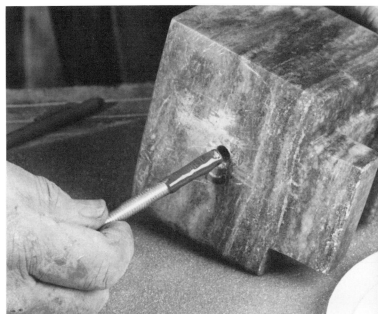

And insert it into the sculpture.

Power Tools and Equipment

The use of power tools and related equipment is appealing to all who use hand techniques. Unfortunately, many of today's artists are concerned with "How quickly can I finish?" disregarding the perception which lies in the fingers. Hand tools have the ability of doing the bidding of the fingers, unlike power instruments which can destroy the character of the stone.

In my opinion, a sculpture that has been totally power carved gives the message that the stone has been slaughtered, and its character destroyed. It is easily recognized as opposed to an impressionable work of hand carving.

It is not that I shun power equipment completely, for I do use it. There is a happy medium, to be sure. In my work, I resort to power for the roughing out of the exterior layers of the stone and for certain refinements. It is a quick means to an end.

I reserve its use for boulders of several hundred pounds, for the hard stones such as marble or granite, and for designated processes that will be described in the subsequent chapters.

In the pages which follow, I have listed and illustrated the various power devices which are available at sculpture supply retailers and hardware outlets. Those of you venturing into this methodology for the first time should choose carefully. Proceed slowly and with caution.

With the exception of the methods using the electric drill for polishing and mounting procedures, I have avoided the discussion of powered machinery in the prior chapters. The intent was to make certain that the student and inexperienced sculptor concentrate on perfecting the technique of hand equipment.

It is easy to be swayed by the glamour of sophisticated power accessories and their potential for speedy production. I will acknowledge the ability to create special effects in carving with these tools. However, the need to perfect the use of the hands with simple tools cannot be over-emphasized.

Do not be deterred. Learn to crawl before you walk. You will appreciate acquiring the ability to decide when to use hand tools, and when to use power. As you become more experienced, it will be your greatest asset.

The initial consideration with power equipment is about ventilation for your work area. The use of power equipment results in large amounts of dust spewed into the air, and adequate protection must be provided. Exhaust fans or other means of dust removal are a necessity. A suitable respirator must be worn to prevent inhalation of hazardous dust particles. If these are not available, power carving must not be attempted.

ELECTRIC DRILL

The electric drill, mentioned in earlier chapters, is the most versatile of all power accessories. A present day household would be handicapped without it and the presence of the drill is as common as the hammer, nails, and screws. The drill enjoys a comparable position when employed in the art of carving stone.

In Chapter V, I discussed the drill for procedures which involved the polishing and mounting of the stone sculpture. It was pointed out that a minimum power requirement of 1800 RPM was necessary to

SILICON CARBIDE - 1/4" Shank

This material, next in hardness to diamonds, works extremely well for grinding very hard stone.

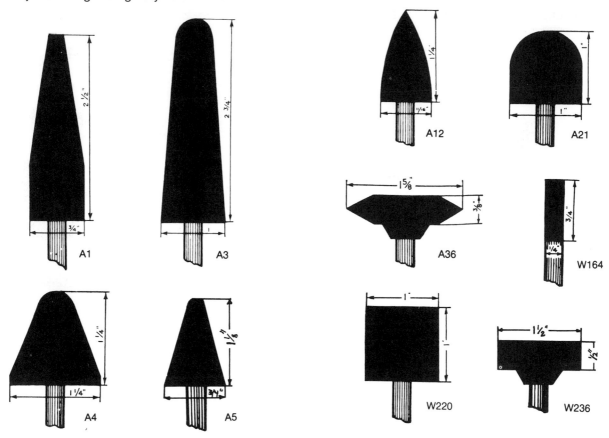

Silicon Carbide grinding bits, courtesy of Sculptor's Supplies Co., 222 East 6th Street, New York, N.Y. 10003.

RUBBER EXPANDING DRUMS - 1/4" Shank

Diameter x Width
3/4" x 1/2"
3/4" x 3/4"
1" x 1"
1" x 2"
1-1/2" x 1-1/2"
2" x 1"
2" x 2"

Rubber expanding sanding drums, courtesy of Sculptor's Supplies Co., 222 East 6th Street, New York, N.Y. 10003.

SANDING BANDS (Silicon Carbide)

Diameter x Width
3/4" x 1/2"
3/4" x 3/4"
1" x 1"
1" x 2"
1-1/2" x 1-1/2"
2" x 1"
2" x 2"

Coarse - Medium - Fine

1/8 HP - FLEXIBLE SHAFT - 2.55 amps

Excellent for fine detail carving, grinding, sanding and polishing stone, wood, metal, etc. Not meant for continuous heavy use.

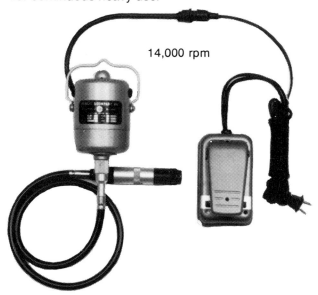

14,000 rpm

1/4 HP - FLEXIBLE SHAFT - 2.6 amps

Exceptionally fine heavy duty machine designed for high-speed carving, grinding, sanding and polishing stone, wood, metal, etc.

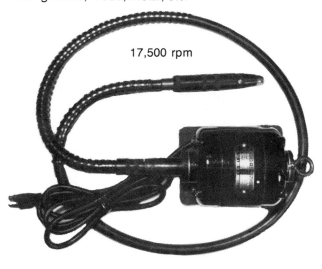

17,500 rpm

RECIPROCAL HANDPIECE - Specially designed for direct attachment to flexible shaft. Selected tools excellent for fine detail carving

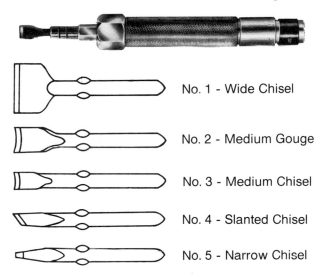

No. 1 - Wide Chisel

No. 2 - Medium Gouge

No. 3 - Medium Chisel

No. 4 - Slanted Chisel

No. 5 - Narrow Chisel

BONDED CARBIDE

The coarse diamond-like particles of tungsten carbide give these tools an excellent cutting edge and long lasting wear . . . Works extremely well on soft and medium hard stone, wood etc.

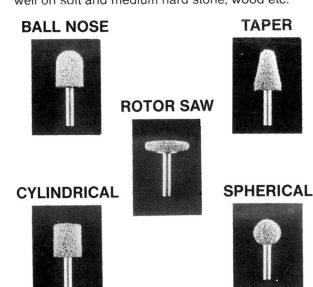

BALL NOSE

TAPER

ROTOR SAW

CYLINDRICAL

SPHERICAL

Flexible shaft machines and attachments, courtesy of Sculptor's Supplies Co., 222 East 6th Street, New York, N.Y. 10003.

SOLID CARBIDE - 1/4" Shank

The ultimate for grinding hard material . . . will out-last steel . . . can be resharpened.

Measurements - Diameter x Length

CYLINDRICAL-END CUT

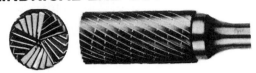

No. C-123	3/8" x 3/4"
No. C-125	1/2" x 1"
No. C-126	5/8" x 1"

FLAME SHAPE

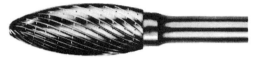

No. C-282	5/16" x 3/4"
No. C-285	1/2" x 1-1/4"
No. C-286	5/8" x 1-7/16"

POINTED TREE SHAPE

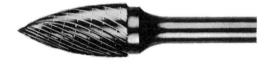

No. C-373	3/8" x 3/4"
No. C-375	1/2" x 1"
No. C-376	5/8" x 1"

BALL SHAPE

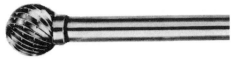

No. C-443	3/8"
No. C-445	1/2"
No. C-446	5/8"

CYLINDRICAL ROUND TOP

No. C-533	3/8" x 3/4"
No. C-535	1/2" x 1"
No. C-536	5/8" x 1"

OLIVE SHAPE

No. C-653	3/8" x 5/8"
No. C-655	1/2" x 7/8"
No. C-656	5/8" x 1"

SOLID CARBIDE - 1/8" Shank

Extremely useful for very fine detail and hard to reach areas.

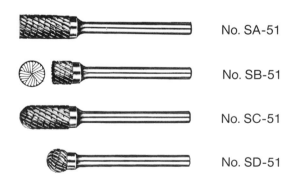

No. SA-51

No. SB-51

No. SC-51

No. SD-51

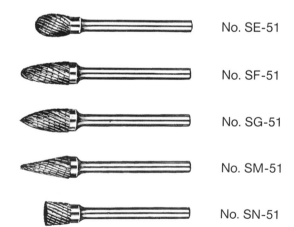

No. SE-51

No. SF-51

No. SG-51

No. SM-51

No. SN-51

Rotary burrs, courtesy of Sculptor's Supplies Co., 222 East 6th Street, New York, N.Y. 10003.

ANGLE GRINDER ACCESSORIES

DIAMOND CUT-OFF WHEELS
Diameters - 5" - 6" - 7" - 9"

1/8" CUT-OFF WHEELS
Available for stone and steel
Diameters - 4-1/2"- 5"- 6"- 7"- 9"

1/4" GRINDING WHEELS
Available for stone and steel
Diameters - 4-1/2"- 5"- 6"- 7"- 9"

SANDING DISCS
Diameters - 4-1/2"-5"-7"-9"
Grits - 24-60-100

FLEXIBLE BACKING PADS
Diameters - 4-1/2"-5"-7"-9"

CUP GRINDING WHEELS
Available for stone and steel
For 4-1/2" - 5" - 7"/9" models

CUP WHEEL GUARDS
For 4-1/2" - 5" - 7"/9" models

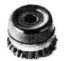

CUP WIRE BRUSHES
For 4-1/2" - 5" - 7"/9" models

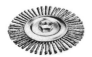

WIRE WHEELS
For 4-1/2" and 5" models

ZEC ABRASIVE SANDING DISCS
Diameters - 4-1/2" and 7"
Grits - 24-50-80-120

ZEC BACKING PADS
Diameters - 4" and 6-1/2"

METABO ANGLE GRINDERS
These excellent machines have an exclusive safety slip clutch which helps prevent overload burnout. The spindle lock feature requires only one wrench. All machines are 115 volts-60 cycles.

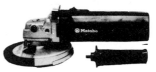

No. AG-550 - 4-1/2" ... Tough 3/4 HP motor maintains high speed even under load.

No-load rpm	-	10,000
Amps	-	5.2
Length	-	11"
Weight	-	4-1/2 lbs.

No. AG-705 - 5" ... This powerful 1 HP motor will stand up to the toughest application.

No-load rpm	-	10,000
Amps	-	6.8
Length	-	11"
Weight	-	5 lbs.

No. EW-9150 - 6" ... Heavy duty 1-1/4 HP motor ... Exclusive electronic automatic speed stabilizer maintains constant speed between no load and full load.

No-load rpm	-	8,500
Amps	-	8.2
Length	-	11"
Weight	-	5-1/4 lbs.

No. W-19230 - 7"/9" Sander/Grinder ... This 2.3 HP motor makes it powerful enough to do most any job.

No-load rpm	-	6,000
Amps	-	15
Length	-	19"
Weight	-	12-1/2 lbs.

Angle grinders and angle grinder accessories, courtesy of Sculptor's Supplies Co., 222 East 6th Street, New York, N.Y. 10003

AIR COMPRESSORS . . .

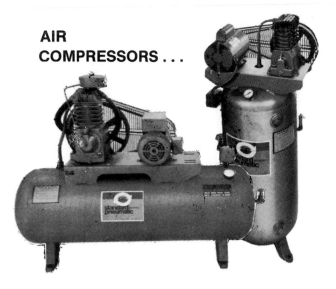

Expertly manufactured with the finest components and materials to build a reliable and dependable compressor that will give many years of trouble free operation.

Portable (2 wheels and handle)
Single Phase - Non-Coded

Model No.	Motor H.P.	Tank Capacity	Tank Style
P20P	2	20 Gal.	Horizontal
P30P	3	20 Gal.	Horizontal

Stationary
Single Phase - ASME Coded

Model No.	Motor H.P.	Tank Capacity	Tank Style
P230V-1	2	30 Gal.	Vertical
P330V-1	3	30 Gal.	Vertical
P360V-1	3	60 Gal.	Vertical
P360H-1	3	60 Gal.	Horizontal
P560V-1	5	60 Gal.	Vertical
P560H-1	5	60 Gal.	Horizontal

PNEUMATIC HAMMERS
- These air hammers give the most efficiency with minimum air consumption. They are the most silent hammers and stand the highest pressure without stopping.

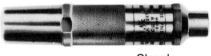

Type	Size	Shank Opening
E	7/16"	5/16"
V	5/8"	1/2"
U	3/4"	1/2"
T	1"	1/2"

PNEUMATIC TOOLS - Carbide Tipped

RIPPERS - 1/2" Shank

Sharpened teeth

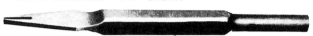

Teeth - 3 - 4 - 5

CAPE CHISELS - 1/2" Shank

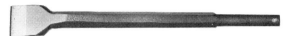

Sizes - 1/4" - 3/8"

CHISELS - 1/2" Shank

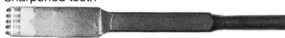

Sizes - 1/8" - 1/4" - 3/8" - 1/2" - 5/8"
3/4" - 1" - 1-1/4" - 1-1/2"

BUSH CHISELS - 1/2" Shank

4 TOOTH

Sizes - 1/2" - 5/8"

9 TOOTH

Sizes - 1/2" - 5/8"

3 ROWS

Sizes - 1/2" - 5/8"

CRISS CROSS

Sizes - 5/8" - 3/4"

Air compressor and pneumatic tools, courtesy of Sculptor's Supplies Co., 222 East 6th Street, New York, N.Y. 10003

Opposite page:
Pneumatic tools and pneumatic die grinders, courtesy of Sculptor's Supplies Co., 222 East 6th Street, New York, N.Y. 10003

PNEUMATIC STEEL TOOLS

STONE CARVING TOOLS

POINT - 1/2″ Shank

No.	Stock		Length
73-D	5/8″	16mm	8-1/2″

CHISELS - 1/2″ Shank

No.	Face		Length
77	5/8″	16mm	8-1/2″
77-B	3/4″	19mm	8-1/2″
77-G	1″	25mm	10-1/2″
77-H	1″	25mm	12-1/2″

RONDELS - 1/2″ Shank

No.	Face		Length
77-AP	5/8″	16mm	8-1/2″
77-BP	3/4″	19mm	8-1/2″
77-GP	1″	25mm	10-1/2″
77-HP	1″	25mm	12-1/2″

PNEUMATIC TOOLS - Steel

RIPPERS - 1/2″ Shank

Teeth - 4- 5 - 6

FROSTING TOOLS - 1/2″ Shank

Teeth - 16 - 24 - 36

BUSH CHISELS - 1/2″ Shank

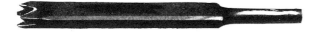

Size	- 1/2″ x 1/2″	Teeth 4 - 9
Size	- 5/8″ x 5/8″	Teeth 4 - 9

CAPE CHISELS - 1/2″ Shank

Sizes - 1/4″ - 3/8″

Tools approx. 8-1/2″ to 9″ long

DRILLS - 1/2″ Shank

Sizes - 5/8″ - 3/4″

TOOTH CHISELS - 1/2″ Shank

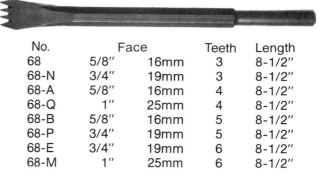

No.	Face		Teeth	Length
68	5/8″	16mm	3	8-1/2″
68-N	3/4″	19mm	3	8-1/2″
68-A	5/8″	16mm	4	8-1/2″
68-Q	1″	25mm	4	8-1/2″
68-B	5/8″	16mm	5	8-1/2″
68-P	3/4″	19mm	5	8-1/2″
68-E	3/4″	19mm	6	8-1/2″
68-M	1″	25mm	6	8-1/2″

WOODCARVING TOOLS

GOUGES - 1/2″ Shank

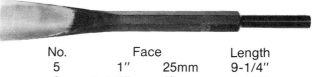

No.	Face		Length
5	1″	25mm	9-1/4″
6	1-1/4″	32mm	9-1/4″
8	3/4″	19mm	9-1/4″
8	1″	25mm	9-1/4″
8	1-1/4″	32mm	9-1/4″

ATLAS COPCO PNEUMATIC DIE GRINDERS -
One of the world's finest high-powered precision air grinders available.

Model No. LSF-16-S300 - 0.34 HP ... Complete with 1/4″ collet and wrenches.

Free speed - 30,000 rpm
Weight - 0.9 lbs.

Accessory : 1/8″ Collet

Model No. LSF-26-S250 - 0.75 HP ... Complete with 1/4″ collet and wrenches.

Free speed - 25,000 rpm
Weight - 1.5 lbs.

ATLAS COPCO PNEUMATIC ANGLE GRINDER - Another high quality ... high powered precision air grinder.

Model No. LSV-26-S150 - 0.7 HP ... Complete with 1/4″ collet and wrenches.

Free speed - 15,000 rpm
Weight - 2.4 lbs.

qualify as a proper stone carving accessory. That means using an industrial quality rather than the simple household caliber tool. The additional expense to secure fine equipment will be minimized when durability and results are considered.

I have owned three drills for a number of years which have proven to be quite satisfactory in all respects. These are the Makita, model 6404, The Black & Decker Professional model 1166, and a Makita Hammer Drill, model 1030. Additional manufacturers of fine products of this type are Bosch, Milwaukee, and Hitachi.

I have found the electric drill most applicable for polishing and drilling of holes. It can be advantageous when used with rotary burrs and rubber sanding drums .The silicon carbide, and solid carbide rotary burrs illustrated, when fitted to the electric drill, can be used for rough removal of surface and interior stone. The use of the drill for this purpose is somewhat cumbersome and my preference for this procedure is to use the flexible shaft machine.

On the other hand, rubber sanding drums fitted with silicon carbide sleeves, are a natural adaptation for the drill. These can perform superbly when used for the reaming out of openings and smoothing of curves.

Take note that I have specified the use of silicon carbide sleeves for this work. All hardware departments supply sleeves intended for wood sanding. These are composed of aluminum oxide, and will not cut stone at all. Be certain that you obtain the proper material available through sculpture supply outlets.

FLEXIBLE SHAFT MACHINE

The flexible shaft machine is a favorite of mine. When fitted with the assortment of carbide burrs, it can provide exceptionally fine detail work, and yet actually be an extension of the sensitivity that you possess in your hands and fingers. Though it has the flexibility that an electric drill cannot offer, it should not be used for drum sanding, polishing, or other heavy duty stone removal tasks. Fitted with a reciprocal hand-piece and appropriate chisels, it can provide superlative and exacting detail work when it is needed.

The most popular machine of this type is one manufactured by the Foredom Company, and I have used the product for years with complete satisfaction.

I have made it a particular point to illustrate the solid carbide burrs and to ignore the mention of steel burrs which are available for the same purpose. The carbide burrs are more expensive. However, the carbide variety will cut better, and will remain sharp longer.

Furthermore, they can be re-sharpened when it is required, whereas the ordinary steel variety cannot. They are a prerequisite for limestone, marble, and the hard stones. Without a hesitation, the investment is warranted.

Assorted drills and port-align.

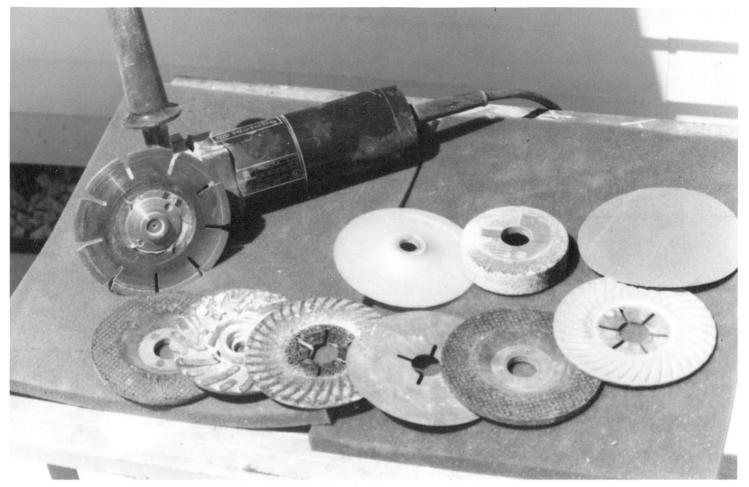

Angle grinder, diamond cut-off wheel with assorted abrasives, by author.

ANGLE GRINDER

The angle grinder is a potent piece of equipment, and requires the observance of extreme safety precautions during use. The availability of cut-off wheels, grinding wheels, and sanding discs creates a wide range of versatility for advanced procedures.

Among the manufacturers that produce this product, there is one that I consider excellent. The Metabo Company, a West German concern, produces an outstanding product and offers a wide range of accessories. I have been using this machine for many years with outstanding results.

The accessories that I prefer are the diamond cut-off wheel, the Zec backing pads, and the Zec abrasive sanding discs. The ⅛" fibre cut-off wheel, and ¼" grinding wheel deteriorate rapidly and have proven to be unsatisfactory for my use.

Among the useful applications are the bulk removal of stone during "roughing-out", surface removal of stone, creating geometric designs, and removal of edges of machine-cut stone blocks. These will be discussed as advanced techniques within the subsequent chapter.

AIR COMPRESSOR

The air compressor is a source of power which drives the pneumatic chisels with reciprocal action. The chisels are placed within the pneumatic hammer, and are capable of delivering hundreds of blows per minute. This is the only advantage of the use of an air compressor and pneumatic tools.

Some years ago, I attended a demonstration and workshop presented by an artist recognized internationally as a leading contemporary figure. I have never forgotten his statement that after some thirty years of carving stone, he had just recently used the air compressor and pneumatic tools. His attitude was as indifferent toward power as you must find mine to be.

Power tools accomplish virtually the same results as hand tools do. The advantage is speed. The roughing-out procedure can be rapidly completed. Surfaces can be reduced without delay, and with little effort. However, there are "give-backs."

1. They do not replace the use of hand tools and cannot transmit sensitivity and emotion to the subject as hands and fingers do.

2. They are far more costly than hand tools.

3. They are noisy and can damage the human hearing abilities.

4. The incessant pounding can cause damage to the circulatory system.

5. Clouds of dust are emitted requiring the use of a respirator and proper ventilation.

6. The blows delivered by pneumatic and power tools can fracture the stone that is being carved. "Stun marks" may appear beneath the surface.

There is a "happy medium" to be reached. As innovative human beings we can use common sense, for it is as incorrect to use only power tools as it is to use only hand tools. Experienced stone sculptors use both methods to accomplish their goals.

Angle grinders, compressors with pneumatic tools, and similar power machinery are particularly suitable for hard stones in the marble category and unnecessary for soft stones of the alabaster type. Adaptations can be made for medium hard stones of the limestone variety.

You are the determining factor! Involvement in a concentrated work effort will assist in determining what is best for you and your particular style.

Chapter VIII

Advanced Techniques

Advanced techniques are a command of the intellect dictated by the advance of acquired knowledge and skill. However, the artist's upward mobility is dependent upon the intuitive and inquisitive nature of the individual. I believe that advancement is an individual distinction, the challenge of achievement, and the exhilaration of success.

If we were to consider the above in their proper perspective, it is safe to assume that there are no predetermined "advanced techniques." Rather, they are the innovations of the individual. Each artist determines his or her own "advanced techniques" which emerges from a combination of training, creativity, and physical dexterity.

Does this mean that I intend to permit you to flounder in deciding which procedures to use? Not at all! What I shall do is to describe the methods that I employ in my work in the areas that I consider to be advanced. This should encourage you to make your own decisions in the areas that you wish to enter, thereby placing emphasis upon the original concept of this treatise, "Individual Creativity." Whatever the cost in frustration, we must avoid "La Manno Muerte."

SPACES AND OPENINGS

It has seemed to me that the construction of spaces and openings in stone sculptures are inherent ambitions of fledgling sculptors. Virtually without exception, everyone wants to create holes in their beautiful stones before they have mastered the rudiments of carving, without consideration for balance, form, or the concept they are trying to convey. A curious analogy can be drawn between the newspaper editor using pictures to avoid the use of text, and the sculptor who creates holes to avoid having to carve stone.

I must caution you that creating space or severe undercuts in the soft stones can be disastrous. Intrusions of this nature in material of the alabaster family weaken the stone and can result in fractures. There is nothing more agonizing for an artist than having a carving split or break due to improper handling of the medium. Even after completion, a weakened stone might break due to stress or undue pressure. I would recommend that you retain such maneuvers for the harder stones such as limestone and marble.

There is a proper time and place for the use of openings in the stone. Consider the form and balance of the projected final appearance. Does the opening relate one dimension to another? Does it indicate a flow and movement from one side to another? Does it create a feeling of being graceful and airy? Does it relate to the message you wish to instill?

I should like to call your attention to several examples of my work to illustrate the use of space and openings. Examine the sculptures "Windsong" (p. 112), "Opus" (p. 113), "Omni III" (p. 114), and "Portrait of the Holocaust" (p. 118).

"Windsong" illustrates the relationship of front to back through the medium of space. "Omni III" depicts the constructivist use of openings as a three dimensional design relating to an architectural concept, and the tortured face of "Portrait of the Holocaust" is imprisoned by the band of stone. "Opus" typifies musical movement.

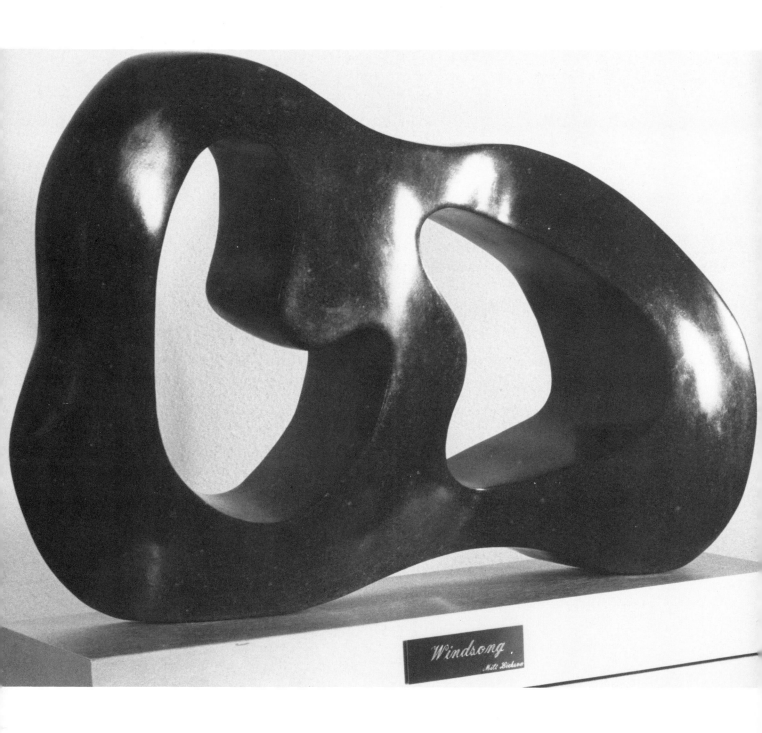

"Windsong," by author, Serpentine 13" H x 17" W x 4" D
1986. Photo by author.

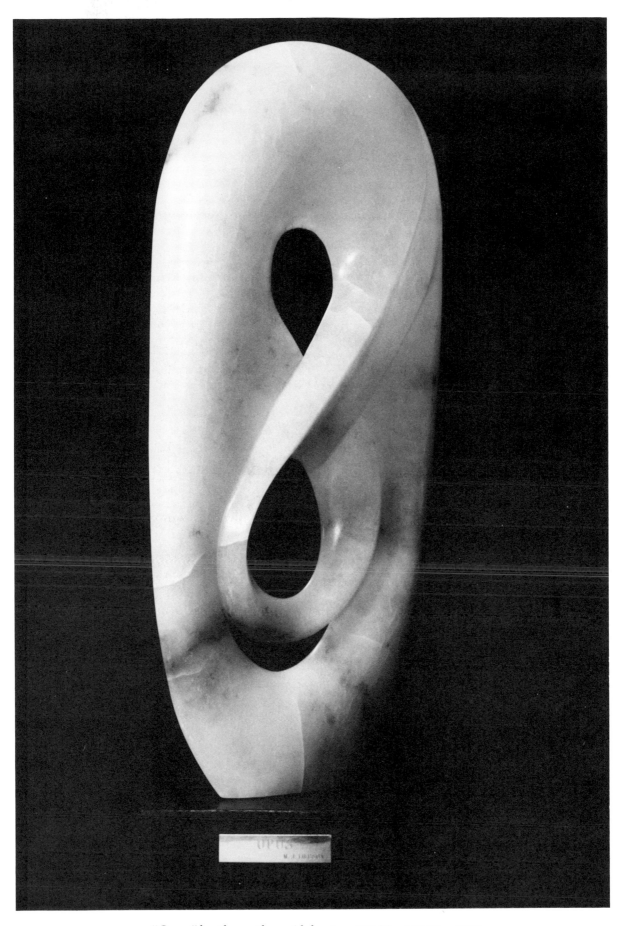

"Opus" by the author, Alabaster, 30" H x 12" W x 5" D,
1985. Photo by Janet Gmall. Private Collection.

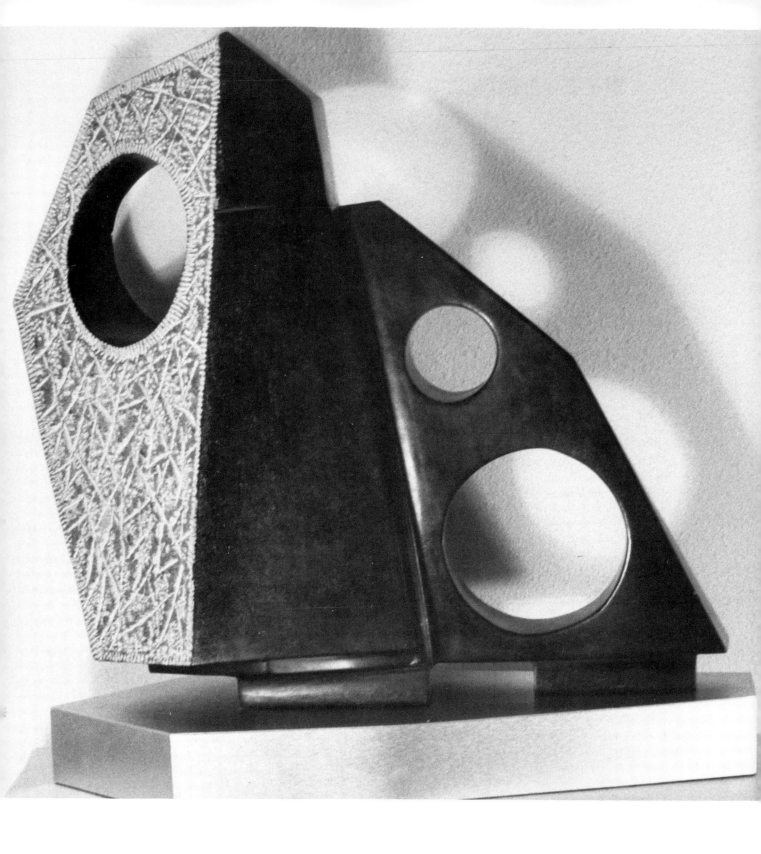

"Omni III," by the author, Serpentine, 16" high x 17" wide x 7" deep, 1987. Photo by the author.

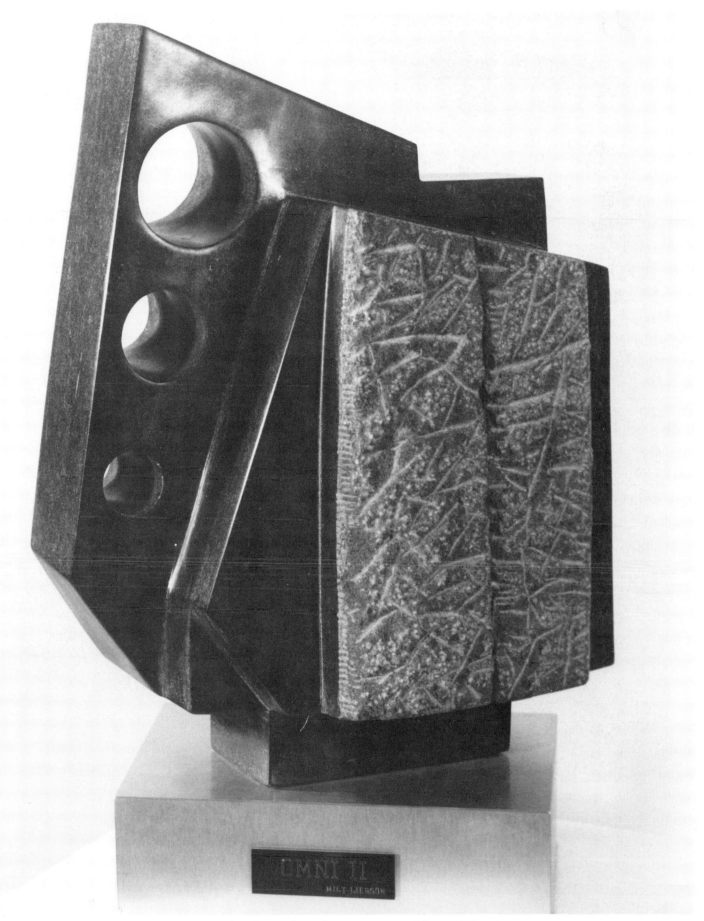

"Omni II," by the author, Serpentine, 24" H x 16" W x 7"
D. 1986, Photo by author, Private Collection.

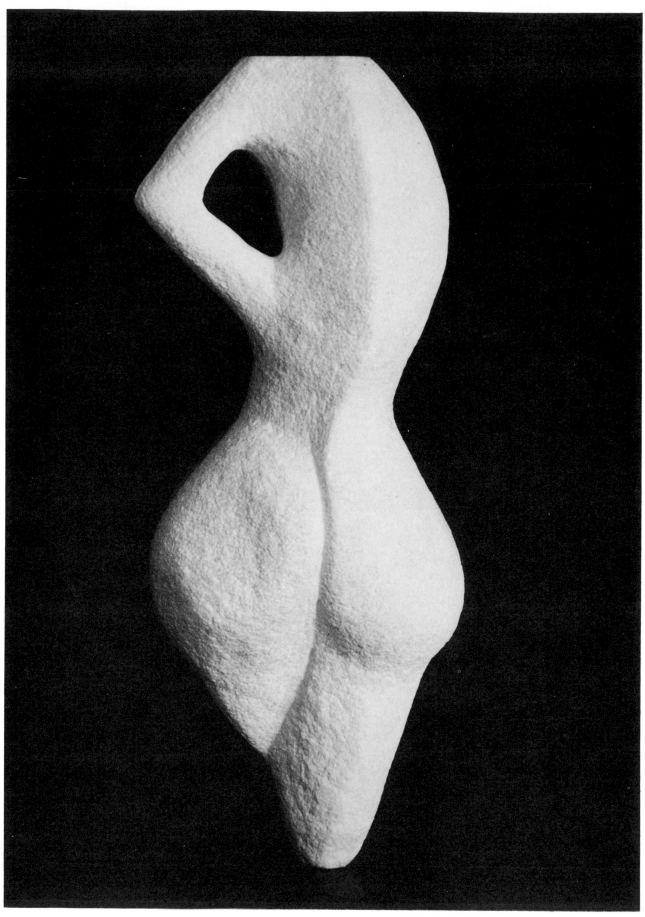

"Genesis," by the author, marble, 28" high x 8" wide x 6"
deep. Photo by the author. Private collection.

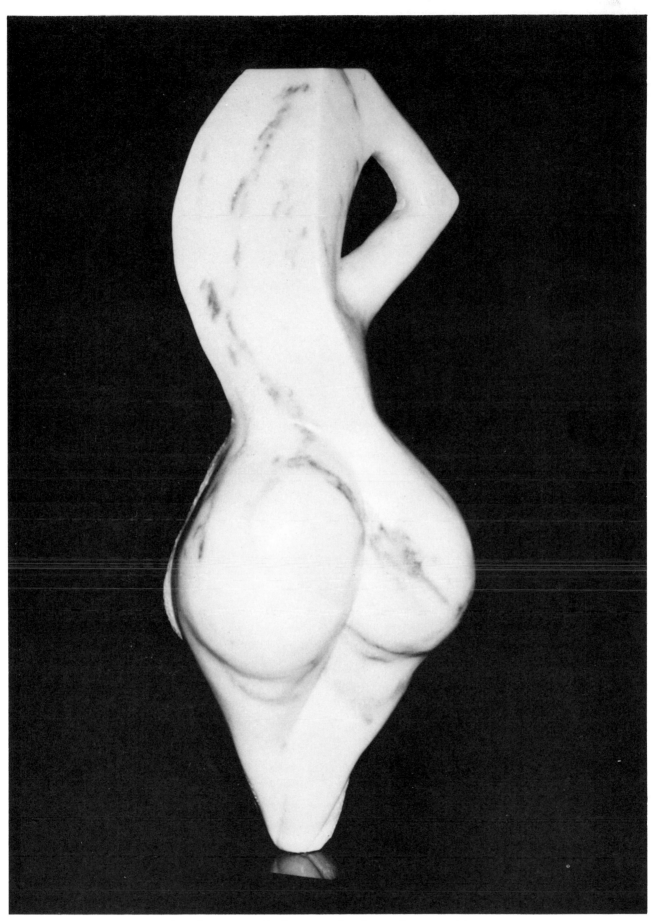

Another view of "Genesis," by the author, marble, 28"
high x 8" wide x 6" deep.

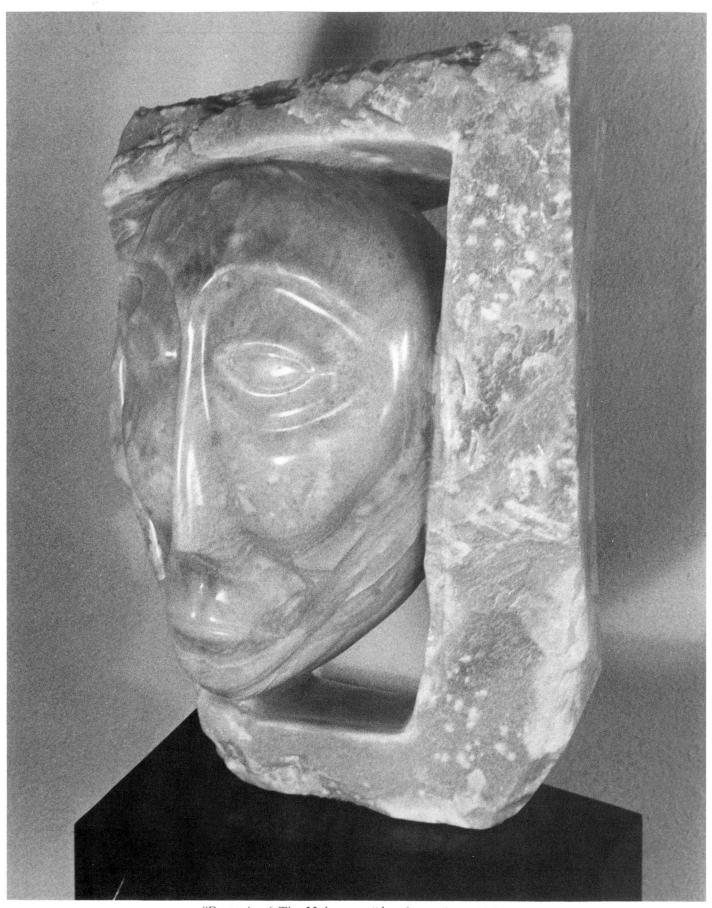

"Portrait of The Holocaust," by the author, Alabaster, 20" H x 10" W x 5" D, 1988. Photo by the author. Private Collection.

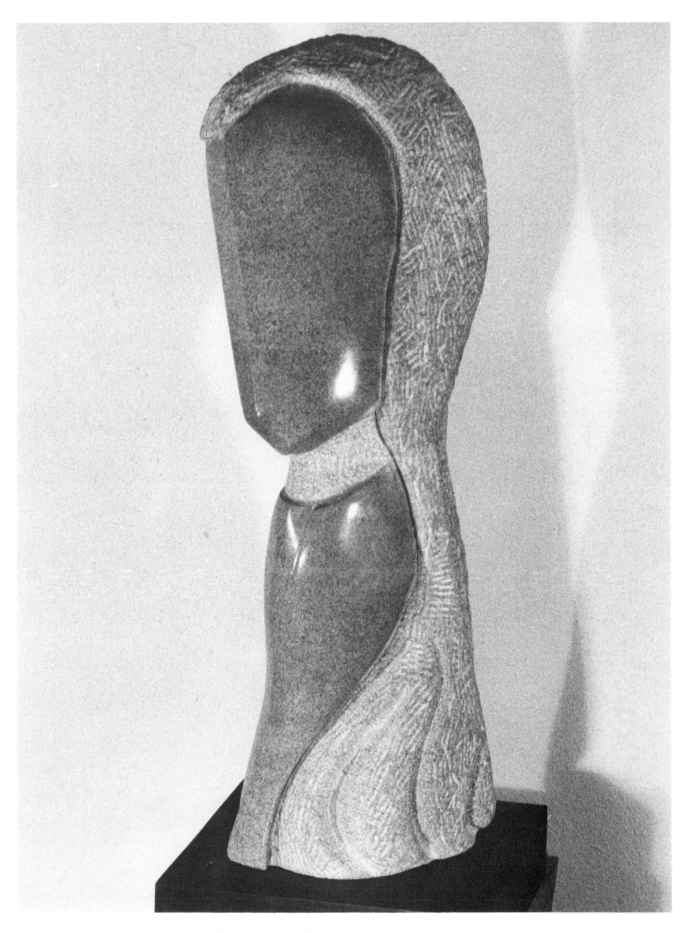

"Phaedra," by the author, Limestone, 27" H x 8" W x 7"
D, 1989. Photo by author.

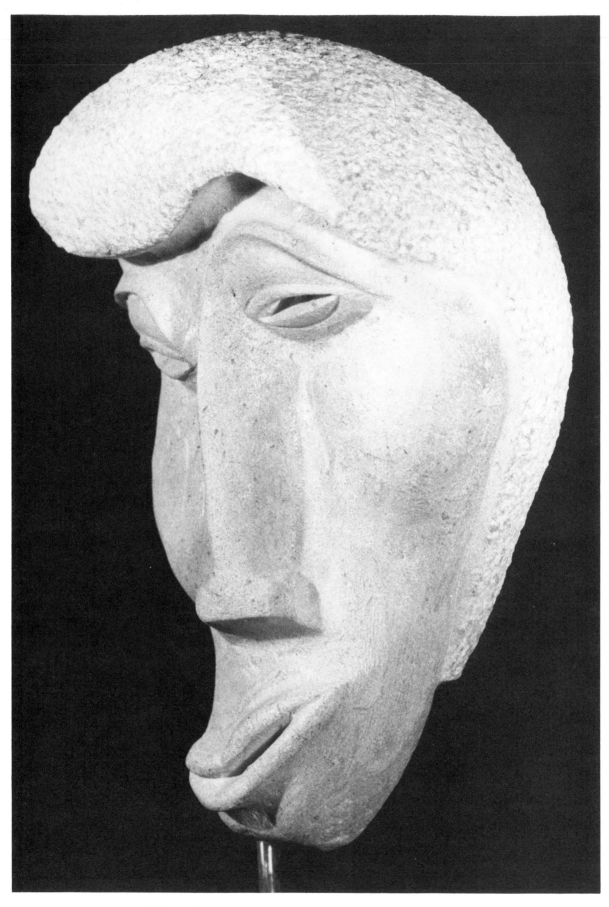

"Mme. Picasso's Mate" by Author Limestone 15" H x 8"
W x 6" D 1988, Photo by Author, Courtesy De Lann
Gallery, Plainsboro, N.J.

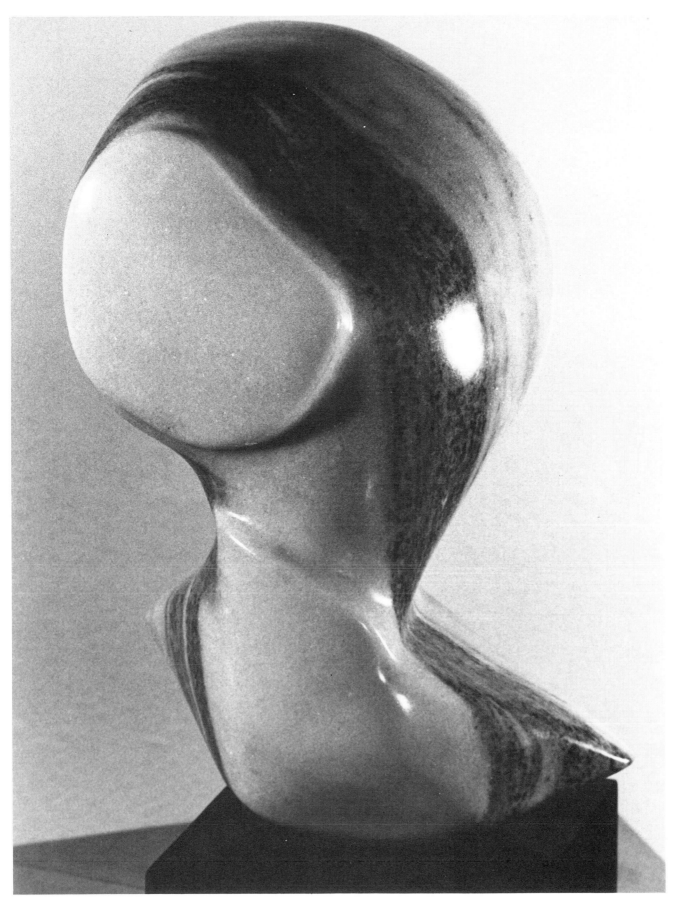

"Modest Madonna," by the author, Vermont Marble,
12" H x 7" W x 5" D Photo by author 1985, Courtesy De
Lann Gallery, Plainsboro, N.J.

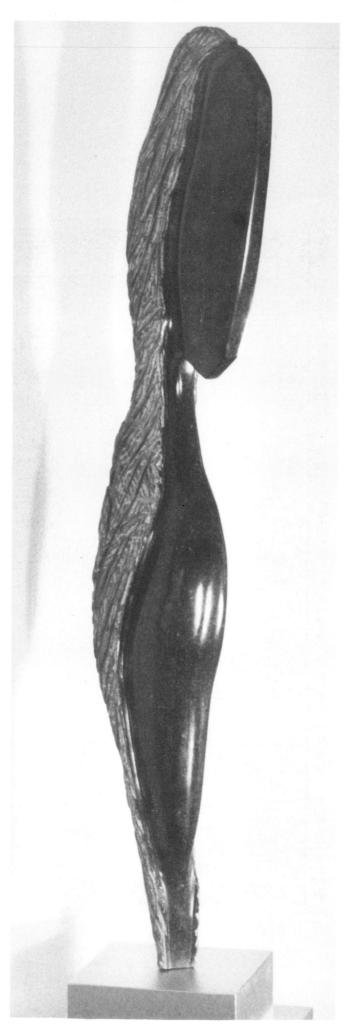

"Nicole," by the author, Serpentine, 33" H x 4" W x 6" D
1990, Photo by author, Private Collection.

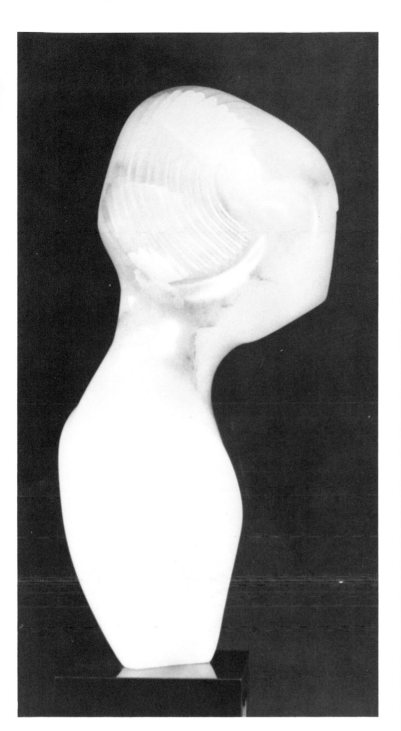

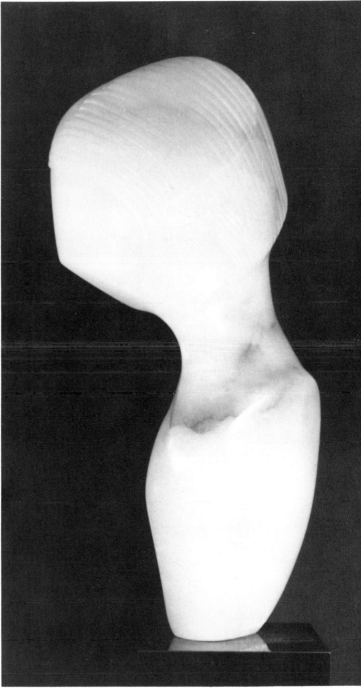

"Monique," by the author, Alabaster, 28" H x 8" W x 6"
D, Photo by author 1986, Private Collection.

The installation of openings in the stone is not a difficult procedure. The tools that I use are:

1. Electric drill
2. Carbide masonry bits, assorted sizes and lengths
3. Drum sanders, assorted sizes, carbide sleeves
4. Stone chisels and hammer
5. Rifflers and rasps

Decide where the opening is to be located on each of the sides involved, where does it start and end. Determine the depth of the projected opening and if needed, reduce the space from each side using the point chisel. Select a masonry bit that will be long enough to penetrate from one side to the other. With the drill and bit attachment, drill a hole through the center of the projected opening. Increase the size of the opening using the point chisel to remove stone. Round rasps and rifflers are excellent for enlarging, smoothing, and shaping the opening.

If a fairly large area is to be opened, drill a series of holes about ¼ to ½ inch apart conforming to the shape of the planned space. These should be no less than 1-2 inches from the outer dimension of the projected opening. The stone to be eliminated can now be broken down and removed by using the point chisel. It may take extended time and persistent effort to remove all of the stone. Do not become discouraged. When you have finished, the circumference of the opening should have a scalloped appearance. The jagged edges can easily be removed and shaped with the use of the point chisel, rasps, and rifflers. Final completion of the form lends itself to the use of the electric drill fitted with the appropriate size drum sander and carbide sleeve, and the flexible shaft machine with carbide burrs. Dynamic shapes and curves can be produced by tilting the drums or burrs as they grind away the surplus stone. Rifflers and rasps refine the ground surfaces prior to final finishing with the carbide papers and buffer.

Refer to the photographs of "Windsong" (p. 112), "Opus" (p. 113), and "Omni III" (p. 114).

When you've decided where you want an opening in your work, use a round form and a crayon to draw the shape.

Use a masonry bit to drill a series of holes around the shape you have defined.

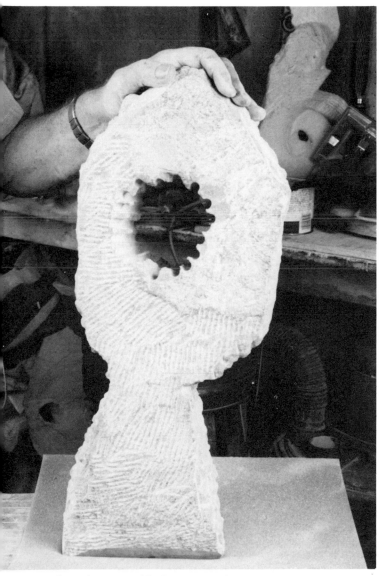

When the ring of holes is complete, it is relatively easy to carve through to the other side.

TEXTURE

Rough hewn surfaces can be retained or created to produce dynamic effects and to highlight areas of work in the visual arts. It is a product of the creative process and the intuitive imagination of the artist.

Texture can represent the natural surface of the stone, architectural design, hair, jewelry, and facial effects, to name just a few.

The natural surface of the stone retains an inherent quality of texture. Plan for the inclusion of the area as a natural texture prior to final carving and finishing. Examine the area carefully to make certain that the stone is not fractured or pitted with point gouges and "stun marks".

In "Portrait of the Holocaust" (p. 118) I had planned to have the victim captured within a prison of stone. After carving the head and face, I became aware that the natural texture of the surrounding stone gave impetus to the sensation of impending doom that I was seeking. The material had a natural pink color with darker reddish veining which produced a perception of bleeding. As the concept developed, I was overcome with a feeling of exhilaration. I had succeeded! The sculpture was alive...it was real...never to be forgotten!

I was transfixed by the wave of emotion that engulfed me. This was not the time for a lunch break. The textured surface was sanded very lightly with 400 and 600 carbide paper, buffed, and polished with wax.

The "portrait" was extremely successful in its impressions upon the public. I shall never forget a viewer who was moved to tears by its impact. It was purchased by a collector and remains part of their private estate.

"Omni III" (p. 114) presents an interesting geometric use of texture which, in this case, lends itself to the constructivist tone of the sculpture. The tools used to produce this effect were:

1. Single Point chisel
2. Claw chisels, ½" and ¾"
3. Bush or Texture Chisel ⅝"
4. Hammer

The material used for this sculpture is Virginia serpentine. In the raw state, the stone is a dark grey and deepens to a grey black after polishing. This affords a striking contrast in color, style, and texture.

I have found it best to polish the smooth areas first and then to establish the textured portion. If

the procedure was reversed, and the polishing completed after the texture, there would be a tendency to contaminate the texture with the darkening process. Adjustments would then have to be made to renew the textured portion.

Initially, establish a pattern of diagonal "crisscross" grooves with the point chisel. From the photograph, you will note that these cuts are well beneath the surface and not merely scratches. The point grooves are in a random pattern, with the intent to create an attractive geometric concept. The grooves created should not extend further than ¼" to the edge of the working area. Be careful that the point grooves do not extend over the edge of the area that you have considered. Finally, a border pattern is created with a claw.

At this time, I shall introduce you to additional tools for your arsenal. I am referring to the frosting tool, the bush chisel, and bush hammer.

These instruments are without parallel for the work that has to be done. As illustrated, the square heads contain many sharp teeth which produce a variety of patterns depending upon the number and spacing of the teeth.

My preference in this instance is the ⅝" x ⅝" bush chisel. The area involved is fairly small, and I have found that it is easier and more accurate to use the chisel rather than the bush hammer to designate areas. The bush hammer is useful for large monumental structures, and even then, I will revert to the chisel when working close to borders.

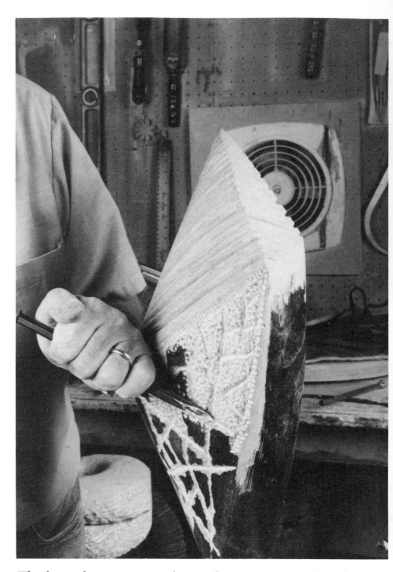

The lines that crisscross this surface were created with the point.

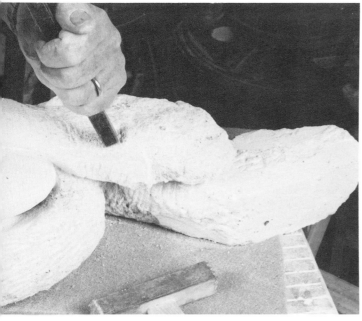

The hole can then be refined with hand tools to the surface you desire.

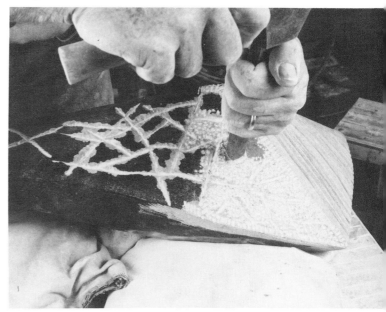

To create the texture between the lines I use a bush chisel. Holding it loosely, I hit it rapidly with the hammer, moving it across the surface as I go.

FROSTING TOOL

No.	Size	Teeth
510	3/8" x 3/8"	16

BUSH CHISELS

No.	Size	Teeth
511	1/2" x 1/2"	9
512	5/8" x 5/8"	9
513	3/4" x 3/4"	9

BUSH HAMMERS

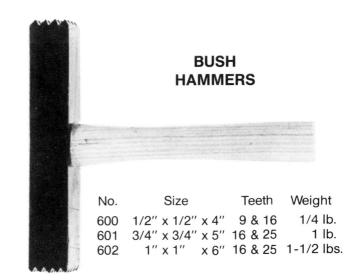

No.	Size	Teeth	Weight
600	1/2" x 1/2" x 4"	9 & 16	1/4 lb.
601	3/4" x 3/4" x 5"	16 & 25	1 lb.
602	1" x 1" x 6"	16 & 25	1-1/2 lbs.

BUSH HAMMERS REMOVABLE HEADS

TEETH

ROWS

Hammer No.	Head Size	Body Length	Weight With 2 Heads	Head No.	Heads Available	
					Teeth	Rows
61	3/4" x 3/4"	5-3/4"		79	9,16,25,36	-
61A	1" x 1"	6"	1-1/4 lbs.	82	9,16,25,36,49	-
61B	1-1/8" x 1-1/8"	6-1/4"	1-3/4 lbs.	85	9,16,25,36,49,64	5,6,7
61C	1-1/4" x 1-1/4"	6-1/4"	2-1/4 lbs.	88	9,16,25,36,49,64	4,6,8

PICK AND BUSH HAMMERS

No.	Size	Teeth	Weight
700	1/2" x 1/2" x 4"	9	1/4 lb.
701	3/4" x 3/4" x 5"	9	1 lb.

Sculptor's Supplies Co., 222 East 6th Street, New York City, N.Y. 10003.

Hold the chisel loosely in the palm in a manner similar to other chisels. Looseness is necessary in order that the chisel bounce when struck with the hammer. Apply blows with the hammer to the head of the chisel rapidly, as the chisel is moved across the area, concentrating on the random shaped boxes created by the point. If the chisel is held too tightly, rapid movement across the surface will be inhibited, and an imbalance will be created in the texture. Proceed back and forth, upward and downward over the surface until the texture produced is to your satisfaction. You will recognize the point of completion. Finally, with the use of a claw chisel, create a border about the area by chiseling inward from the edge for about out ¼ inch. The depth of the clawed border should be about the same as with the point cuts. Touch up areas required with the bush chisel, and the work is completed. Brush away the debris carefully and completely.

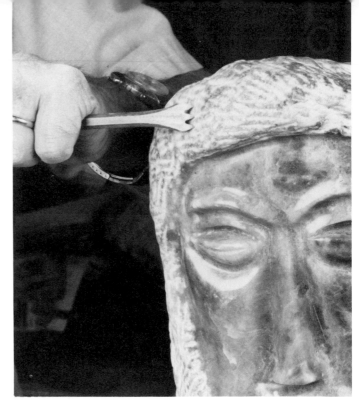

The claw is also useful for creating the texture of hair.

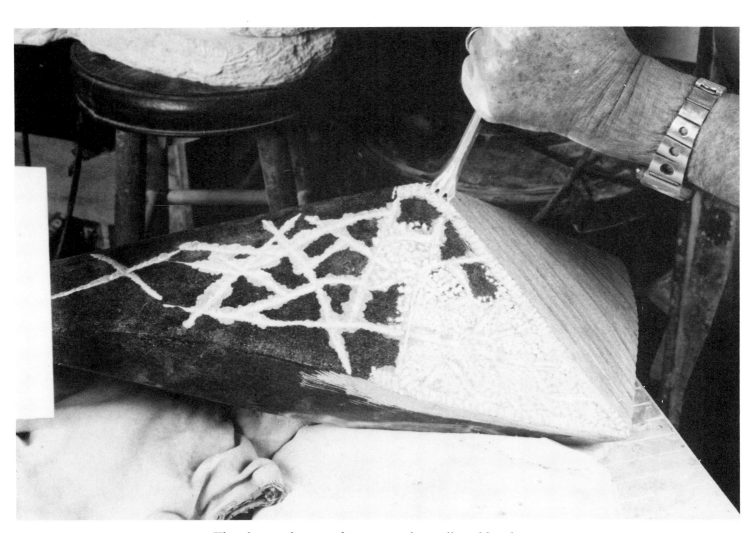

The claw is then used to create the scalloped border.

128

"Genesis (p. 116 & 117) offers an example of the relationship of polished and textured surface within a single sculpture. The work portrays the creation of two forms from one being. In order to separate the characteristics of the two, one side of the torso was polished to a high gloss while the other was textured by using the number 511 and 512 bush chisels, a number 510 frosting tool, and a two pound hammer.

The technique involving the use of the bush chisels is similar to that described in the carving of Omni III. The marble used in the carving of Genesis is about twice as hard as the serpentine of Omni III and you will find it more resistant to the formation of a textured surface. Repeated sharp blows upon the hard, brittle medium will readily produce a desired effect. The initial step is to produce a basic course texture with the bush chisels carefully avoiding edges and grooves which might chip or fracture due to heavy pounding. The frosting tool produces the final fine texture throughout. The small size and tiny teeth of the tool will facilitate accurate texturing of edges and grooves.

The carving of hair is probably the most often used of textures. As examples of the various concepts, I have chosen "Phaedra" (p. 119), "Mme. Picasso's Mate" (p. 120), "Nicole" (p. 122), and "Monique" (p. 123).

In addition to the carving of the hair, "Phaedra" displays an ornamental neck band that transverses the area and disappears under the flowing tresses which cover the entire back of the sculpture.

The hair was created with the use of a sharp four point claw chisel. If the chisel is dull, the teeth will not penetrate to produce the desired effect of strands. Chisel in all directions to simulate a flowing movement with concentration on an overall vertical direction. The depth of the cuts, which relate to the strands of hair, is an individual choice. The artist alone must make this decision.

The band was installed with the use of a ⅜" x ⅜" frosting tool. This instrument is similar to the bush chisel except that the head is smaller and has sixteen tiny teeth which produce a delicate fine texture. It would be improper to use a bush hammer in this situation. The frosting tool is excellent for adhering to borders in a rather small, tightly controlled area. The technique is the same as with the bush chisel and hammer. Hold the tool lightly. Move it rapidly back and forth as you repeatedly and gently pound with the hammer. Brush the debris away continually in order that you can determine the progress and completion of the task.

"Mme. Picasso's Mate," displays a hair texture which is typical of that installed by a bush chisel. A bush hammer may be used on this larger surface, but my choice is the chisel. I do not wish to give the impression that I do not own a bush hammer. In fact, I own two, but seldom use them. I prefer the control afforded by the chisel.

In order to obtain the proper effect of tightly curled hair, I use two bush chisels, as seen in this portrait. The ¾" x ¾" chisel produces deeper and heavier textures in contrast with the smaller sizes of the ⅝" x ⅝" chisel. Both are used to produce a pleasing effect. As I have said in prior discussions, the use is at the discretion of the artist.

The rough skin tone of this portrait was achieved by refining the stone with rifflers and files until I was satisfied with the results. In this case, the stone was not polished with carbide papers or waxed. Limestone is a stone which lends itself to finishing without the need for polishing. Combining the rough hewn with a polished finish in a single sculpture can produce dramatic effects. Consider "Phaedra" and notice the contrast between the skin tones and the hair.

"Nicole" presents a dynamic portrayal of contrast in color between polished and unpolished surface. The hair in this instance flows downward with deep grooves and swirls accentuating the contrast.

Initially, the 4 point chisel was used to create the texture representing hair. Riffler rasps, numbers 164 and 165, were used to deepen the grooves in order to accentuate the flow of the tresses. Finally, a flexible shaft machine, fitted with carbide burrs, numbers C-282, and SM-51 added the finishing touches and highlights. The C-282 burr adapts easily for the carving of deep curves and curls along the flow of the hair.

The use of a claw chisel in producing texture includes the crushing of crystals as it creates the desired texture. This may be desirable as a means of contrast with the darker stone. In this situation, the white markings typical of crushed crystals were removed with riffler rasps and files. Curved rifflers such as numbers 161, and 167, are excellent for that purpose.

"Monique," required a variation in the approach. The work was commissioned by a client who requested a modern subject with an "art deco" motif. After preliminary sketches were accepted, I decided to add an air of a coquette to the lady. The hair was to be a critical decision. In order to qualify as modern "art deco" a deviation from the norm was needed. It was my wife, Lila, who suggested and sketched a French style hair-do which produced

the name "Monique." All the variables were falling into place.

The outline of the hair was carved, draping over the eye on one side of the face, and swinging around the eye on the other side. The hair was indeed to be the focal point!

The portion representing hair was refined and polished to a high gloss. A center part was created and concentric lines were drawn about ⅜" apart adhering to the outline of the draping of the hair, leading to the center part. The flexible shaft machine, fitted with a fine point burr, was used to incise the lines to a depth of about 3/16 of an inch. Riffler rasps similar to number 165 were employed to deepen and grade the spaces which produced the effect I was seeking. The hair section was polished to a bright shine with carbide papers, buffer and polishing block, and wax. Care must be taken in this type of situation to maintain the positive and negative forms of the newly created texture. Rubbing with carbide paper can quickly reduce our diligent efforts. In order to polish the negative areas of the concentric rings which represent the hair, wrap the carbide paper around a thin wooden modeling tool and rub carefully. Follow the lines, one after another, until all are polished. Time should not be the concern. The effort produces a beautiful sculpture.

The clients were overjoyed, and "Monique" is part of their private collection to this day.

CARVING HEADS AND FACES

"How do I carve a head and face?" is probably the most common question asked by novice students bent upon producing a masterpiece during their early stages of training. The question is not illogical, for we all perceive the face as a means of human representation. The intent to proceed toward that goal without acquiring the proper fundamentals is indeed illogical.

Michelangelo once said, "You must carve a thousand faces in order to carve one good face." This is one area where there is no alternative for apprenticeship. Memorizing formulas for facial proportions and the series of steps in the procedure will not necessarily produce quality results. All faces are different and the procedures for creating these differences vary with each artist and each individual face.

The roots of creativity, which are embedded within the intellect of the artist, must be activated. The creation of the human image involves emotional exploration of the imagination. For most of us, there is a long and frustrating process to be perfected before good quality faces can be achieved.

"Marina" (p. 132), by Soviet sculptor Yuri Orechov, is an example of fine classical portrait carving which has pervaded Soviet sculpture until recent years.

Those who have had no prior experience in the carving of human dimensions should practice with an oil base clay (plastiline) to determine whether the desired effect can be produced. An illustrated book of art anatomy can be helpful to those who cannot visualize the placement of features.

Delay the sculpting of a head and face until you are ready for the harder stones such as limestone or marble. Facial features can be sculpted in the soft stones such as alabaster, however, delicate carvings will tend to fracture and crumble.

A suitable stone to accommodate the carving of a head and neck would be a rectangular block about 30 inches tall, 10 inches wide and 8 inches deep.

Use the pitching tool and point to round the top of the stone by breaking off large pieces at the edges and corners. The aim is to change the cube-like shape of the stone to resemble the top portion of the cranium. When this is accomplished, put the pitching tool aside and complete the shaping with points and claws.

If we were to view a head from the side, the profile suggests the high points of the features and their relationship to each other. The nose would be designated as the high point, with the lips, chin, forehead, cheeks, and eyes as secondary forms in proper descending order. Consider the "V" shape of the corner of the stone to be the profile line, and note that the natural contour moves directly inward in both directions similar to the natural planes of the head. If we were to use the flat center of the stone as a high point, a good deal of energy and stone would be wasted to create a profile in the center. It already exists at the corner...why not use it?

Using a heavy crayon, draw a profile line at the corner designated as the high point of the head, extending from the neck portion upward over the forehead, the top of the head, and downward centrally to the back of the neck. Draw a horizontal line across the profile line from one side of the head to the other for the position of the eyes. This line should be just above the median line of the head. Finally sketch the outline for the eyes, nose, and lips.

Negative areas are created to yield high points of

the cheeks, eye balls, nose, and chin. A point chisel can be used for this procedure, although I prefer the ease and versatility of the flexible shaft fitted with appropriate carbide burrs.

It is best to leave the detailing of the eyes for last, after the rough carving of the other facial features. The nose, mouth, chin, and neck must relate to each other. The bulge of the forehead, and the egg-like formation of the eyes and their relationship to the cheeks, can now fall into place. The eyes may be hollowed for a desired effect or the more common oval positive forms. By leaving the decision for the shape of the eyes for last, an irreversible error can be avoided.

Examples of hollowed eyes, by author:

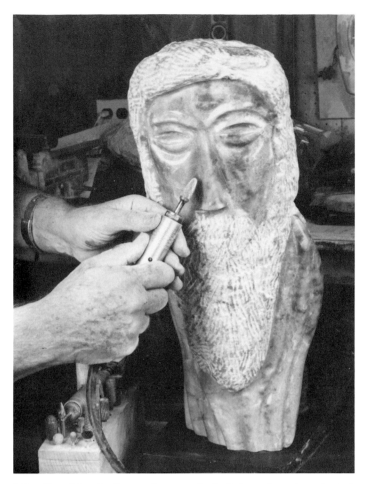

The flexible shaft machine is helpful in forming facial features...

Two examples of hollowed eyes sculpted by the author.

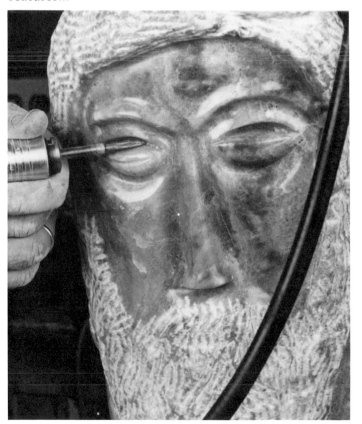

and eyes.

131

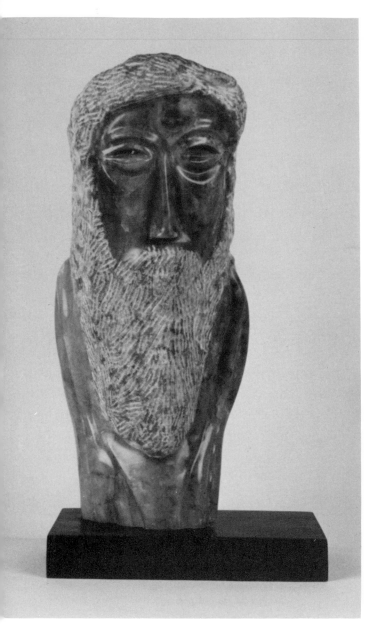

"The Elder," by the author, Colorado alabaster, 22" H x 9" W x 7" D, 1987. Photo by the author.

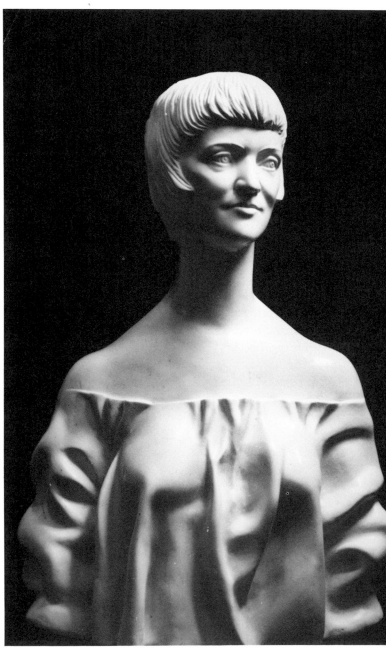

"Marina," Orechov, Yuri, Carrara Marble, 31" high, 1989, Courtesy of the artist.

FILLS AND REPAIRS

Stone is a material which forms naturally, it is not poured from a test tube. There is no accounting for the entrapment of debris and foreign material during metamorphosis or sedimentation of the stone. Other problems might arise. A stone that is being carved might develop cracks or chips. In the case of limestone, the material can be naturally pitted with tiny holes beneath the surface. The lovely veining of alabaster sometimes splinters and fractures.

If the terms "fills and repairs" are accepted as being part of the carving process, then we are admitting inferior technique. I have made it a point never to use external materials to correct imperfections which occur within the stone during carving. I prefer to eliminate the fault by carving it away, adjusting the design if necessary.

I have found that sculptors tend to overuse synthetic materials for repairs. This technique is not intended as a cure-all for mistakes or poor carving technique.

Earlier in my career, I completed a sculpture which included a "fill" with a synthetic epoxy material. Although the repaired fault was indiscernible, it irritated me to the point that I never publicly displayed the piece, and it remains to this day a representative of the cliche', "collection of the artist."

To my way of thinking, a flaw that is eliminated by means of a synthetic material remains a "repaired flaw." A viewer might not be aware of the repair, but I would be, and the perfection that I always strive for could never be achieved. When I resort to "fills and repairs," I prefer to think in terms of correcting a damaged existing sculpture or artifact of stone.

I have made wide use of the repair process of completed work and for laminations which I shall describe in a subsequent section. Despite my personal prejudices against the use of a synthetic to repair stone during carving, some sculptors have no hesitancy. The choice is yours.

The name of the stone epoxy is "Akemi," manufactured in West Germany and widely available in this country at the various stone sculpture suppliers. It is available in a flowing grade for horizontal surfaces, in buff, white, and transparent. The knife grade for vertical surfaces is available in buff, white, transparent, limestone, and travertine spackle. All grades except limestone will polish to a high gloss using the same technique as with the polishing of the stone itself. The correct amount of hardener is supplied with each can and additional tubes of the hardener can be obtained if necessary.

Akemi coloring paste is available and may be used with all of the varieties of the adhesive. The colors supplied are black, white, red, green, ochre, and brown, which are mixed with the mastic portion of the epoxy in diluted amounts to match the color of the stone. The limestone and travertine grades are supplied ready to use and do not require tinting.

Akemi will accept iron oxide colors and, for that purpose, I have found it to be advantageous to obtain dry paint pigments from a paint supply dealer. The wide range of colors available at the paint dealer affords a greater degree of matching accuracy.

The single disadvantage to the use of Akemi is that the chemical reaction between the mastic and hardener is rapid and the material will set in less than eight minutes. This is not a product for a slow worker. You should attempt to slow the reaction as much as possible. The slower the setting of the epoxy, the stronger the bond will be. A high room temperature or adding excess hardener will speed the setting time of the adhesive.

A suitable room temperature for working with Akemi is about seventy degrees or less. If the mixing of colors is a new experience for you, it might be advisable to consult with a painter. To the painter, mixing colors to produce a desired effect is an every day experience.

The materials needed are:

1. Akemi adhesive and hardener
2. Coloring paste or dry pigment
3. Disposable plastic lid
4. Small flexible steel spatula

A trial batch to determine the accuracy of the color match is the first order of the procedure. Place about ½ teaspoonful of the transparent or white Akemi on a piece of disposable plastic. Akemi will not adhere to plastic, and for this purpose a lid from a fruit or cheese container will suffice. Add the coloring agent in small quantities, mixing well, until the shading of the sample is slightly darker than the polished surface of the material to be repaired. If the damaged piece is unfinished, it will be a good idea to determine the final color by completely polishing a sample of the stone from which it is carved.

Next, I add the hardener to the colored mastic. People tend to overuse the hardener. It is a natural tendency, and I suppose that is the reason extra hardener is available. The correct proportion of hardener to resin is 2% to 3% by weight, which is approximately a one inch bead of hardener to one tablespoon of mastic. Too much hardener speeds up the setting time, but also reduces the strength of the bond.

I prefer to underuse the hardener by almost 50%, thereby slowing the reaction and increasing the strength of the bond. The correct amount is a matter of "feel" and experience will guide you for future operations.

Add about ¼" of hardener to the sample of colored resin, mix rapidly until homogeneous, and allow to set. The "set" is complete in about eight minutes and the material can be carved in about thirty minutes. If you are certain that the final color of the sample matches the area to be repaired, proceed with a new batch of epoxy mixture to repair the damaged stone.

Make certain the area which is to receive the Akemi is dry and free of debris and dust. Use the spatula to pack the epoxy mixture into the area for repair. Add enough of the adhesive to slightly overfill the area and allow to set for at least thirty minutes. The final shaping can be attained with the use of rifflers and files. Finishing and polishing will produce a final product with the repair barely discernable.

The Akemi Travertine Spackle is used for filling the natural cavities of travertine and for sealing the surface. It may be tinted with ochre, producing a distinct contrast between the cavities and the stone. The final product may be polished to a high gloss.

The Limestone Akemi varies from the other varieties in that it will not accept a polish and requires planning to coordinate its use. It is used for patching and laminating limestone and is available in a matching color and texture which is extremely close to the natural stone.

Natural limestone is capable of developing a high gloss and a deep beige color when polished. The limestone Akemi will not accept a polish and will retain a buff color which is similar to the natural stone. Hence the need for planning.

Refer to the photographs of "Phaedra" (p. 119) and "Mme. Picasso's Mate" (p. 120). The Picasso portrait is unpolished and represents limestone in its natural state. The "Phaedra" is an example of polished limestone combined with natural stone.

The Akemi limestone could be used to repair the Picasso and the textured area of "Phaedra," but the lack of shine would prevent its use for the polished area. To repair the polished area, I would use the transparent variety and attempt to match color with paint pigments.

Limestone in the natural state will vary in color ranging from a light beige to a deep buff, and although the manufacturer has claimed Akemi Limestone Super to match the natural color of the stone, this is not always the case. It is possible to improve the quality of the match with dry paint pigments as I have described in previous sections. There is also another method.

In situations where the limestone Akemi does not match the natural stone, it is always because the adhesive appears lighter than the stone. The variation is never intense, but the slight difference can be noticeable. As we have discussed, the variation between the polished limestone and the Akemi is indeed intense, both in color and shine. To overcome this type of situation, I have had success in hiding the repair by creating a texture throughout the area of the patch.

A determination must be made that the insertion of an added textured area will enhance the design of the work. The creation of hair, ornaments, attire, or rough skin tones are samples of textures that can be used for this purpose. I shall offer a dramatic illustration of this procedure within the following section.

LAMINATING STONE

About a year ago, one of the premier sculptors of the Soviet Union was a guest at my home for a week as part of a Soviet-American cultural exchange program. We had a fascinating exchange of ideas and techniques. While working together in my studio, I had the opportunity to discuss the process of laminating stone, and some of the equipment used in my work. To my great surprise, my guest had never heard of the German product, Akemi, and was not familiar with the flexible shaft machine, and the laminating process in general. He was so taken by the procedure and the results, that I gave him a supply of the Akemi and the information for obtaining a Foredom flexible shaft machine for his personal use in the Soviet Union.

With the advent of modern power equipment and adhesives, we are able to enter a world of sculpture where the ancients were unable to tread. The brilliant master carvers of Egypt created

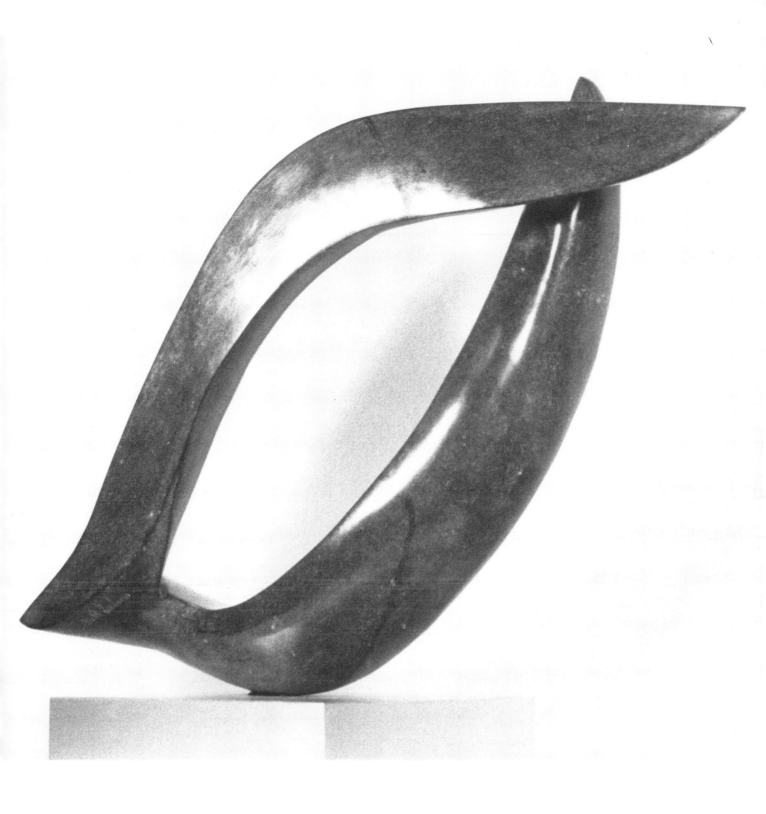

"Seabreeze," by the author, Serpentine, 15" H x 23" W x
6" D, 1985. Photo by the author.

facades of stone and used various grouts to join stones. Modern epoxy cements are more efficient.

The transporting of marble from the fields of Carrara to the construction sites of the Roman empire was difficult. In order to conserve the use of marble, many of the columns and buildings constructed by the Romans were actually facades of marble, covering a local base stone such as limestone or basalt. For the times, the feats were creations of genius.

We don't have to claim genius capability. The availability of superior equipment has closed the gap.

At the very beginning of my career as a sculptor, I conceived an idea which was, in my inexperienced view, original and innovative. Why not join two stones of contrasting color and then carve as if they were one piece? I obtained machine cut pieces of black African wonderstone and white Italian alabaster. Each of the stones had at least one perfectly flat side so that the two could fit together without gapping. I reasoned that if dowels are used to join woods together, why not steel dowels for stone. Capitalizing upon my experience with wood, I installed two steel dowels, joined the two stones together with stone epoxy, and exerted pressure upon the bond with additional stone.

With great fervor I carved the joined stones and produced a sculpture which, with my limited experience, I considered to be a success. Lo and behold, at the first public showing of my work, my "remarkable" black and white laminated original was sold. Nothing could stop me now! I had re-invented a new and better wheel!

I was slightly embarrassed at my immaturity when I became aware that the concept had been done many times before, and with a great deal more skill. Nevertheless, I was pleased that I could secretly claim originality for myself, though without public recognition.

I have thought about the incident many times, and continue to feel better about it with each passing year. This is what artistic creativity is all about. The ability to innovate, to experiment, to have the courage and confidence of your convictions, and to bask in the glory of success...limited as it might be.

Isamu Noguchi used laminations frequently in his work with stone. I have never tired of visiting his sculpture garden and museum which is within sight of mid-town Manhattan, at the Queens end of the 59th Street bridge, New York City. The museum, which opened in 1985, brings together two hundred of Noguchi's finest works in a setting created by the master himself. Here is an opportunity to meditate amidst the work of a twentieth century genius.

The technique of lamination is a precise and exacting procedure. It can be used to join stones of contrasting or identical color and shape prior to or after carving, and to repair damaged works.

Several years ago, a student in one of my classes had the misfortune of an alabaster torso, on which he was working, fall off his table. The torso fractured in two at about mid thigh. Ordinarily, I would have advised against any type of repair, but the student was so despondent that I decided to salvage his cherished work and laminate the separated portions.

The break was fairly clean and straight, with little chipping along the edges. Vertical holes, ¼" x 1" were drilled in each thigh on both sides of the separation. Using the tracing paper method which was described during the mounting of a sculpture on a base, the holes were accurately lined up opposite each other on each side of the segments. A threaded steel rod was cut to fit and a trial fitting proved adequate. The two segments fit securely with very little gap at the edges.

Dry paint pigment to match the stone was mixed with the resin portion of transparent Akemi knife grade. Hardener was added, mixed, and applied to the rods and the entire surface of the fracture, in sufficient quantity to ooze slightly from all sides after joining. Pressure was maintained sustaining the joint until the adhesive had set. After about eight minutes, the excess adhesive was scraped from all sides of the repair, and the repaired torso was allowed to cure for another 30 minutes. The final steps included smoothing and refinishing with rifflers and files. After the torso was polished and waxed, the break was barely visible. The student was completely satisfied and much to my chagrin, took great pride in displaying the work. To me it would always be less than perfect.

Let us investigate the laminating of stone from a positive approach fortified with adequate planning. The sculpture "Torso" (p. 137), involved the joining of two pieces of black serpentine and one of pink Colorado alabaster.

Strange as it may seem, the question most asked of me by viewers of this type of work has been, "Do you carve the stone after it is joined, or before it is joined?" Most assuredly, the answer is after joining the stone. I am always puzzled that students of art procedures find this question necessary.

The initial step in planning a laminated design should be to determine the form of the finished product. Will it be multi-colored or mono-tone? Is it to be a solid construction? Is it to be circular, perhaps with an opening through the center? Interlocking rings are an intriguing possibility to be considered.

In the case of "Torso," two steel dowels were used. One to bond the upper lamination, and another to secure the lower.

"Voyager" (p. 138) is constructed of limestone, redwood, and brass. The protruding brass antenna served both as a dowel for anchoring the upper redwood form to the limestone and as an exterior design. A second dowel of threaded steel joined the upper and lower limestone while passing through another redwood panel.

Isamu Noguchi's sculpture, "The Sun At Noon," is a circle of laminated French red and Spanish Alicante marble measuring sixty-one inches in diameter. It required the lamination of squares of the stones in alternating sequence to form a huge square with a center opening. The laminated stones were secured with steel dowels at each end. Once the square was completed, the circular form was carved from the internal and external borders of the squares. The effect is breathtaking. Examine the work carefully when you visit the Noguchi Museum in Long Island City, New York.

The primary consideration in laminating stones is the availability of machine cut surfaces of stone. Cutting exact edges by hand is an impossibility. The surfaces to be adhered must be perfectly fitted to one another without a presence of gaps or spaces between the stones. Professional stone vendors have special water-cooled saws which have the ability to cut stone with edges of precise exactness and can supply special orders for your needs. Stone cutting companies can supply cuts in the shape of circles, spheres, and curves. It would be to your benefit to take advantage of their services.

The materials required for laminating are:

1. Stones for the project
2. Akemi knife grade adhesive
3. Steel spatula
4. Plastic lid as mixing surface
5. Threaded steel rod for dowels
6. Electric drill
7. Carbide tipped masonry bits

As a means of impressing you with the quality results that can be obtained with a careful

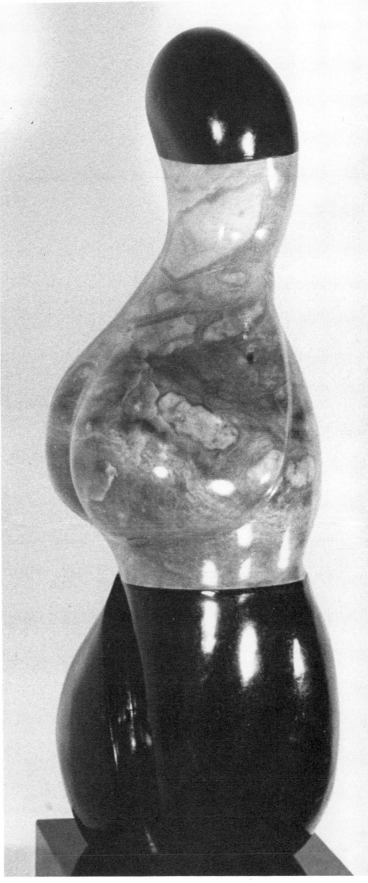

"Torso" by the author, Serpentine and Alabaster, 18" H x 6" W x 6" D 1987, Photo by author, Private Collection.

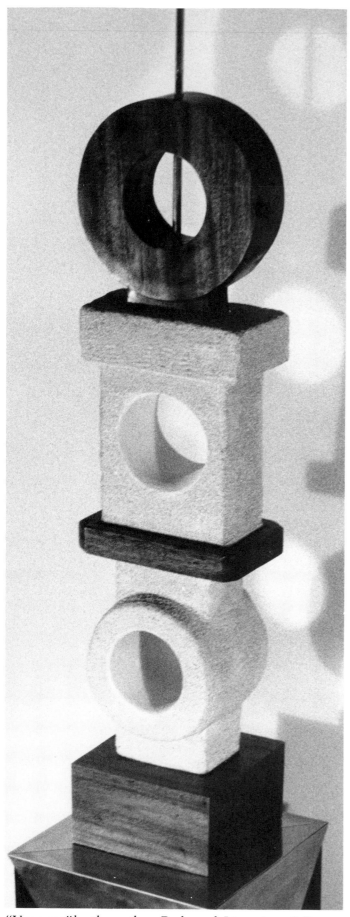

"Voyager" by the author, Redwood, Limestone & Brass, 35" H x 8" W x 7" D 1989, Photo by author.

application of the laminating process, I would like to call your attention once again to my work, "Phaedra" (p. 119). This sculpture is a result of joining two pieces of limestone, each weighing about sixty-five pounds. The lamination is well hidden, and to this day viewers have not been aware of the joining of two stones.

"Phaedra" was selected for exhibition in the Soviet Union during July and August, 1990, by a Soviet-American cultural exchange committee. It was part of an exhibit of 96 works of leading contemporary American artists.

Lamination and Carving

Two limestone blocks were selected, each weighing sixty-five pounds. Two holes were drilled in one of the blocks, ⅜" x 2" and the locations transposed to the other block using the tracing paper technique described under "Mounting the Sculpture." Threaded steel rods were cut to fit and the stone and dowels were set in place to determine accuracy.

Working rapidly in a cool temperature setting, enough of the Akemi Limestone Super was mixed to insure a spill-over of the material from all four sides of the joined blocks. The Akemi mixture was applied to rods in sufficient quantity to fill the drilled holes, and to the entire surfaces of both of the stones to be joined. The layer of Akemi should be at least ⅛" thick. The stones were quickly placed in position. Additional weight was placed on top of the joined pieces to insure a tight bond. In this instance, I added about 150 pounds of stone to produce pressure until the bond was secured.

After about eight minutes, the epoxy had begun to set and turn rubbery. Excess material was then scraped from all four sides and the joined stones were left undisturbed for thirty minutes to one hour to insure complete "curing." The completed project provided a limestone block with dimensions approximately 33" x 12" x 12". Then the carving process began.

Carving the Laminated Form
I made a decision to carve a stylized head and upper torso with long flowing hair, in a manner best described as abstract-realism. One might say that I started with the abstraction and worked toward realism, stopping short of reaching it.

During the early stages of carving the head, proper handling of positive and negative forms was

important. A pitching tool was used to round the top and sides and change the cube-like shape of the stone. As soon as the flat top and sides of the stone were changed to an oval shape, I had no further use for the pitching tool. The point was used to create the beginnings of a negative area in the vicinity of the neck. The cut which swept diagonally downward from the left side of the head was the beginning of the pattern for the torso.

Take note of the cross hatching technique to facilitate the bulk removal of stone in order to project the head as a positive mass. The bottom portion of the emerging form has not been disturbed, to allow for the eventual carving of flowing hair.

The seam of the laminated area will eventually form the neck ornamentation, hidden in back and sides by the texture of the hair. From the neck area, the point was used to form the rough oval outline of the head. The rough outline of the head was the first to be carved. It would have been a mistake to commit to areas of the torso prior to establishing the high points of the head, which was to be the

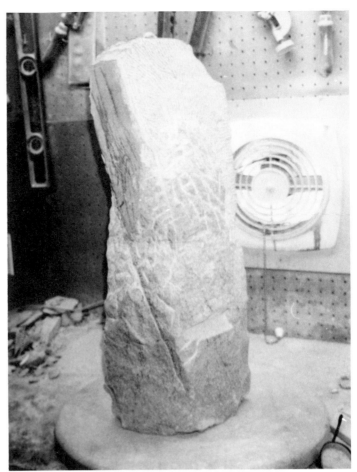

Step 2: Roughing out the block

focal point of the sculpture. All remaining details were supportive of the center of attention which was the head.

Step 3 typifies the continued roughing out of the evolving form. Chalk markings have been used to accentuate and outline the area designated for the face and torso accents.

The point was the tool of choice to remove stone and deepen negative areas in order to project the head as a positive form. Gradually, bulk was removed from all areas of the block in order to develop a graceful curve and tilt of the head. Note that I did not commit to a hair pattern and sufficient stone remained with which to do this.

During step 4, the point was left aside and a four point claw was employed to shape and carve. A definite tilt to the head was established and the diagonal cross line was emphasized as part of the torso. The claw also provided the means to refine and break down the hills and valleys created by the former tool, the point.

The rear portion of the head still had excess stone to provide hair. I allowed the head to develop gradually without a commitment to features such as neck, nose, ears, or hair. A premature

Step 1: Laminating the Stones

139

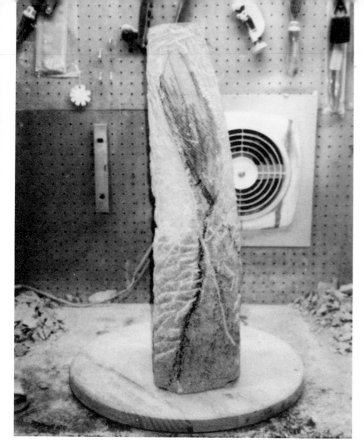

Step 3: Roughing out Continued

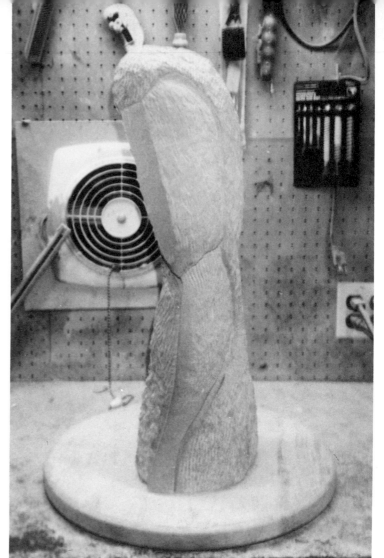

Step 5: Refining

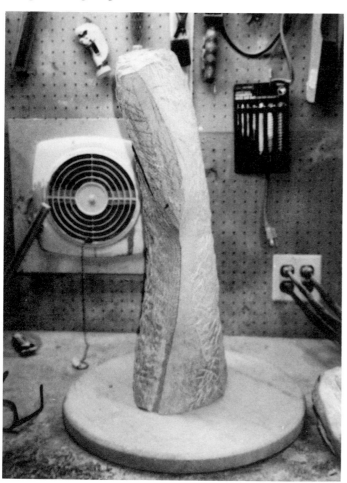

Step 4: Shaping and Refining

development of these features could result in failure.

There seems to be a compulsion on the part of students to identify a face by carving the features prior to establishing the shape of the head. Invariably, the head sinks deeper into the stone, becoming smaller, and the features become disproportionate attachments.

You will note that I had not as yet made a decision on the final form of the head, or made a decision as to whether or not I would carve such features as the nose, mouth or ears.

The changeover from step 4, to step 5, is quite dramatic. I had retained the tilt of the head and reduced the oval nature of the face to form a flat elongated frontal portion. This will eventually represent the nose and mouth in abstract form.

The neck was identified by chiseling inward with the point along the line of the jaw and chin portion. Note that I have not extended the neck carving to the back of the head, but retained stone in that area

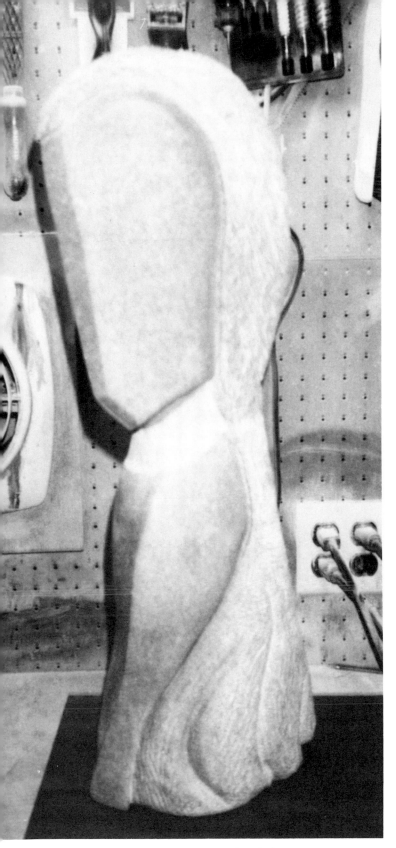

Step 6: Refining, Finishing, and Polishing

for the tresses of hair that will flow the length of the sculpture.

The line of the hair was cut with the point and extends around the face, downward past the neck area, swinging across the lower torso. In order to produce a positive form, the area represented as hair was designated as a high point and all other areas reduced in volume accordingly. Do you recall?...In order to produce a positive form, a negative must be created. For this purpose, a four point claw was used to shape and refine the rough surface originally created by the point. The hair extends down the back and wraps around the torso in a graceful sweep. Texturing of the hair was created by use of the claw, and various riffler rasps, with random negative and positive representations of a billowing and flowing appearance.

The line, which extended from the chin to the base, was deepened. Another negative area was installed to the right of the line, thereby producing another positive portion designated as the portion of a dress or tunic.

I was now ready for final refining and finishing.

Limestone is a material that appears equally attractive whether in unpolished state or polished state. I decided that the overall uniformity of a pale buff tone of the unpolished stone would not suit my interpretation of the tragic legend which involved my heroine, "Phaedra."

In Greek mythology, Phaedra, the wife of Theseus, killed herself, and through a suicide note was responsible for the death of her stepson Hippolytus, who had rejected her advances. The suicide note falsely accused Hippolytus of ravishing her. Theseus called upon Poseidon for vengeance and the God sent a sea monster, which so terrified Hippolytus' horses, that they dragged him to death.

I wanted to display Phaedra as lovely and graceful, without evidence of the moral turpitude that enveloped her. Therefore, the face was portrayed without features indicating an absence of conscience, and the skin tones were polished and smooth. The polishing of limestone causes the stone to deepen to a dark beige, thereby emphasizing a contrast between the textured areas of the neck ornament, skin, and hair.

The neck ornament was installed by using a 16 point texture tool and served the double purpose of being decorative as well as concealing the lamination seam.

Final smoothing polishing included the use of carbide cylinders, carbide paper, buffing with a polishing block, and waxing.

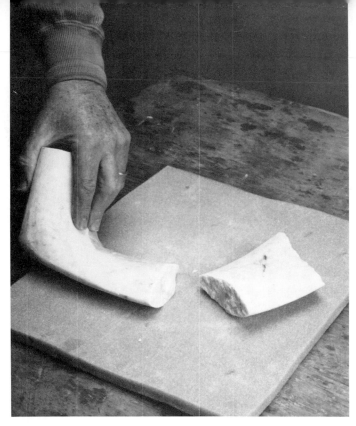

Sometimes it is necessary to repair a piece. This one came to me in several pieces after it had fallen off a shelf.

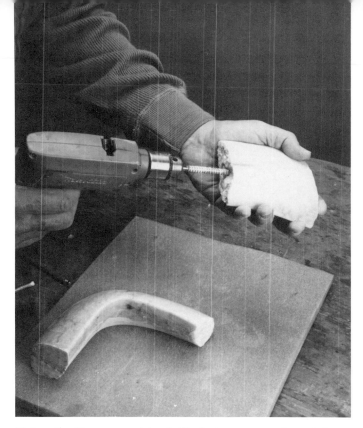

Using the line as a guide, drill a hole in one side and then the other. The hole should be as close in size to the connecting rod you are using as possible. Because of the inaccuracy of the process it is sometimes necessary to go back and enlarge the hole to provide leeway for alignment.

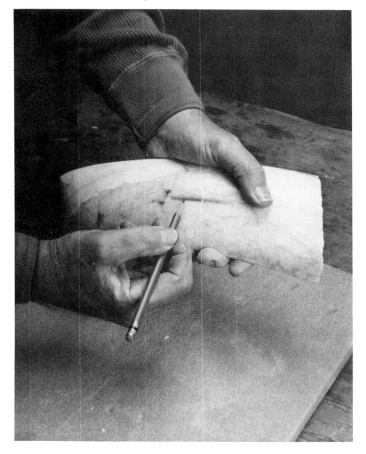

Since the breaks are never perfectly flat, it is not as easy to be as exact as it was in the lamination process. Here we align the two pieces and draw a line across the joint. This will enable us to drill our hole relatively accurately.

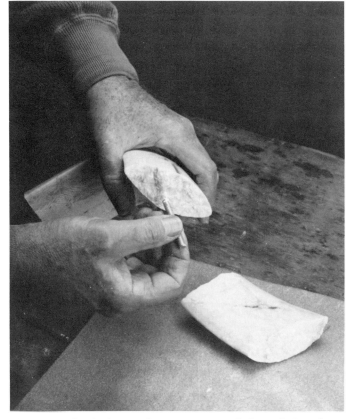

Measure the holes and cut a piece of threaded rod to connect the two.

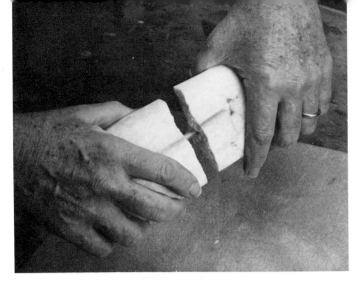

Put the two pieces together with the rod to check fit.

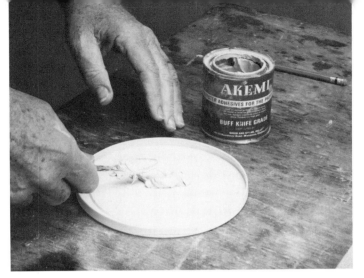

Place enough Akemi on a plastic lid to do the job. While Akemi will stick to almost anything, it comes off the plastic quite easily after it dries.

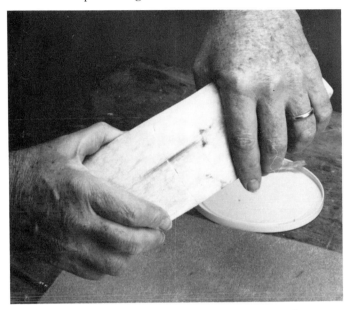

The two sides should align and fit snugly together.

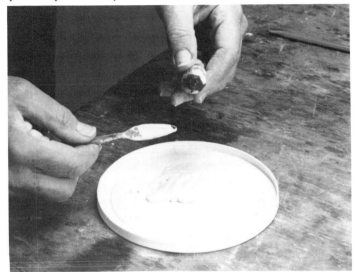

I add the slightest amount of red tint to the Akemi. When this stone is polished it takes a darker tone. This pigment will help in the match. A little pigment goes a long way.

The Akemi comes in cans, ready to mix. The middle tube is the hardener, and the tube at the right is an iron oxide pigment.

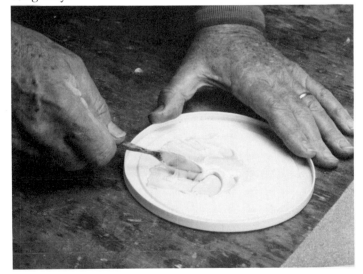

Thoroughly mix the pigment into the Akemi. Everything must be ready before you add the hardener.

Knead the hardener with your fingers before adding it to the Akemi.

I use about half the amount of hardener the manufacturer recommends. By doing this the hardening process is slower. This not only gives me more time to join the pieces, but the slow hardening also creates a stronger bond. Squeeze the amount you want to use on the lid next to the Akemi. Before you mix it in, be certain you are ready to proceed. After they are mixed you only have about eight minutes.

Mix the Akemi and hardener thoroughly.

Apply the Akemi liberally to one end of the threaded rod.

Insert the rod into one side of the piece.

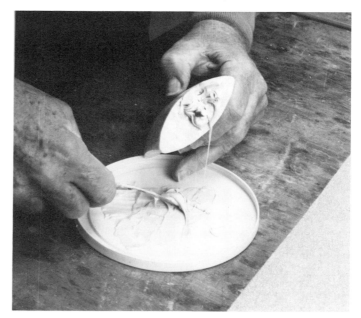

Liberally apply Akemi to the surface to be joined...

144

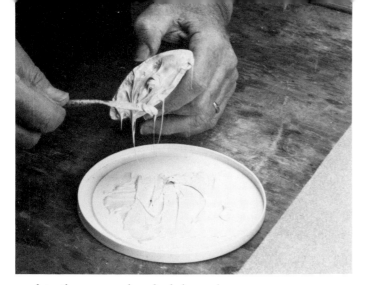

and to the exposed end of the rod

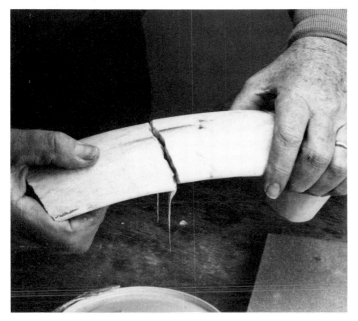

Join the two pieces together. Akemi should ooze out from the joint.

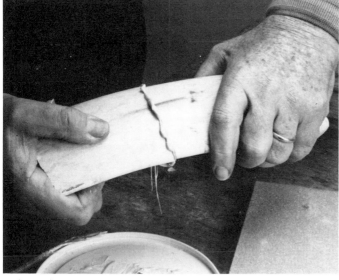

When the two pieces are well-seated, apply pressure for eight minutes.

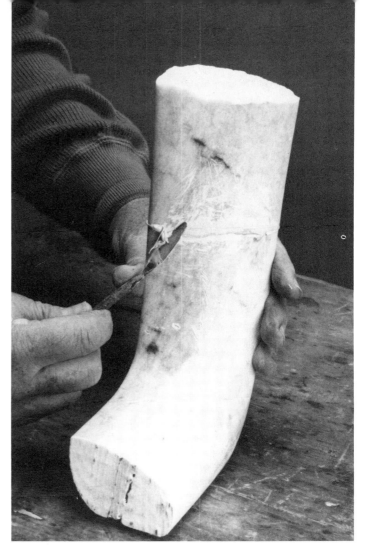

Use the trowel to remove excess Akemi. The more you remove now, the less you will have to remove when it has hardened.

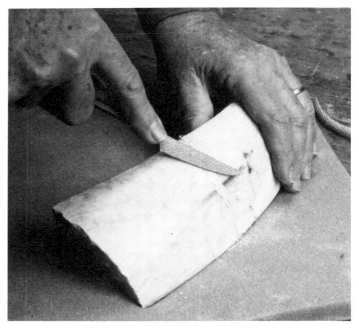

Let the piece cure for about 30 minutes. When it is cured you can use a riffler to remove the excess material and refine the joint.

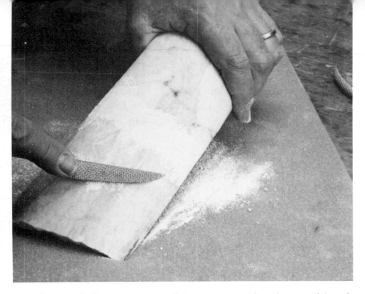

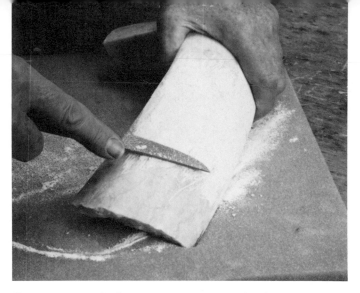

Go beyond the joint into the piece itself to better blend the repair.

Continue until the joint is even with the piece and smooth. You will then follow the sanding and waxing procedures as usual.

POWER TOOL CARVING

Sculptor John Libberton of Sausalito, California, has graciously contributed photographs and descriptions of his work "Entre" in order that you may follow power tool carving via a step by step procedure. Completed in 1986, it is an outstanding example of carving with power tools with hand assistance to reach an objective. Additional examples of his sculpture are shown earlier in the text. Photographs are by the artist.

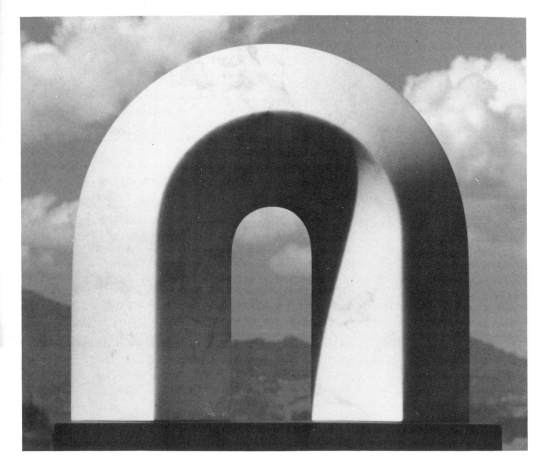

1. The finished sculpture photographed by Mr. Libberton against the Sausalito skyline. Libberton, John, "Ertre," Italian Statuario Marble, 17" x 18" x 10", 1986.

146

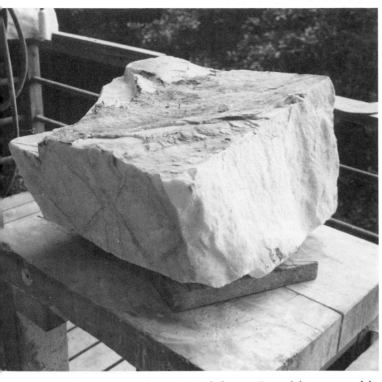

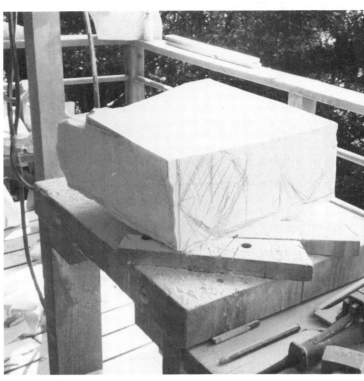

2. The stone in its original form. Pencil lines roughly mark the position of the underside of the vertical elements of the design.

4. Using the bottom as a reference to square, the two sides, front and back are sawed and the opposite planes made parallel to each other.

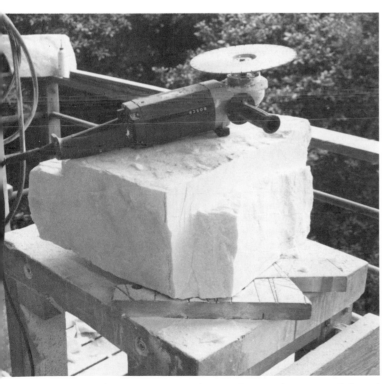

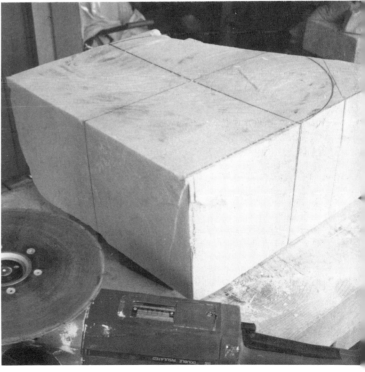

3. A Bosch 5000 RPM right angle grinder is used fitted with a nine inch diamond blade. The stone is sawed to the depth limited by the tool's hub, broken away, and sawed and broken again until the required surface is established.

5. Careful layout is essential. Pencil lines are sharp and are sprayed with artists pastel fixative for greater permanence.

147

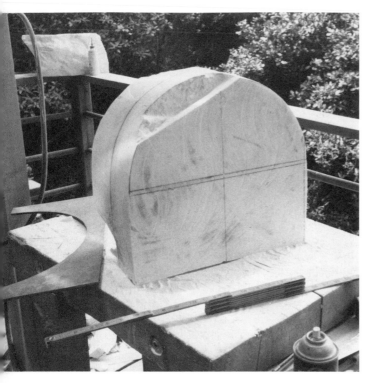

6. The semi-circular portion has been formed by sawing and power sanding using a 24 grit Zec disc. Note the masonite template to check the arc. The center edge is now indicated with a pencil line. (The diagonal break in the upper left was made to check the depth of a flaw in the stone, no problem was encountered.)

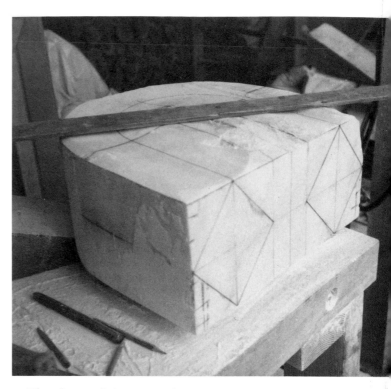

8. The shape of the vertical sections is indicated.

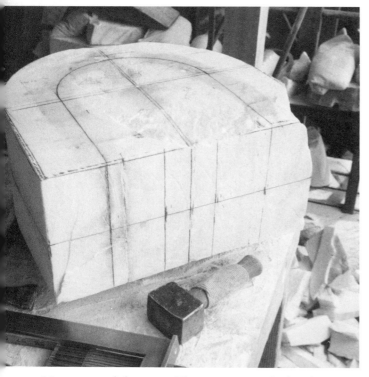

7. More pencil layout. The position of the front is established. Note that hand tools are being used... pitching tool (bull chisel) and hammer

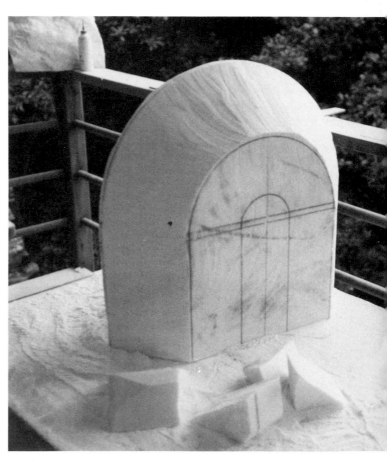

9. The outer form is roughly dimensioned using the nine inch diamond blade and right angle grinder.

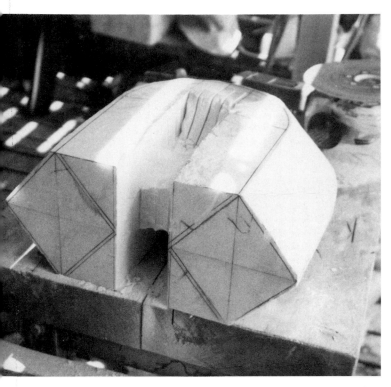
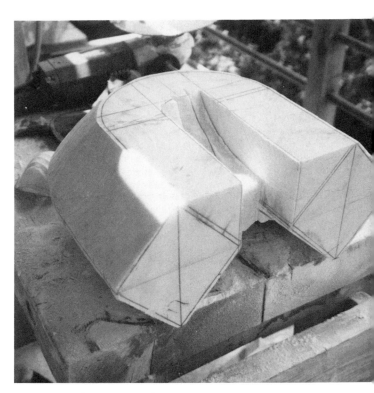

10. & 11. Progress in the center using the nine inch diamond blade.

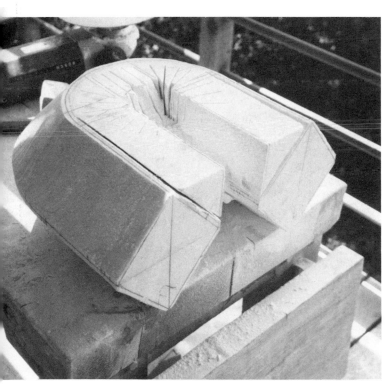
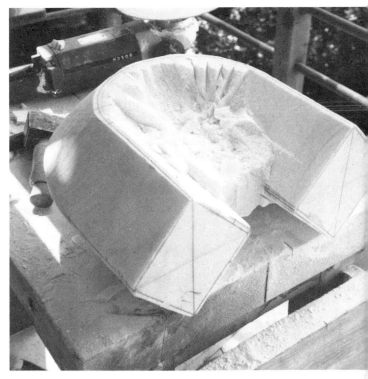

12. Saw cuts around radius in center and along one leg. Since the saw can only penetrate to about 2½ inches, stone must be broken away and the process repeated for additional depth. Note the two pencil lines; the outside one is at a safe distance for sawing.

13. More development of the interior using the diamond blade and hand tools if needed.

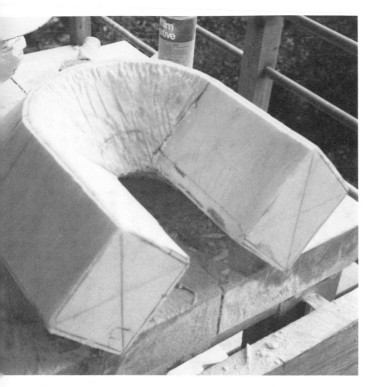

14. Pneumatic percussion tools were used to clean out the center of the arc. Hand tools such as points and claws can be used.

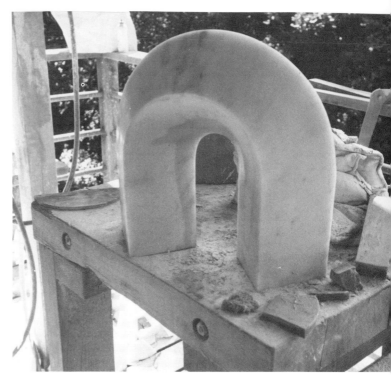

16. Final development of the form with abrasive stones (carbide cylinders) and wet and dry sandpaper prior to polishing with oxalic acid and polishing block.

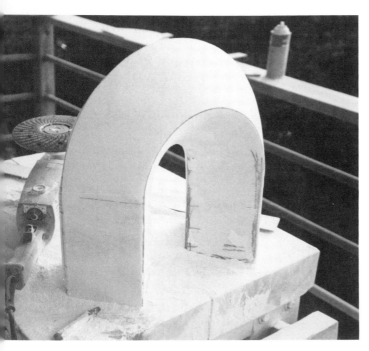

15. Coarse abrasive discs (Zec Discs) and a die grinder with a conical stone abrasive refine the form. Critical to the process is the use of colored crayon. Prior to the grinding, the surface is colored completely with the crayon. This enables the sculptor to see exactly where the tool contacts the surface and avoid coming in contact with the critical edges. This crayon/grinding procedure is repeated over and over, never encroaching on an edge until the final surface conformation has been reached.

17. The finished sculpture ready to be mounted on a appropriate base.

Chapter IX

Marketing Your Skills

The universal question asked of successful artists and instructors by students is, "Can I make a living through my work in the art field?" The question seems to be pervasive throughout the arts, but is perhaps more prominent within the visual arts. There are so many painters and sculptors, and so few recognized super stars.

I recall driving into a service station for gasoline. It was being attended by a young artist with whom I had become acquainted. He was visibly embarrassed at being discovered performing, what seemed to him to be so menial an occupation. His predicament seemed to intensify as he explained that the money he earned by pumping gas was needed as he had not sold any paintings recently.

My compassion for the young man was genuine as I reassured him that if he possessed the propensity to create, he would continue painting whether or not he was able to make money from art. The path he had taken was correct...pump gas and assume part-time duties in any capacity to provide income until the chosen career in art could sustain his lifestyle. The road to success in art is long and difficult...many times with little reward.

Stone sculpture has experienced a revival during recent years, but as yet it does not occupy the position of prominence that it received during the days of ancient Egypt, Greece, Rome, and the Renaissance in Europe.

I would recommend that the approach toward sculpture be viewed as something you love to do, and not as a primary source of income. Pursue a career in a field that will provide you with a good income for you and your family. Maintain your love

for the arts and express your affection for sculpture by carving in spare time. In the event that the pendulum of income swings in favor of the arts, that will be the time to devote full attention to sculpture or any of the media that is your specialty.

The art form is crucial for the maintenance of equilibrium in our civilization and your participation is vital. Art is the means by which future generations will learn of our present day endeavors, as we have learned of the past. Without art there is no civilization. What remains is chaos.

Professional or Non-Professional

During a question and answer period following a lecture that I presented before an art appreciation group, I was asked, "Why do you pursue your career in art?" This was not an illogical question when I considered the affluence of the audience compared to the financial status of the majority of today's artists. I answered by saying that throughout the ages since the dawn of time, civilizations rise and fall. Wars, disease, famine, and other natural disasters add to the demise of our presence. Two things have remained throughout the centuries...the art form, and the cockroach! Some day, about two hundred years from now, someone might view my work in a home, a gallery, or perhaps a museum. They probably will not be familiar with the names of our current leaders of government, but perhaps they will know who I am, and I will have proven that my contributions have been as indestructible as the cockroach!

There is of course the potential of profit through

the arts. For today's visual artist this potential is highly suspect, but not beyond reach. Is money therefore, the point of separation between professional and non-professional? I prefer to think that it is not. Rather, I believe that it is the attitude of the individual artist toward the perfection of his inherent talent, the increased recognition of his creativity and its contribution toward the stability of our world.

The road to financial success in the visual arts, and sculpture in particular, is long and rocky. The exhilaration of success is continually being tempered by the potential of disappointment. Perseverance and determination to reach the projected goal must be a part of the artist's nature. It is not for the flighty or "spur of the moment" individual who cannot brush setbacks aside while planning objectives for the future. Dedication to the art form as a basis for the existence of our civilization is a prerequisite.

Aside from my teaching career, I have often been asked by artists to evaluate and critique the work that they have completed. I seldom refuse such a request. My career in art has reached a comfortable level of success and helping others would be my way of indicating my gratitude.

There have been instances where, after examining the work that showed talent and potential, the artist resisted plans for marketing, indicating that they loved the work and could not bear to sell any of it. I find it difficult to extend any degree of compassion toward such a person. A statement of this type violates the basic concepts which have been the foundation of creative arts for centuries. Typically, this is the thinking of a non-professional. Inherent in this person is the fear of rejection, and the unwillingness to extend their efforts toward perfection and success. Instead their work remains in view of the inner circle of friends and family from whom admiration can be obtained without risking competition with other artists. In the vernacular of the street, it is a "cop out."

Strategic marketing plans should be directed at the true professional or one whose aspirations extend into that area.

Once training has been completed through accredited schools of art, workshops, or apprenticeships, our emerging sculptor must leave the security of the master's nest to produce work on their own. It was Brancusi, when asked why he had left his apprenticeship with Rodin, who said "Acorns cannot grow in the shadow of a great oak tree."

It must be pointed out that sculpture produced in classes, workshops, or any area that is under the tutelage and guidance of an instructor is not considered original. To exhibit or sell classroom produced art work that bears the influence of the instructor as an original product of the seller is fraudulent. Continued study with master carvers is always advisable, but independent work to produce original sculpture is a necessity.

The Camera as a Tool

The ascent toward recognition and acceptance in the art field can consume years of concerted effort. Visibility must be your first approach, with photography as its vehicle.

My files contain hundreds of black and white photographs and color slides of each of my completed sculptures. Photography has always been a hobby for me, and I have found the transition from using the camera for general purposes to photographing sculpture a simple and enjoyable procedure. All of the photographs of my work which appear in this volume were taken by me, with my own equipment, and in my own studio. I am aware that a professional photographer would have produced superior results, but at a cost which was beyond my reach during my earlier years. Nevertheless, my photography has influenced the success that I have achieved, and I have enjoyed "doing things myself."

The work horse of your photographic equipment should be a fine quality professional type 35mm camera. For many years I have used a Cannon A-1 fitted with a 75-150 mm. zoom telephoto lens, and a 28-70 mm. wide angle zoom lens. Supportive equipment includes various flood lights, and tripod. With this equipment I have produced the bulk of my photographs and slides. Recently, I have added two additional cameras, a Chinon Automatic 3001 35 mm., and a Polaroid Spectra. Each has specific uses for special effects. I have never become involved with developing, printing and enlarging of photographs, preferring to leave this involved process to the professionals. The processing company that I have used with complete satisfaction has been Custom Quality Service, Chicago, Illinois. Their service has been of the highest quality, efficient, and economically priced.

Immediately following completion, the sculpture is photographed with 24 exposures of Ektachrome-400 which produces high quality 2 x 2 color transparencies, and the same number for black and white prints using TMax-400. After processing, I

select the best color transparencies and black and white negatives for reproduction and enlarging. Duplicates of the color slides, and 8 x 10 black and white glossy enlargements are obtained to provide me with twelve of each. Although the type of film has varied through the years, I have followed this procedure beginning with the very first work I produced.

It is extremely crucial to have the photographic material available at the time it is needed, by exhibition jurors, newspapers, galleries, agents, clients, or any other source involved in the promotion and culmination of sales. The immediate submission of slides and/or photos to those requesting them instills confidence among the recipients that they are dealing with an experienced professional. A non-professional would have to scramble about, trying to comply, usually without success. The time lag required to produce photo items that I have described would be almost impossible to overcome. It could mean the difference between success and disappointment.

Art Organizations

Nearly every city and town throughout the country is blessed with an art organization. In addition, there are regional and national groups which offer membership for artists in all media. Their primary intent is to serve as a means for member artists to regularly display their work and to disseminate information about artists and the art field. The majority of these groups offer a monthly newsletter and actively seek opportunities for their members to take part in group exhibitions. They are a means of the visibility that you, as a budding sculptor are seeking.

I have been a member of several of these societies, and am quite satisfied with my current membership with a local group, The Trenton Artist's Workshop Association, Trenton, N.J., and the International Sculpture Center, based in Washington, D.C. The combination offers a complete span of local and world-wide information that I require on a regular basis. The national organization supplies a fine monthly magazine and other services which make membership a necessity for any professional or non-professional sculptor.

Catalog

To organize your sales material, obtain a fine quality leather bound loose leaf presentation catalog which will be able to hold about fifty double sided pages of heavy duty transparent plastic inserts. This will be your means of displaying your wares for prospective clients, agents, and gallery owners. It will be your calling card and showpiece. Do not underestimate its importance.

My current catalog includes my activities from the last ten years. It accompanies me to all professional activities, for one never knows when a prospective client, gallery owner, or agent might be available for consultation. There are four pages of resume which itemizes major exhibitions and awards, two pages listing collectors of my work, thirty-four pages of newspaper articles featuring my work, and forty 8 x 10 black and white photographs of my current sculptures, including those which have been sold to clients. It is a dynamic tool and makes a solid impact upon the viewer.

The resume should list your education and training, exhibits, and awards on an annual basis. Arrange to add to the listing as the event occurs, and it will build to an impressive instrument of substantial proportions as the years go by.

Exhibitions

With foundation established, you are ready to step out into the sunlight of public view. Local shows, open or juried, should be your initial consideration. Your art association, newspapers, and bulletins issued by county or city cultural art commissions are excellent sources for announcements of these events.

Exhibits, open and juried

Open shows refers to automatic acceptance to participate in the exhibit. Unfortunately, the quality of the work displayed by other artists in a show of this type is unpredictable...in many cases it is poor to average. Nevertheless, as a beginning, it is a good opportunity to get the feel of public viewing and acceptance of your work. Perhaps you might receive an award which will add credence to your resume.

Juried exhibitions, on the other hand, are more prestigious, and usually include a higher quality of art submissions. Permission to exhibit is dependent upon the approval of a qualified expert appointed by the exhibit chairman. This is your opportunity to determine where you stand with experienced exponents of art, but acceptance or rejection by a juror should not be taken as a final determination

of quality. Preferences and experience of jurors vary from one show to the next and it is not unusual for an artist to receive an award for a particular entry in one show, only to have the work rejected by another.

Consider the juried group exhibit as a vehicle to promote the visibility of your work. Have your photographs ready for submission when requested by the promoters of the show. If my instructions regarding photographs are followed, you can simply pull them from your file. This prompt response will give your work an advantage over that of the artist who delays a response.

The potential of sales at shows of this type is usually minimal. However the opportunity for you to promote your name before the public, art critics, agents, and gallery owners is of greater importance.

Newspapers & Periodicals

The power of the press is more than merely a cliche. Every newspaper, local, regional, or national features columns written by art critics with particular concentration upon current exhibitions and artists that are active or reside within their trading area. Their writers and photographers actively pursue local art activities in order to announce award winners, and the work that they are impressed with. An aggressive approach on your part will include you in their promotions.

Newspaper editors love the use of photographs. It brings an impact to articles and saves print space. This is another instance where having photographs of your work available will produce advantages. If you are appearing in an art show, or have received an award, or for any event of interest, do not hesitate to send a photograph of your work together with a press release describing the event to the newspaper or periodical. The material is bound to be used, and if you enclose a self addressed and stamped envelope, they will even return the photograph. The article and photo that will appear will be a valuable addition to your emerging catalog and highlight your name and work before interested viewers.

Galleries and Agents

All artists depend upon galleries and/or agents for sales of their work. Group shows and exhibits that we have discussed do not produce sales of any consequence. Most buyers, unless they are extremely sophisticated, do not have the self-confidence to select quality art work displayed at open or even juried shows. They depend upon the expertise of a gallery or agent to provide quality work of a reputable artist, and they are willing to pay more for that privilege.

Gallery owners are not prone to pioneer with artists lacking a prior sales record, reputation for quality, and a professional business like approach. Appreciate that their reputation is at stake as much as the artists that they represent. Your presentation package should include your catalog containing the resume, newspaper articles, and 8 x 10 photos. In addition, a folder of 2 x 2 color slides are required for the curator of the gallery to study at his or her leisure.

Investigate the trading area that you wish to enter and make a listing of the galleries within the district. The telephone yellow pages or the local chamber of commerce can be of assistance. Visit the galleries that you have selected for the sole purpose of examining the space available, and the quality and style of the art on hand. Do not announce yourself as an artist. Rather, enjoy the attention afforded a potential client.

Ask yourself the following questions:

1. Does the gallery have floor space for display of sculpture?
2. Does the art displayed conform to the style of your work?
3. Do you see work of reputable artists on display?
4. Will your stone sculpture be unique for the location?
5. Does the atmosphere seem dynamic and aggressive?
6. Does the gallery have a history of longevity in the area?
7. Does the gallery advertise in local newspapers?
8. Are the sales personnel knowledgeable?
9. Are the prices compatible with your price range?
10. Do you have an instinctive positive feeling about an affiliation?

If your responses are affirmative, write to the curator or owner of the facility for an appointment to make your presentation. In addition to your catalog and slides, you may wish to bring one or two of your best works. Visual examination of the actual sculpture is far more valuable than photographic renditions.

Although not visible to the general public through

retail establishments or general advertising, agents possess a common bond with galleries...they must sell art to generate profits. Successful agents maintain direct contact with potential buyers such as collectors, corporate art directors, decorators, schools, museums, and any medium through which art is sold. They are a rather small, select group and cater to artists of established reputation. In other words, their approach is, "Don't call me, I'll call you."

I have had successful association with galleries and agents. The gallery will produce more frequent sales while the agent is prone to the more lucrative corporate installations.

The Business of Art

A relationship with either gallery or agent will bring you in direct contact with the "business of art," an entity of which you must be aware. There are many issues which influence the legal affiliation between artist and middleman. These concern such items as contracts, copyright, consignment agreements, income taxation, legal representation, and various additional aspects of the business world. Artists must endeavor to become business oriented.

A discussion of legal manifestations which would involve you and your art would require a complete and separate dissertation. A practical and efficient solution, short of obtaining legal training, is to purchase a book entitled, "Legal Guide for the Visual Artist," revised edition, by Tad Crawford. This excellent treatise is published by the Madison Square Press, Inc., New York, and has been my salvation for the solution to the many questions that arise.

The text contains samples of commission contracts, consignment agreements, and suggestions for sources of legal assistance. These are the samples which have formed the basis for the contracts that I have used successfully. I would have found it difficult to negotiate with my clients and agents without this guide as a reference.

Upward Mobility

The continued and increased success of the artist is largely based upon the personal drive and ambitions of the individual, with a liberal amount of good fortune thrown in. During the early years of the twentieth century, patrons of the arts were prominent in the "discovery" of exciting talent which emerged from the doldrums of nineteenth century classicism. The quantity of excellent art that is being produced today is far greater than that of the early part of the century and the competition to be "discovered" is fierce. Disappointments and frustrations are the rule rather than the exception. Nevertheless, the constant and relentless search for upward mobility must be part of the nature for all artists if they are to become successful.

The artist must continually seek new outlets for sales through galleries located in the major centers of the country. This is where the action is and it is where you should be if your talent is to be recognized.

Cities such as New York, Chicago, Los Angeles, Philadelphia, Miami, Dallas, and others, are the mecca for such activities...and acceptance within these centers has become increasingly competitive. As a result, many fine artists are denied access to notoriety and fame. Conversely, society is denied the privilege of being able to appreciate the untapped resources of the talent that surrounds them in this country.

Government Subsidy of the Arts

It becomes increasingly apparent that there is need for a form of government subsidy for the visual arts, and yet many of us tremble at the prospects of government support becoming a reality. History has shown us that concurrent with patronage by church or state is the ever present evil of suppression of freedom of expression.

At the present time, we have witnessed the Congress of the United States debating the withdrawal of funding for art which they do not consider acceptable. The form of art which the Congress is questioning is not the issue...the possibility of setting a dangerous precedent for the removal of artistic freedom is!

During recent years, The Netherlands has fostered creativity in the visual arts by supplementing the income for painters, sculptors, and artists in related media with the proviso that government would not interfere with expression. Has this been the utopia artists have been seeking? Unfortunately, it has not succeeded. The result has been an over-abundance of production and an under-achievement of assimilation. Warehouses have become storage depots for the excess of art, some of fair quality, much of it inferior. A similar experience existed in the United States during the depression of the late 1920s and early 1930s as a part of the Works Project Administration (WPA). This was short-lived and

intended to be a part of an economic program for the entire nation, rather than a savior for the arts in particular.

During the past year I have developed a close friendship with a prominent sculptor from the Soviet Union and I have had discussions with him regarding relative status of the arts in his country and the United States. The Soviets have added an additional wrinkle to the pattern of governmental subsidy. An annual grant or pension is afforded to artists to permit them to continue to live and produce art in a relatively affluent lifestyle. However, in order to qualify for this privilege, the artist must be qualified to receive an appointment to the Union of Soviet Artists. Members of this select group, which numbers about thirty thousand, produce art for the government and at the direction of the government.

What is the status of the artists outside of the union? Their efforts are relegated to small local exhibitions, without the assistance or recognition of the ruling body, and devoid of financial support. They constantly strive for membership in the union and the assurance of financial rewards. The work that is produced therefore, is reflective of proletarian acceptance and indirectly results in suppression of creative thinking.

Although we would hate to admit it, aside from the reward of government support, the Soviet system is strangely similar to the visual art caste system which exists in the United States. Our system produces stratified levels of success which is not always based upon ability. The expansion of production within the field of visual art, which exists as a result of inherent right to personal liberty, has limited the chance of financial success to comparatively few. Many talented artists will never receive the recognition they deserve. However, the strength of our system remains as always, freedom of expression! To the artist, it is the essence of existence!

We in the visual arts are in a catch-22 situation. We need support in order that our artists continue to produce the quality that has made this country the contemporary art center of the world... but is it worth the price of bureaucratic controls?

I have weighed the pros and cons of free enterprise versus government intervention and I emphatically continue to favor the former and the maintenance of the free spirit. A sound economic environment is based upon the ability of individuals to raise their level of achievement and to bask in the sunshine of their success. I believe that excellence will surface, mediocrity will merely survive, and inadequacy will fade away.

Epilogue

Some years ago, I was asked to issue a statement which described my work as a sculptor. Without hesitation I replied, "Everything is sculpture...any material, any idea born into space is a relaxing, imaginative, creative lapse into a dream world from which I reluctantly must return to reality."

What I have come to realize over the years is that the "dream world" which I enter is not a lapse. Rather it enables me to become the person that I really am, and all other experiences of life are merely supportive of that experience. The art world has enabled me to become a better husband, father, grandfather, and a citizen of the world, one who contributes rather than takes. I sincerely trust that you can share a similar experience.

What I have attempted to present is a written account of my experience as an instructor in direct stone sculpture. I have envisioned the reader as a student in one of my studio classes at Mercer County College and at Artworks, the Visual Art School of Princeton. Presumably, it has made the presentation informal, direct, and to the point. It was a simple procedure to intersperse fact and direction with personal anecdotes, experience, and doctrines which assist me in my own work as a stone sculptor.

I wish to stress that there is no set pattern for technique. Instead, it is a means for experimentation which will produce new and, I hope superior methods. Someday new books will have to be written. This can only be achieved by you, the artist, and your continual struggle to improve and improvise.

Bibliography

Brommer, G.F. *Elements of Design and Space,* Davis Publications, 1974
Butler, Ruth. *Western Sculpture,* Little, Brown & Co., 1975
Crawford, Tad. *Legal Guide for the Visual Artist,* Madison Square Press, 1986
Elsen, Albert E. *Modern European Sculpture,* George Braziller Inc., 1979
Fauchereau, Serge. *Arp,* Rizzoli International Inc., 1988
Hoffman, Malvina. *Sculpture Inside and Out,* Crown Publishers, 1939
Kelleher, Patrick, J. *Living with Modern Sculpture,* Princeton University Press, 1982
Lerner, Abram. *The Hirshhorn Museum and Sculpture Garden,* Abrams Inc., 1974
Lieberman, William S. *Henry Moore,* Thames & Hudson Inc., 1983
Moholy-Nagy, L. *Visions in Motion,* Wisconsin Cuneo Press, 1947
Noguchi, Isamu. *The Isamu Noguchi Garden Museum,* Harry N. Abrams Inc., 1987
Padovano, Anthony. *The Process of Sculpture,* Doubleday & Co., 1981
Porter, A.W *Elements of Design, Shape and Form,* Davis Publications, 1974
Prince, Arnold. *Carving Wood and Stone,* Prentice-Hall, Inc., 1981
Redstone, Louis G. *Public Art,* McGraw-Hill Book Co., 1981
Schneider, Bruno F. *John Wood's Sculpture,* University of Minnesota Press, 1958
Tangerman, E. J. *Carving Faces and Figures in Wood,* Sterling Publishing Co., 1980

SUGGESTED READINGS

Butler, Ruth , "Western Sculpture"
Elsen, Albert, "Origins of Modern Sculpture"
Fauchereau, Serge, "Arp"
Finn, David, "Henry Moore, Sculpture and Environment"
Finn, David, "How to Look at Sculpture"
Getlein, Frank, "Chaim Gross"
Hammacher, A. M., "The Evolution of Modern Sculpture"
Hammacher, A. M. "Jacques Lipchitz"
Hoffman, Malvina, "Sculpture Inside and Out"
Hunter, Sam, "Isamu Noguchi"
Krauss, Rosalind E., "Passages in Modern Sculpture"
Lieberman, William, "Henry Moore, 60 Years of His Art"
Lipchitz, Jacques, "My Life in Sculpture"
Moore, Henry, "My Ideas, Inspiration and Life as an Artist"
Michaelson & Guralnik,"Alexander Archipenko"
Neumann, Erick, "The Archetypal World of Henry Moore"
Noguchi, Isamu, "The Isamu Noguchi Garden Museum"
Read, Herbert, "Concise History of Modern Sculpture"
Read, Herbert, "The Art of Sculpture"
Schneider, Bruno, "John Rood's Sculpture"
Varia, Radu, "Brancusi"
Whitney Museum of Art, "200 Years of American Sculpture"

LIST OF SUPPLIERS

STONE
Colorado Alabaster Supply, 1507 N. College Ave., Fort Collins, CO 80524
Dodd Marble, P. O. Box 298, Woodland Hills, CA, 91365
Flatlanders Sculpture Supply, 11992 E. US-223, Blissfield, MI 49228
Gawet Marble Co., Rutland, Vermont 05736
Imperial Black Marble Co., 8013 Chesterfield Dr., Knoxville, TN 37919
Milt Liebson Studio, 69B Picea Plaza, Cranbury, NJ 08512
Montoya Art Studios, 435 Southern Blvd., West Palm Beach, FL 33405
Sculpture House Inc., 30 East 30 Street, New York City, NY 10016 and 100 Campmeeting Ave.,
 Skillman, NJ 08850
Sculptor's Supplies Co., 222 East 6th St., New York City, NY 10013
Soapstone For Sculpture, P.O. Box 3241, U. Station, Charlottesville, VA 22903
Stone's Sculpture Project, 835 S. Deerfield Ave., Deerfield Beach, FL 33441

TOOLS
Flatlanders Sculpture Supply, 11993 E. US-223, Blissfield, MI 49228
Montoya Art Studios, 435 Southern Blvd., West Palm Beach, FL 33405
Sculpture House Inc., 30 East 30 Street, New York City, NY 10016 and 100 Campmeeting Ave.,
 Skillman, NJ 08850
Sculptor's Supplies Co., 222 East 6 Street, New York City, NY 08850
Stone's Sculpture Project, 835 S. Deerfield Ave., Deerfield Beach, FL 33441
Trow & Holden Inc., P.O. Box 475, Barre, VT
Woodcraft, 210 Wood County Industrial Park, Box 1686, Parkersburg, WV 26102
W-T Tool Co., 12155 Stephens Dr., Warren, MI 48090; 1234 Washington St. Stoughton, MA
 02072; 9212 Adamo Drive, Tampa, FL 33619; 9909 E. 55 Place, Tulsa, OK 74146; 8100
 Pinemount Drive, Houston, TX 77040; 4200 Barringer Dr., Charlotte, NC 28224

BASES
First Base of New York, 1651 Third Ave., New York City, NY 10128
Inverness Distributors, 1434 Dairy Road, Charlottesville, VA 22903
Milt Liebson Studio, 69B Picea Plaza, Cranbury, NJ 08512
Montoya Art Studios, 435 Southern Blvd., West Palm Beach, FL 33405
Sculptor's Supplies Co., 222 East 6th Street, New York City, NY 10013
Sculpture House Inc., 30 East 30 Street, New York City, NY 10016
Stone's Sculpture Project, 835 S. Deerfield Ave., Deerfield Beach, FL 33441

Index